T0250395

ART, CREATIVITY, AND PSYCHOANALYSIS

Art, Creativity, and Psychoanalysis: Perspectives from Analyst-Artists collects personal reflections by therapists who are also professional artists. It explores the relationship between art and analysis through accounts by practitioners who identify themselves as dual-profession artists and analysts. The book illustrates the numerous areas where analysis and art share common characteristics using first-hand, in-depth accounts. These vivid reports from the frontier of art and psychoanalysis shed light on the day-to-day struggle to succeed at both of these demanding professions.

From the beginning of psychoanalysis, many have made comparisons between analysis and art. Recently there has been increasing interest in the relationship between artistic and psychotherapeutic practices. Most importantly, both professions are viewed as highly creative, with spontaneity, improvisation, and aesthetic experience seeming to be common to each. However, differences have also been recognized, especially regarding the differing goals of each profession: art leading to the creation of an artwork, and psychoanalysis resulting in the increased welfare and happiness of the patient. These issues are addressed head-on in *Art, Creativity, and Psychoanalysis: Perspectives from Analyst-Artists*.

The chapters consist of personal essays by analyst-artists who are currently working in both professions; each has been trained in and is currently practicing psychoanalysis or psychoanalytic psychotherapy. The goal of the book is to provide the reader with a new understanding of psychoanalytic and psychotherapeutic processes from the perspective of art and artistic creativity. Drawing on artistic material from painting, poetry, photography, music, and literature, the book casts light on what the creative processes in art can add to the psychoanalytic endeavor, and vice versa.

Art, Creativity, and Psychoanalysis: Perspectives from Analyst-Artists will appeal to psychoanalysts and psychoanalytic psychotherapists, theorists of art, academic artists, and anyone interested in the psychology of art.

George Hagman, LCSW, is a clinical social worker and psychoanalyst in private practice in New York and Stamford, Connecticut. He is on the faculty of the Training and Research Institute for Self Psychology, and the Westchester Center for the Study of Psychoanalysis and Psychotherapy. This book is a companion piece to his prior Routledge volume *Creative Analysis: Art, Creativity, and Clinical Process* (2015).

ART, CREATIVITY, AND PSYCHOANALYSIS

Perspectives from Analyst-Artists

Edited by George Hagman

Routledge
Taylor & Francis Group

LONDON AND NEW YORK

First published 2017
by Routledge
2 Park Square, Milton Park, Abingdon, Oxon OX14 4RN

and by Routledge
711 Third Avenue, New York, NY 10017

Routledge is an imprint of the Taylor & Francis Group, an informa business

British Library Cataloguing in Publication Data
A catalogue record for this book is available from the British Library

Library of Congress Cataloging in Publication Data
Names: Hagman, George, editor.
Title: Art, creativity, and psychoanalysis : perspectives from analyst-artists / edited by George Hagman.
Description: New York : Routledge, 2017. | Includes bibliographical references and index.
Identifiers: LCCN 2016028221| ISBN 9781138859111 (hardback : alk. paper) | ISBN 9781138859128 (pbk. : alk. paper) | ISBN 9781315717494 (e-book)
Subjects: LCSH: Creative ability—Psychological aspects. | Creation (Literary, artistic, etc.)—Psychological aspects. | Psychoanalysis and art.
Classification: LCC BF408 .A78 2017 | DDC 701/.15—dc23
LC record available at https://lccn.loc.gov/2016028221

ISBN: 978-1-138-85911-1 (hbk)
ISBN: 978-1-138-85912-8 (pbk)
ISBN: 978-1-315-71749-4 (ebk)

Typeset in Bembo
by Keystroke, Neville Lodge, Tettenhall, Wolverhampton

To Carol M. Press – artist, scholar, colleague, and friend.

CONTENTS

CONTRIBUTORS

Donna Bassin, MPS, PhD is an art therapist, clinical psychologist, psychoanalyst, published author, film-maker, and fine art photographer. She is Adjunct Clinical Assistant Professor at New York University Postdoctoral Program in Psychotherapy and Psychoanalysis. She maintains a private practice in New York City. She has exhibited her work at museums and galleries and was awarded the Gradiva Award for Artwork Contributions to Psychoanalysis.

Anna Carusi, PsyD, is an Italian self psychologist, member of IAPSP and co-founder of the Italian Association for Self Psychology (Aipsé). Professor of Psychodynamics at the University of Rome, she is now in private practice. She has published many articles on psychological consultancy to health units and educational institutions and a collection of Kohut's articles on empathy. She is a painter and has taken part in several group and solo exhibitions, describing her art as an active meditation where art is the expression of the relationship between the visible and the invisible.

Rosalind Chaplin Kindler, MFA, Dipl. TCPP, RDT, is a psychotherapist in private practice in Toronto, working with children and adolescents and their families, as well as adults. She is past director of the Toronto Child Psychoanalytic Program, now renamed CICAPP (Canadian Institute for Child and Adolescent Psychoanalytic Psychotherapy), a training institute in psychoanalytic psychotherapy for children and adolescents, where she is also faculty and supervisor. She is a past president of the Canadian Association of Psychoanalytic Child Therapists. She is a registered drama therapist with a background in theatre and drama. She has presented and published in the fields of psychoanalytic psychotherapy and drama therapy, attempting to forge links between the two. She has a special interest in building bridges between the worlds of child and adult psychoanalytic practice. She also really likes to sing the Blues.

Linda Cummings is a psychoanalytically trained psychotherapist practicing in New York City. She is also a practicing fine art photographer whose work is represented by dm|contemporary gallery in New York City. She has been on the teaching faculty at the International Center of Photography in Manhattan since 1995. Her photography is exhibited extensively in museums and galleries both nationally and internationally and published in leading contemporary art journals and catalogues. She has been the recipient of numerous fellowships and residencies from art institutions including the Whitney Museum of American Art in New York City and Yaddo Artist Colony in Saratoga, New York. She holds a Masters of Fine Art from Mason Gross College of Art at Rutgers University and a Masters in Social Work from the Ehrenkranz School of Social Work at New York University. She completed postgraduate studies at both William Alanson White Institute and the Stephen Mitchell Center for Relational Studies.

Heather Ferguson, LCSW, is a psychoanalyst and group therapist in private practice in New York City. She is on the faculty at the Institute for Expressive Analysis and the Institute for the Psychoanalytic Study of Subjectivity, New York City. She co-authored "Full of yourself: How eating disorders encode a relational history," in the *International Journal of Psychoanalytic Self Psychology* in 2011 and "The enigma of Ana: Lost and found in cyberspace?" in the *Journal of Infant, Child, and Adolescent Psychotherapy* in 2014. She has been a drummer/percussionist for 30 years and serves as a consultant to the Drummer's Collective in New York City, where she was a student.

Dan Gilhooley, Psya.D., is an artist and NYS-licensed psychoanalyst. He is a teacher, training analyst, and supervisor at the Center for Modern Psychoanalytic Studies. He earned his masters and doctoral degrees from the Boston Graduate School of Psychoanalysis, and in 2007 was a fellow in the Psychoanalytic Research Training Program at Yale University. He has published ten papers in the areas of psychoanalytic research and clinical technique. As an artist, he has mounted 18 one-person shows and participated nationally in over 100 group exhibitions. Elected to the National Academy of Design in 1991, in 1995 he received a Gradiva Award for Art Contributing to an Understanding of Psychoanalysis.

Sandra Indig has been trained and is practiced in multiple disciplines: art, psychotherapy, poetry, and dance. She attended the University of Michigan and earned her BFA from Syracuse University. She is a graduate of the NYU School of Social Work and Washington Square Institute for Psychotherapy and Mental Health. She is an active member of art societies (NY Artists Circle, The American Alliance of Museums, JAS); has curated numerous exhibitions (including three for the New York State Society for Clinical Social Work, NYSSCSW); has twice been nominated for the Gradiva Award in Art, National Association for the Advancement of Psychoanalysis (NAAP); is the Committee Chair, Creativity & NeuroPsychoBiology, NYSSCSW; and has been honored by the Society for contributions to the field. For

examples of her artwork and writing, go to www.sindig.com. Her book *Image/Word* will be published by MindMend Publishing. She is in private practice in New York City, specializing in working with people living with creativity, addiction, and trauma.

Diane Lawson Martinez, MD, MFA, is a psychiatrist and psychoanalyst in full-time private practice in San Antonio, Texas, specializing in the treatment of individuals and couples. She is a Training and Supervising Analyst Emeritus at the Center for Psychoanalytic Studies in Houston. She has an MFA in Creative Writing from the Vermont College of Fine Arts and writes works of fiction and creative non-fiction, in addition to her professional papers.

Julia Schwartz is an artist living and working in Santa Monica, California. Her paintings, deeply influenced by years of psychoanalytic study and practice, have been included in *New American Paintings* and *1000 Living Painters*. Her work has been exhibited widely, both nationally and internationally. Most recently, she curated a show called *States of Being* at Torrance Art Museum. As the Arts Editor for *Figure/Ground Communication*, she interviews visual and other artists about their creative process. She completed a residency in psychiatry at Massachusetts General Hospital in Boston, Massachusetts in 1987 and her psychoanalytic training at the Los Angeles Psychoanalytic Society and Institute in 1996. She works in private practice in Santa Monica in psychotherapy and psychoanalysis and has written and presented in the areas of creativity and trauma.

Karen M. Schwartz, PhD, is a clinical psychologist with an independent practice in Atlanta, Georgia, who holds adjunct faculty appointments in the Departments of Psychology and Psychiatry at Emory University and is a Scientific Affiliate in the Emory University Psychoanalytic Institute. She is also a painter represented by the Bill Lowe Gallery (www.lowegallery.com) in Atlanta and Life on Mars Gallery (www.life onmarsgallery) in Brooklyn, New York. Her website is www.karenschwartzartist.com.

David Shaddock, PhD, is a poet and a psychoanalytically informed psychotherapist with a specialty in couples therapy. His poems have won the *Ruah Magazine* Power of Poetry Award for a collection of spiritual poems and the International Peace Poem Prize, among other honors. They have appeared in such journals as *Tikkun, Mother Jones* and *Earth First! Journal*. His poetry books include *Vernal Pool, In This Place Where* Something's Missing *Lives* (with an afterword by Rabbi Arthur Waskow), and *Dreams Are Another Set of Muscles* (with an introduction by Denise Levertov). His play *In a Company of Seekers* was performed at the 2012 Festival of Two Worlds in Spoleto, Italy. His psychotherapy books include *Contexts and Connections* and *From Impasse to Intimacy*. He is a clinical supervisor at the Wright Institute of Berkeley, California and visiting faculty at the Tampa Institute for Psychoanalytic Studies. He is on the Coordinating Council of the International Association for Psychoanalytic Self Psychology, and co-chairs the Couples Therapy Interest Group for that organization. He maintains a private practice in Oakland, California.

Lee Miriam Whitman-Raymond, PhD, MFA, is a psychotherapist and poet. She has published articles on the issue of recognition in the *American Journal of Psychoanalysis* and the *International Journal of Self Psychology*, as well as an article on issues of class in *Contemporary Psychoanalysis,* and has won prizes and published poems in numerous literary and psychoanalytic magazines. Her book of poems *The Light on Our Faces and Other Poems* was published in 2009 by Pleasure Boat Studio.

PREFACE

In this Preface, I would like to make some comments regarding the origin of this book, and to share some thoughts about the analyst-artist contributors and their essays. First, I see this volume as the fourth in a series focusing on aesthetic experience, creativity, art, and psychoanalysis. Each volume has approached these subjects from a particular perspective, the first being theory (Hagman, 2005), the second, the psychology of artists (Hagman, 2010), and the third, the creative and artistic nature of psychoanalytic treatment (Hagman, 2015). Over the years that I worked on this project, I had the pleasure of talking with many artists, whose personal observations and thoughts contributed to my own theories and applications. Often, I would present my work at conferences and participate in panels at meetings, at which time I would engage with many analysts who had an interest in the arts. Over time, I realized that there were many analysts who were also serious, even full-time practicing artists.

These analyst-artists would approach me after presentations with phone images or brochures from exhibitions. Most had self-identified as artists for years, in many instances since childhood, when a budding passion for art combined with talent led them to organize their sense of self around artmaking and identifications with hero artists and mentors. Some had pursued art with unflagging devotion since that time, others had put art aside for some period as they pursued careers as therapists and analysts, and not a few raised families as well. All of those I met were also deeply committed, experienced therapists and analysts, having come to their psychotherapeutic careers in early adulthood, often as a result of their own encounters with treatment as patients. Although I met many analysts who engaged in art as a hobby or casual pastime (however passionately), it was the analysts who also identified themselves as artists and devoted time, energy, and self-esteem in the pursuit of artistic success who interested me most.

In my own case, I stopped doing art when I was a young adult. Because of this, I have always been troubled by the possibility that my recent theorizing, not

hampered by reality, would be flawed. Do I really have valid insight into what art and artmaking is? In other words, as an aficionado, rather than a practitioner, do I know what I am talking about?

As I got to know these analyst-artists, I saw the possibility of testing some of my ideas by asking people who are immersed in both worlds to reflect on their experience. Perhaps these analysts would have insights into art and artmaking that I could never obtain from my readings and discussions. I hoped that these analysts would be able to report first hand from the frontier where both art and psychoanalysis come together. I believed that, by asking them to turn the analytic instrument back on their own lives, they might enlighten me and others about the psychology of art and artmaking in a way in which other artists are not equipped to do. Despite the fact that in the end we never identified any general "truth," the rich complexity and diverse experiences of my contributors' "findings" is its own reward.

Additionally, I wondered what these analyst-artists could tell us about the relationship between artmaking and analytic therapy. Casually, they often noted a connection, such as the use of improvisation, aesthetic sensibility, and the narrative, imagistic, and musical dimensions of the analytic exchange. But as I myself began to dig deeper into the meaning of art, I began to see connections between the two disciplines about which these analyst-artists might have many enlightening things to say. So, over time, I began to recruit analyst-artists for a new component of the larger project, which would be a series of essays by analyst-artists who would write about the experience of pursuing both professions with equal ambition. I sought out people who had had busy and prosperous psychoanalytic and analytic psychotherapy practices for at least ten years, and who had also practiced as artists with some success. Most of the contributors have been formally trained in the arts and they maintain studios and exhibit their work in galleries or other public venues. As analysts, they also have formal training, often at postgraduate institute levels, they are members of professional analytic organizations, and they have identified themselves publicly with one or another school of psychoanalytic practice.

In making invitations to join the project, I looked for analyst-artists who had never written about their dual professional identities before, even perhaps had never thought particularly deeply about themselves in this way. These were my best contributors. They would come to the problem with few preconceptions, and without a shtick, or bone to pick about the topic. In all instances, the analyst-artists who agreed to join the project did so because they saw it as a chance to think and feel deeply about two of the most important things in their lives: being an artist and being an analyst. These contributors would hopefully approach the subject with fresh eyes and a passion for the project that other authors, however articulate and informed, would lack.

In addition, I sought out analysts with varied theoretical and clinical approaches. The group of contributors found in these pages represents self psychology, object relations, modern psychoanalysis, and relational psychoanalysis. Not as broad a spectrum as I had wanted, but I also discouraged the contributors from making their essays too theory filled or partisan. I encouraged each to think of himself or herself

as a practicing therapist who is also an artist, not primarily a self psychologist or relational analyst. In the end, I think you will quickly be able to identify each writer's "school," yet I do not think you will find any author polemical. Most hold their theories lightly, and emphasize the common experience of being a practicing therapist who on alternate days or late at night works hard to be an artist.

As a group, my contributors are also quite diverse professionally. In this sense they reflect the nature of the psychoanalytic profession today. There are several social workers, as well as psychologists, psychiatrists, drama therapists, child analysts, and one licensed psychoanalyst. Hence they bring to their discussion of psychoanalytic practice a rich assortment of perspectives reflecting their unique take on the usefulness of a psychoanalytic approach by different professional disciplines with different populations and in various settings. I believe their observations apply to clinical work beyond the private practice consulting room.

Finally, I sought out analyst-artists who practiced various art forms. Hence here you will find painters, several poets, one rock drummer, a novelist, a vocalist, a photographer, and a film-maker. Obviously, getting input from artists who engage in several, often very different art forms, is of interest. And you will see how music, narrative, visual acuity, etc. all impact differently on the work of analyst-artists depending on their craft. In the end, art is not just one thing, and the interrelation of doing art and doing therapy is enriched by the varieties of artistic practices and forms, as much as by the incredible diversity of analytic patients.

The analyst-artists in this volume are practitioners. They work hard at difficult, emotionally challenging careers. In most cases, there is little romance or magic in how they experience their work. They have put their noses to the grindstone (so to speak) for many years, thus you will find more often than not a realistic, hands-on, experience-near perspective. I encouraged the authors to not shy away from the "dark side." Hence you will hear that art and therapy conflict at times – that the attitudes required for each discipline can be glaringly at odds, that time and energy (physical and emotional) are limited, and that the psychological strains and rewards can be stark and hard to balance. Art and analysis can be profoundly different activities. If some of these analyst-artists experience this conflict, I encouraged them to write about it.

My hope, indeed my expectation, was that after years of intense immersion in both professional disciplines, they would be able to identify commonalities and differences between being an artist and being an analyst. The following is a list of questions that I gave to each contributor – not as a requirement, but more to let them know what I personally was interested in hearing about:

1. Describe in detail how you became involved in your career as an artist and your career as a therapist.
2. Were there some common factors in the choice, or differences between the professions, that played a part?
3. How have you integrated the two professions in your work life, social life, and family life? Give details from your daily experience. Share the challenges you have had to confront in trying to do both.

4. Are there emotional, psychological demands that you have had to deal with to do both jobs?
5. Describe your theory, work orientation, and practice methods as an analyst.
6. Describe your theory, work orientation, and practice methods as an artist.
7. Include specific examples from your work: poems, images, selections from your writing, songs, etc.
8. How is being an artist different from being an analyst?
9. Do you find similarities?
10. Can you give a clinical example from your analytic practice that seems to be relevant to your work as an artist?
11. How would you describe your creative process in both art and analytic practice?
12. Discuss several ideas that have seemed important to you in relation to both professions – for example, the importance of form, the role of affect and emotion, aesthetic experience, creativity, etc. Give concrete examples of how you have struggled with these issues in your work.
13. Discuss in general the psychological and emotional role that each profession has in your life. Which gives you the most personal pleasure and/or satisfaction – and why?
14. What are the ambitions that you harbor and/or are pursuing with each profession?

I certainly didn't expect or advise my contributors to stick slavishly to my list of queries. As you will see, most of them seemed aware of my interests but proceeded in their own way, exploring ideas that were of importance to them. At first, I worried at the freedom contributors showed as they strayed far away from my guidelines. But in the end, I came to believe that the questions that I gave them were too restrictive and academic. Fortunately, my contributors did not feel overly constrained by me as, more often than not, they penned essays that reflected their own experience, thoughts, and values. Given the result – a rich assortment, sometimes quirky, always honest and thoughtful, invariably unpredictable – I am grateful that few of them took me too seriously.

That being said, I should note the obvious: that this is not a rigorous research project. It is a collection of highly personal and idiosyncratic accounts of what it is like to be both a practicing artist and a psychoanalyst in contemporary America and, in one person's case, Italy. We do not make any claims to a general truth about art and psychoanalysis. If there is truth here, it is in the honest reporting by each contributor of his or her ambitions, struggles, and accomplishments as he or she pursues two demanding, and highly fulfilling, careers. My hope is that by just being frankly self-reflective, the result, while not being universal, will be vividly and entertainingly real.

Obviously, the volume does not accurately capture the range and diversity of analyst-artists currently in practice. Many art forms remain absent and there is only one representative from the international community. In addition, I have over the years come to recognize that the worlds of art and psychoanalysis are vast and exceedingly complex. There are so many different schools of psychoanalysis

and within each school infinite varieties of perspectives and approaches to practice. This is perhaps even more true for the arts, not just with the overheated art market driving more and more innovation, but also the generative force of globalization and cultural cross-fertilization. In the face of such diversity and constant transformation, it is perhaps best that we have selected a small group of devoted practitioners, who, from the limited perspective of their own world of work, can let us in on the truth, as they live it. No more, no less.

Finally, an added benefit of this book is the inclusion of artwork by each analyst-artist. The visual painters and photographers have each included a selection of images in color and black and white for the interested reader's pleasure. And the poets and novelist have added to their essays excerpts of representative writings. Unfortunately, we have not been able to include material from the work of the musician contributors, but we have added information regarding links to appropriate websites and internet music shopping sites where performance videos and/or albums or MP3s can be found.

In closing, I want to be clear that I am not endorsing any of the artwork in this volume. My opinion of the quality of the artist's work had nothing to do with my extending an invitation to take part in this project. In some cases, I had only a cursory knowledge of the potential contributor's art at the point of invitation. All that mattered to me was that he or she was a serious artist and analyst, who had the desire to work hard and to reflect on his or her work. He or she did not even have to be a skillful writer. I was simply hoping for a heartfelt, honest exploration of what it has been like for this particular analyst-artist to simultaneously pursue these two remarkable professions.

References

Hagman, G. (2005). *Aesthetic experience: Creativity, beauty, and the search for the ideal.* New York: Rodopi.

Hagman, G. (2010). *The artist's mind: Psychoanalytic perspectives on creativity, modern art, and modern artists.* New York: Routledge.

Hagman, G. (2015). *Creative analysis: Art, creativity, and clinical process.* New York: Routledge.

ACKNOWLEDGMENTS

"To Daphne and Virginia" by William Carlos Williams, from *The Collected Poems: Volume II, 1939–1962*, ©1953 by William Carlos Williams. Reprinted by permission of New Directions Publishing Corp. in Chapter 2.

Copyright for all poetry by David Shaddock featured in Chapter 2 is retained by him and reprinted with permission. "Schema," "Instruction," and "All Sports All the Time," are previously unpublished. "Vernal Pool," "Live Oak Park," and "After Psalm 23" are from *Vernal Pool*, published in 2015 by White Iris Press/Kelsay Books, Hemet, CA. "Hornet" was published in *Bosque* in 2015 by "A Great Blue Heron at Boynton Beach" was published in *From the Well of Living Waters* in 2011.

The excerpt featured in Chapter 5 is taken from *A Tightly Raveled Mind* by Diane Lawson Martinez, published in 2014 by Cinco Puntos Press, www.cincopuntos.com. Reprinted with kind permission of the publishers.

Copyright for all poetry by Lee Miriam Whitman-Raymond featured in Chapter 7 is retained by her and reprinted with permission.

★ ★ ★

In the course of working on this project, Karen Schwartz, Ros Kindler, and Julia Schwartz lost close family members. Despite these tragedies, they continued to be accessible and devoted to finishing their essays. I want to share with them my sadness at their losses and extend my warmest condolences. Thank you, Karen, Ros, and Julia, from the bottom of my heart.

To each of the other analyst-artist contributors, thanks to each of you for the enthusiasm and honesty with which you pursued your part of this project.

To the International Association for Psychoanalytic Self Psychology and the International Association for Relational Psychoanalysis and Psychotherapy for inviting several of the contributors and myself to present earlier versions of these essays at annual conferences. The collegial atmosphere of these organizations fed and nurtured this project at crucial times.

To Carol M. Press for her continual support and partnership over many years. Carol, your companionship and positivity has sustained and motivated me. Thank you.

Thank you to Kate Hawes at Routledge publishers. Your acceptance has meant much to me over the past few years as I have pursued several difficult book projects. Your support has made all the difference to me.

To my children Peter Hagman and Elena Hagman, and my wife Moira. I love you.

Finally, to the memory of my mother, Elena Davila Hagman, the first artist I ever met and the inspiration for my lifelong enjoyment of and interest in the arts and artists – probably the most important gift she could have given to me.

1

COMING INTO BEING AS ARTIST AND PSYCHOTHERAPIST

Keeping self from falling together too soon

Karen M. Schwartz

When I was bored in junior high, before I learned that one was supposed to listen when a teacher spoke, I spent what seemed like hours looking at boys and their shirts, which, in the 1970s, tended to be plaid or striped and colorful. I would redesign the shirts, deleting one color or stripe or aspect of a pattern and visualizing how this would change their look, for better or worse. Thus began my informal and only early training as an artist. Naturalistic observation, intense looking, improvisation, and experimentation informed my eye.

As an early teen, I began a lifelong habit of taking a camera everywhere, and in particular on frequent trips into New York City, about a 30-minute train ride from where our family lived. I wandered the streets with a friend, exploring neighborhoods and taking pictures like those of the New York and Paris street photographers whose work I saw in museums. I became a fan of black-and-white photojournalism in *Look* and *Life* magazines and the cityscape photography and photo portraits of Cartier-Bresson, Brassai, Kertesz, Atget, and Walker Evans. Photography continues to inform my painting to this day in terms of cropping and a preference for unusual angles that camera use brought to the consciousness of painters like Degas.

My unacknowledged ambition to be an artist arose in middle school with the requirement that I choose an elective in the arts, either visual art or music. I chose visual art and found out that I could draw what I saw. Having grown up around New York City in the 1970s and often been dragged to museums by my parents, my principal influences were the great Modernist painters, Matisse and Picasso. So, of course, I saw no problem with simultaneous presentation of multiple perspectives, nor with the absence of traditional perspective in my renderings. Fortunately, my art teacher had no problem with my Modernist vision of what I looked at, a vision that was flat and more true to the way my eye sees line than to exact replication. A dentist's wife who used his instruments to make jewelry and sculpture on the weekends,

she encouraged me with the advice not to change my last name when I became famous. (I have not become famous yet and still have not changed my last name.)

I approached the prospect of college with the idea that I would find a place where I could pursue art and psychology, my two interests. However, having been told all my early life that I had a logical mind and should become a lawyer, I had the idea that the psychology route was closer to my assigned path, the more legitimate adult choice of the two that interested me. I only knew one artist personally and she was kind of unstable. I had no sense of how to craft a life as an artist.

So, I applied to graduate school in psychology and, once committed to that path, found little to no time for painting and drawing, interests I kept alive through college with continued camera toting and art history classes. However, I remembered and missed falling asleep thinking about a painting I was working on and what palette would be best for it, as I had done on a summer semester program in Provence after my sophomore year, my only studio art course in college. Again, as in middle school, during that summer course, I was lucky with my teachers. They did not tell us how to paint or draw. They simply exposed us. They would drive us to Mt. St. Victoire, the subject of Cézanne's most famous landscapes, and say, "This is what Cézanne looked at." Then they would leave us to ourselves.

I returned to artmaking by what seemed like chance, when my husband introduced me to an artist in connection with a collaborative presentation comparing the creative process in psychotherapy to that in artistic endeavor. The parallels between these two processes have been a focus of the professional presentations and writing I have done over the past 20 years. I first approached the subject of parallel processes in art and psychotherapy from the position of a brief experience I had with creative writing. However, once I re-entered the studio of my new artist friend, I found myself compelled to look at and make visual art once again. A generous invitation to come paint live models in her studio evoked in me the response of a kid in a candy store. "Use whatever you want," she would say. That meant full access to her studio of artist materials and, most importantly, provided a model I needed of how one set up oneself to pursue these activities. Though a former instructor at the Maryland Institute of Art, my friend and "could-be" teacher did not try to instruct. Instead, she encouraged me to trust my instincts and to just begin, based on what I saw, and to allow myself to fall into deep engagement with looking. She saw that drawing came to me as a natural outcome of looking and respected that I was making my way authentically.

At this point, I was primarily a once-in-a-while weekend painter who anticipated stolen moments away from practice and family with the eager stealth of a thief. For a long while, I remained very discreet about the increasing time and emotional investment I was putting into art, especially with my psychotherapy colleagues. I thought that doing both would make me seem like a dilettante, someone with expertise in and serious commitment to neither endeavor. But the truth was that I saw artists and psychotherapists as kindred spirits who shared curiosity and a way of exploring human nature and the human condition. As I will elaborate, I have come to see painting and psychotherapy, both, as ways of making sense and making

implicit experience explicit and known. And, contrary to my expectations, I have come to find that patients value my experience as an artist. If anything, I consistently find that knowing of my artistic pursuits emboldens patients to risk sharing their own creative aspirations. Knowing that I live in the world as an artist seems to offer hope that my artistic sensibility might allow me to recognize, appreciate, and support fragile buds of creative spirit in the people who decide to trust me with their cherished ambitions to create something original and authentic to them.

Over the past few years, my art and psychotherapy lives have become increasingly entwined. I continue to present papers and write about the way these two creative processes synergize my dedications to both. However, the organization of my time is quite defined and split into a psychotherapy and an art portion of the week. From Monday through Thursday, I am in my office seeing patients and doing supervision. On Thursday evening or Friday midday, I make a transition to immersion in art and studio that lasts through the weekend. The image that captures the switch in focus is that of Clark Kent tossing off his eyeglasses and suit jacket disguise to reveal the Superman get-up underneath. I can be spotted in the parking lot behind my office building pulling off my work costume and donning paint-stained pants and sneakers under my work skirt. I do this in the parking lot so as not to waste time, of which there is never enough. I throw my briefcase into the trunk of my car and head for my studio, located in a large industrial space about ten minutes away. Interestingly, I don't go from the studio to work, ever. Too much to zip-up?

When I am not in a phase of being clear on where I am headed with my painting, the transition can feel difficult. I sometimes think I am wasting time on Fridays, lingering at the office as I tie up loose ends from the week of psychotherapy practice before letting go of the structured life of scheduled appointment times and 50-minute sessions. The jump into the unstructured format of wide-open warehouse space to create something where nothing exists, not yet, can be daunting. I remind myself that I am not alone, thanks to my time around my artist friend who did not teach me how to paint or draw, but did embody how an artist might be. I am aware that some artists engage in rituals, like lighting candles, to help them cross the studio threshold to tackle the blank canvas that awaits and can intimidate them. When I hesitate to make the transition to the studio, it is the promise of immersion and loss of myself in the work of making things that gets me there. I am drawn in by the selfish anticipation of being responsible to no one but myself, and the prospect of being subversive, at risk to no one but myself, as there are no rules in the studio. There is just me, yielding to the human desire and daring to experience a hand in something bigger and beyond, through the act of creating.

Phase 1: portraiture and psychotherapy – building a sense of self

In my office, most of the week I look intently at seated patients, especially at their faces. (Sometimes I find myself wanting to draw their faces and take that as a sign to get myself into the studio.) I listen hard to their words as I look and absorb what is implicitly, as well as explicitly, stated. So it is natural that I took the human face as

my first subject, and then the human figure and gesture, when I sized up and started working more with live models in life-size format.

My early paintings were Expressionist portraits. I worked from my own photographs of people I knew or of strangers, and also from small black-and-white newspaper photos of well-known people. When I could con a family member or friend to sit for me, I worked from life (*LOST IN THOUGHT*).

FIGURE 1.1 *LOST IN THOUGHT*

Source: Karen M. Schwartz. Mixed media on canvas, 2012

Doing portraits connects to my earlier creative writing efforts and the use of words to create character and convey person in fiction. I associate both of these artistic endeavors, fiction writing and drawing/painting, with the depiction of personhood and the building of a sense of self through the dialogue that is psychotherapy. Loving portraiture as I do (my own and that of photographers and other artists), I am fascinated by what my contemporary psychoanalytic theory of clinical practice, self psychology, suggests to me about the literal building of self that I feel engaged in as a painter of people. Self psychology's fundamental assumption is that communicating from an empathically informed relational stance one's experience of another person to that person, over time, constitutes an essential developmental experience that builds and strengthens that other's sense of self. In my mind, the clinical conversation, verbal and non-verbal, is a record of the dyadic process of the creation of self-experience.

These principles fit well with my sense of what I am doing non-verbally when I do a portrait. I find that looking and drawing is to doing pictures of people what listening and explaining is to the clinical exchange in psychotherapy. I work to capture something essential in a portrait through repeated engagements or "sessions" with a live model or a photograph. I make a series of moves on the painting surface that externalizes my subjective experience of my subject onto a canvas. Then I interact with my own externalized subjective experience, bit by bit, building or finding form. This sequence seems to me closely related to the process of building a sense of self through the relational exchange in psychotherapy. As with a patient in psychotherapy, my experience of a painting subject is filtered through my own subjectivity. Rhythms are established in painting by the elements of time away from the studio between painting sessions, as well as within a studio session, when I step back to look before making a next move. The rhythm of active engagement created by these elements, both as crucial to the painting process as mark making itself, reminds me of the rhythm of listening/reflecting/understanding and responding/explaining in self psychology-informed psychotherapy. The relational aspects of painting involve the artist's engagement with the externalized aspects of self, concretized in an emerging visual form, as well as the relationship between artist and model, and between artist and viewer.

Another continuity I have come to realize between my two practices is literal: my hand's role in the practice of listening and the more obvious role of my hand in my painting practice. That I take notes when I am face to face with many of my patients, something I once swore I would never do, feels like an extension of the use of my hand as an artist. As when contour drawing (a type of drawing that involves looking at a subject and drawing it without looking at one's paper), I barely look down at my session notes as I write them. I experience writing as integral to listening, an organic extension of the listening apparatus. My hand has become like an organ of the listening process, just as it is intricately entwined with looking and trying to make sense of what I see when I draw. Patients almost unanimously seem to accept this practice of writing as I listen as a part of my engagement, perhaps because it is so much a part of the person I am to apprehend the world with a writing or drawing implement, or a camera, in my hand.

The flow between my process as a painter and as a psychotherapist goes both ways and is ever present. The act of painting other people recruits the empathic skills that I practice regularly as a therapist. One must look hard, delve, and understand on an experiential and sensory level to transform meaning into a visual form that captures something essential and integral that the painting will express or evoke in a viewer. When painting a face or figure, I literally use my body to read into my subject's pose, posture, facial expression, and gestures. Repeatedly, I will catch myself literally mimicking a facial expression or twisting my own body and shifting my weight to embody what I am trying to capture and put down on canvas. I literally take on what I see and as that experience sieves through my subjectivity, I am inspired to make moves on the painting surface that express the energy and gesture I feel in my body. This empathic reach to connect and know through intense looking and the embodied simulation (Gallese et al., 2007) that connects painter to model to viewer bypasses outside perspective and conscious thought. It is knowing from the inside, implicit knowing, and has earned me the most cherished feedback I have received about my pictures of people: "You paint people's insides."

I believe that having concrete reference points in my painting practice for the exercise of empathic reach as a psychotherapist deepens and reinforces the fundamental acts of listening and of imagination that empathy requires. It is through painting that I understand the imaginative reaching into the being of another on a concrete, embodied, and procedural level.

Phase 2: from portraiture to life-size abstract figurative work – freedom within the containing boundary of a frame

My paintings, though often arrived at by Abstract Expressionist means, always seem to come back to the human figure. I moved from doing portraits to life-size figurative works at the encouragement of another key figure in my development as an artist, an Abstract Expressionist painter and an enormously gifted teacher. Yet again, it was my good fortune to come under the mentorship of an artist who encouraged me to develop my unique style. Importantly, he offered me an artistic identity by naming my physicality as a painter and fearless use of materials as related to an Abstract Expressionist sensibility. He encouraged me to size my work up to a larger scale that would accommodate my energetic metabolism and athletic approach to painting. Introducing an element of self-reflection that was curiously missing from my painting practice, he challenged me to think about why and how I was painting what I painted, to make connections between my work and the artists I most admire, and to marry choice of materials and the size of my work, and other aesthetic choices, to painting content and message.

In *DIRTY DARA*, the movements required to make the large gestural sweeps of paint are visible in the way the paint is applied and in the execution of line and brush stroke. The use of Abstract Expressionist techniques that prize spontaneous gesture focuses me on conveying human energy and the process of trying to capture it through the quickly-rendered, expressive marks and the fast, energetic way that I

FIGURE 1.2 *DIRTY DARA*

Source: Karen M. Schwartz. Mixed media on linen, 2014

apply paint and draw line. The result: gestural marks that convey urgency, immediacy, and emotional charge because they are a record of the actions that made them and of my attempt to make sense of what I see by painting it. I believe these efforts also reflect an honest engagement with my painting subject, my model.

I have come to approach painting as if it is a sport or a dance. Making large paintings is first and foremost a distinctly physical activity that involves the whole body in motion. I find that I choose paints and drawing implements and surfaces that suit my metabolism as an often-in-motion, fast-moving person. I treat my raw linen canvases with rabbit skin glue to get a tight-as-a-drum stretched surface that affords a Zamboni-like glide that facilitates large, free moves. I favor fat oil sticks that skate easily over the smooth surface of the linen so as not to inhibit the quick, energetic gestures of my whole body in motion making moves and marks to react to, reproducing in my own gestures and process the large scale and energy of the life-size figurative content that is my subject.

Process, the free and exuberant joyful experience of creating the painting, is a subject in itself in the more abstract of my figurative paintings such as *WOMEN AND SAWHORSES*. This is one of a "raw linen series" of spare, abstract figurative, life-size paintings of the human figure that are done on unprimed, unstretched linen tacked to the wall, a set-up that connects me to the cave painters of long ago and their fundamental human urge to self-express, to communicate subjective experience, and to share in the creation of meaning. At first unaware, then unconcerned that I was "supposed" to paint on the white, gessoed side of linen canvas, I freely fell into using the "wrong" side of the gessoed canvas, the raw linen side, for its natural beauty.

I tend to take a "by-whatever-means-possible" approach to developing image on a painting surface. That means grabbing whatever will help me make the forms and marks I am trying to build. I often use my hands instead of a paintbrush. I paint with partially dried clumps of oil paint (*PINK LADY*) and then leave the clumps in the painting. Like other painters who employ Abstract Expressionist methods, I am fascinated by the "accidents" that result from mixing oil and water-based materials that do not go together, using anything from my gloved hands to kitchen utensils to apply paint, mixing low-brow materials such as house paint with the finest art supplies.

I am enamored with the process of creating, and inviting my viewer into that process, by being open and revealing in my mark-making methods and through the semi-ambiguous content of my work. The way marks add up to just barely suggest the human figure in less spelled-out paintings, like *WOMEN AND SAWHORSES*, reminds me of the way patients and I come to create meaning together: bit by bit, taking turns playing with and adding to aspects of our shared process. We are deeply engaged in this accretion-of-meaning process, before we even have a sense of why the pieces of meaning are important. Similarly, the abstract techniques I use do not prescribe outcome. Rather, they enable it to build up and to be located in a series of marks that reveal a transparency of process evident in visible first attempts and visible reworkings. No mistakes and no erasures!

FIGURE 1.3 *WOMEN AND SAWHORSES*

Source: Karen M. Schwartz. Mixed media on linen, 2011

FIGURE 1.4 *PINK LADY*

Source: Karen M. Schwartz. Mixed media on linen, 2014

WOMEN AND SAWHORSES especially excites me because of its marriage of execution and content through the use of abstract elements in a repeating, rhythmic pattern (two figures, two architectural elements, two vertical lines) that echoes and thus strengthens the figurative content of the painting. The spontaneity, freeness, and openness of the marks in this picture invite viewers into those same attitudes as they attempt to make sense of what they are seeing in it. Said in the language of contemporary psychoanalytic talk, the way I made this painting and its gestural quality invites intersubjective relating and relatedness to fill in what is left unstated and,

to an extent, ambiguous. Because gestural marks carry the meaning of a suggestion or hint of what is there without spelling out the fullness of implied meaning, there is room for the viewer of a painting like this one to enter into the artist's process in order to make sense out of what is not explicitly stated.

Doing life-size figurative work affords both a sense of freedom from the physical constraint I feel in the practice of psychotherapy, as well as freedom from the rules of engagement I associate with psychotherapy practice. As a psychotherapist, I do not use physical touch, even when I want to. I sit rather than move about, even when I want to. I find that there is much physical restraint involved in practicing psychotherapy that the dance of creating life-size human figure paintings releases and relieves. As a psychotherapist, I feel a responsibility to the group, to my identity as a psychologist and psychoanalytically oriented practitioner. These responsibilities commit me to a way of doing things and, thus, to a status quo. Departures from that way of doing things bring me into arenas of shame and guilt, even though I trust that the unplanned joint improvisation of "now moments" (Stern et al., 1998) and "disciplined spontaneous engagements" (Lichtenberg et al., 1996) is where the therapeutic action is. In the name of the individual, I think that both artists of all kinds, and psychotherapists too, do well to be open to the questioning, rather than the defending, of the status quo. Poet e e cummings (1958) commented on the heroic human struggle that we all face in trying to preserve our own individual subjectivity:

> To be nobody but yourself in a world that's doing its best to make you somebody else, is to fight the hardest battle you are ever going to fight. Never stop fighting.
>
> *(p. 13)*

As a psychotherapist, I feel called to champion individual experience in its unique aspects and to be subversive in relation to the duplicitous aspects of social relating and the ubiquitous, deceptive aspects of human attachment. My subversiveness as a therapist gets expressed by deep respect for personal idiosyncrasy and individual subjectivity, and is backed up by adherence to a theoretical perspective that privileges these values. I bring a strong sense of discipline to my work as a psychotherapist that comes from dedication to training and membership of professional groups whose values I feel a responsibility to uphold. When I paint, subversiveness comes into play through my untrained, ignorant, and completely promiscuous use of materials. Neither formally trained as a painter, nor loyal to any academic art training or tradition, I am not burdened by knowledge of how materials are supposed to be used, nor the "right" way to paint. I love this! What a relief from the professional restraint I feel obligated to exercise as a psychotherapist. There are no mistakes to be made in painting, just marks to react to. Whereas self-consciousness is the hallmark of psychotherapy – both inherent to its process, and, in a way, the goal of the process – freedom from concern about how I am doing what I am doing and not being self-conscious are the conditions that propitiate my artmaking. As is the case

in practicing psychotherapy, I cannot not encounter myself when I paint. However, instead of reflecting on motives or meanings and disciplining how I express them, or perhaps as a first step toward doing just that, I enact what I encounter. Again, in painting, action and making moves are the name of the game.

Intentionality informs these spontaneous processes and freedoms I so crave in the studio when I claim accidents, such as those afforded by employing materials not meant to be used together, or make an unconventional use of materials (the "wrong," unprimed, linen side of a gessoed canvas) as a deliberate, pre-meditated part of my creative process. I also am intentional about striving to avoid premature resolution and to push the elements of chance and happening by building time away from a work-in-progress into my process, restraining my ever-ready impulse to act and make a next move. Time away affords a new look and a rhythm of engagement informed both by freedom and restraint, acting and looking. One might say that the element of time is the source of perspective in modern and post-modern painting.

I have learned that the exuberance of uninhibited improvisation can be facilitated by informed preparation, by a *frame* for my activities. So, I will discipline myself at times to dilute paints and inks ahead of time so they are ready for spontaneous moves such as pouring, spraying, and throwing materials at the canvas. It does not come naturally to me to plan ahead. Sometimes I just lose it and attack the canvas or my wood panels or paper tacked to the wall with whatever is closest at hand and easiest to apply: paint straight out of the tube, ink in spray bottles, saffron-infused tea that will stain, oil sticks, charcoal, or the charcoal remains on an eraser.

As a psychotherapist, I am trained to respect the value and function of the notion of a frame (Bass, 2007; Langs, 1982) for the work of psychotherapy. As an artist, I feel freer to experiment and investigate this notion for myself. When I first decided to scale up my work to life-size, it was partially to accommodate parts of the human figure I could not get to fit within the edges of my paper or unstretched canvas tacked to the wall. I often would make marks beyond my painting surface right onto the wall. I seemed unable to stay within the boundaries of my designated work surface, so I extended them with additional sheets of paper to accommodate overflowing images, a technique I borrowed from abstract artists who challenged the notion of a rectangular or square frame. I discovered that no amount of extra space keeps me from having my figures run off the surface I am working on. So I accept this and see that close cropping and cut-off figures add a psychological dimension to the work. Close, unusual croppings also reverberate with my photography experience of shooting and framing images from off-kilter viewpoints and perspectives and create a sense of intimacy and being in the space with the figures I paint (*CUTOFFS*).

As an artist, I can go with my wont to disregard arbitrary rules and frames and make art out of it. However, it is not lost on me, the psychotherapist, that the frame serves a useful and important function. Adhering or not to the notion of a frame, which is not just a notion when one is making a concrete object, a painting, has artistic risks and consequences, just as in psychotherapy. Working right to the edges of my unstretched canvas means losing parts of the image when it comes time to stretch and show it. So, with that realization, I discover the undisputable function of a

FIGURE 1.5 *CUTOFFS*

Source: Karen M. Schwartz. Mixed media on canvas, 2011

frame that I tape off on my canvas before I start to work. When I draw over the edge, I can see what I will have to sacrifice when I present my work outside the studio. My taped frame allows me to confront artistic decisions regarding composition, what must be included or not in the painting. It is an essential element of the experience of freedom within the discipline of a thought-out, deliberate approach to the artwork.

That I have a material product to show for my art work is a deeply fulfilling counterpoint to the uncertainty and unease I can feel doing psychotherapy, where I often do not have a certain, nor even agreed-upon, outcome, nor a concrete work product to show for my effort. I will paint for the rest of my life for the thrill of total immersion in a process that thrives on freedom, courage, and integrity and results in the creation of a tangible, visible record of my work process that is concrete. As a psychotherapist and as an artist, I carry the faith that what I am doing does or will amount to something meaningful, that it will assume coherent form. Only as an artist, however, am I rewarded by the materiality of that meaningfulness. I am thrilled to make an object that will go on being, that can be seen and hung or leaned against the wall – a solid enduring externalization of my subjective experience.

Phase 3: making sense and meaning in a relational context

I love drawing and painting the human figure, but tire of the inevitable replay of the dynamics that seem to attract people to posing nude in front of a room of artists. When the woman, whose magnificent body of an African goddess dominates and dictates all her interpersonal exchanges (along the lines of her aptly chosen work as a dominatrix), starts to subtly refuse to alter her pose, or requires me one time too many to take studio time to pick her up from the train station, I am ready for a break from the arrangements involved in painting the model. I also sometimes crave time alone in the studio and the opportunity I have discovered that painting can afford to organize chaos in my mind, even when I am not aware it is there.

Model or no model, when painting, I try to give myself over to a process in which I have faith of finding something true and honest about my engagement with a subject, either another person I am painting or my own subjective experience, externalized into a concrete emerging form on the canvas (Hagman, 2005). I do not set out with a preconceived agenda or narrative when I paint. That is even more the case when I do not start with a live model or a photograph. I cannot say ahead of time, nor when asked, what I aim to paint. Artmaking for me is wordless. I do not think when I do it, in the usual sense. Instead, I go into the studio and give myself over to something non-verbal. I do not direct this process by the conscious intention or control that talking to myself in words might involve.

In the studio, I give myself over to a process in which I have faith. I have learned that my subjective experience will come out in the work. I have discovered that painting is a way of making sense, a way of making implicit experience explicit, of giving literal form to otherwise unformulated experience. When a painting violates my expectations and reveals an inner state that I have not been explicitly aware of and could not have articulated without "reading" it in the painting, my faith in the painting process is rewarded by a coming together of meaning in coherent form and human connection. When the painting I make engages viewers, their reactions often reveal to me feelings and thoughts that I did not realize I felt or had within me to express (*DOWN THE RABBIT HOLE*). That is, I can find out what I think, feel, perceive by painting. Painting is thinking and the wordless work and thinking of artmaking is a relief to me, a release from the effort – albeit the rewarding effort – of putting into words what is not consciously known.

As an example, the body of work I produced over the past year was necessarily dictated, though not intentionally so, by the sudden, unexpected illness and loss of my mother. Aware only of an intention to work more abstractly, I found that as soon as I stopped working from live models, what was inside, my inner inchoate experience, started coming out in the paintings. I didn't see it at first. I found masks, birds, sometimes cartoon characters, a rabbit or two suggesting themselves to me as I threw, poured, drew, scraped, and sprayed painting surfaces (*PRIMORDIAL VISION*). These are common metaphors, to be sure, yet I was surprised to be finding them in my paintings. Their presence connected me to the broader human experience of dealing with loss, mystery, and transformative human

experience. Bringing these metaphors to light and to life in these paintings has given form to a personal search to make sense. I found that realness lends itself to metaphor because there is both an abstract and a concrete aspect to essential human experience. Metaphor joins these essential aspects, the abstract and the concrete. Through the act of painting and through painting as a medium, I was able to link the abstract, emotional experience of loss to concrete, depictable images, like a bird flying, as a search for my mother in the sky, an issuing of the question: "Where did she go?"

FIGURE 1.6 *DOWN THE RABBIT HOLE*

Source: Karen M. Schwartz. Mixed media on linen, 2014

FIGURE 1.7 *PRIMORDIAL VISION*

Source: Karen M. Schwartz. Mixed media on linen, 2014

Human or humanoid figures, animal creatures, and sometimes human-made cultural icons of the former continue to populate my paintings (*TOTEMISM*). They appear in the service of expressing aspects of my subjective experience that are unknown or unformulated until I see them on the canvas. The year of my mother's dying offered plenty of intense, emotionally rich compost from which a new and personal abstract-figurative vocabulary could sprout. And on top of that, the year included growing exposure to the aesthetic of Brooklyn painters, whose work I encountered through my mentor's connections. I would describe that aesthetic as one that holds straightforward authenticity in high regard, that disregards

FIGURE 1.8 *TOTEMISM*

Source: Karen M. Schwartz. Mixed media on linen, 2014

established concerns for how form comes about in a painting, that prizes simultaneity and the welcoming of unexpected combinations of seemingly unrelated content and methods, as long as these emerge authentically.

I have also experienced more rapprochement between my painter's life and psychotherapy existence than ever before. As is evident in the way my essay is written, the two practices are in constant exchange in my mind. The interconnectedness of the two practices speaks to their differentness, as well as ways in which they are similar. I see signs of continuity of the "me-who-paints" and the "me-who-does-psychotherapy" in the fun, humor, and poignancy I have found in giving titles to

my paintings over the past year. Titling my paintings brings the two practices into exchange; that's when I recognize "Oh, so *that's* what that painting is about," and realize a meeting of implicit and explicit ways of knowing.

Painting has taught me more about myself than any other activity I have ever engaged in or any life experience I have lived. I am fortunate to have come into my own as an artist the way I believe development and authentic self-expression is best facilitated, and the way in which I believe psychotherapy should be done. I was exposed to and educated about art through a series of nurturing relationships, but not trained and not taught. And I should add that I have been held by and found structure through membership of an atelier, a group of artists who collected around my most recent mentor's painting and drawing workshops to explore art together, to critique one another's work, and to share tips and resources about making work. Creative activity can be a lonely pursuit; the atelier group does much to make it less so.

Painting affords the most direct means available to me to know my unformulated thoughts and feelings. It is my way of depicting what I have not yet grasped in words. Artmaking offers me the most convincing evidence of the unconscious I know and assures me of the method of free association as a way to find form. Through the physical acts of making a painting, I find and formulate my thoughts by literally giving them form. The metaphor that links form and meaning lies in the illusionistic possibility of paint. Paint is both substance and can suggest illusion simultaneously. Painting is one expression of the basic human hunger to make sense and find meaning in our experience.

Both painting and psychotherapy thrive on surrender to a deep engagement, tolerance of uncertain outcome, and embrace of multiple, simultaneous, and ambiguous meanings. I find procedural reference points and anchors in my experience in the studio that serve as guideposts and sources of self-regulation in my work as a psychotherapist. My studio experience helps me tolerate uncertainty and the anxiety of holding the discomfort and unease associated with disorganized or unformulated emotional experience that I encounter in psychotherapy and in life. I remember how I can go from being enthralled by the way my marks on paper or canvas build toward a form or impression that is just coming into coherent being, to being disappointed, even disgusted, with my over-eagerness to find form and order in an over-stylized shorthand that talks about form instead of being form. I bring faith from my experience as an artist in the way order and form do emerge in time from uncertainty and even from chaos, given a prepared, relational environment – a frame, if you will – that makes it safe to be open and curious.

I close with a paraphrasing of words that some attribute to poet e e cummings (n.d.). We do not believe in ourselves until we have an experience that reveals something deep and valuable, "worth listening to, worthy of our trust, sacred to our touch." To that I would add, "perhaps our literal touch." Once we believe, we can risk curiosity, wonder, spontaneous delight, or any experience that reveals the human spirit. Transforming lived experience into visual objects of coherence (beautiful or ugly) and, through these objects, sharing with viewers in the creation of

meanings has offered me a deeper sense of trust in my experience, a strengthening of self-belief. It is not unlike the self-belief that comes about through the creation of shared meanings in a therapeutic relationship. And so, artmaking has opened me up to risking those attitudes that nourish the human spirit, as an artist, as a psychotherapist, and foremost, as an individual.

References

Bass, A. (2007). When the frame doesn't fit the picture. *Psychoanalytic Dialogues, 17*, 1–27.

cummings, e e (1958). A poet's advice to students. In *e e cummings: A miscellany*. New York: Argophile Press. (Revised edition 1965 by George Firmage, October Press.)

cummings, e e (n.d.). Quote. Retrieved from www.goodreads.com/author/quotes/10547. E_E_ Cummings

Gallese, V., Eagle, M., & Migone, D. (2007). Intentional attunement: Mirror neurons and the neural underpinnings of interpersonal relations. *Journal of the American Psychiatric Association, 55*(1), 131–176.

Hagman, G. (2005). *Aesthetic experience: Beauty, creativity, and the search for the ideal*. New York: Rodopi.

Langs, R. (1982). *Psychotherapy: A basic text*. New York: Aronson.

Lichtenberg, J., Lachmann, F., & Fosshage, J. (1996). *The clinical exchange*. Hillsdale, NJ: The Analytic Press.

Stern, D. N., Sander, L. W., Nahum, J. P., Harrison, A. M., Lyons-Ruth, K., Morgan A. C., Brushweilerstern, N., & Tronick, E. Z. (1998). Non-interpretive mechanisms in psychoanalytic therapy: The "something more" than interpretation. *International Journal of Psycho-Analysis, 79*(5), 903–921.

2

TO BUILD A NEW WORLD

Creative and aesthetic choices in psychoanalysis

David Shaddock

A new world

Is only a new mind.

And the mind and the poem

Are all apiece.

(William Carlos Williams, 1953)

I am both a poet and a psychoanalytically-oriented psychotherapist. Both are deeply involving for me. I've spent the majority of my life honing my craft as a poet, and have numerous awards, magazine publications, and three published books to show for it. But more importantly, I have come to view my poetry career as a journey of the self, not just in terms of self-expression, but also of self-expansion. A kind of mastery marks my progress as a therapist as well, marked by hard-won economy of expression and a depth of understanding about the human condition that only lived life can provide. In this essay, I will try to bring the two worlds together and examine the roles that creativity and aesthetics – central considerations in poetry – play in psychotherapy.

In searching for ways to describe the psychoanalytic process, contemporary thinkers have used analogies to improvisational theater (Ringstrom, 2001), to free jazz (Knoblauch, 1999), to poetry (Shaddock, 2010), and to the regulatory interaction of caregivers and infants (Beebe & Lachmann, 2002). These analogies emphasize the dyadic nature of the treatment process, and highlight the spontaneous, improvisational nature of the analyst's responses. This essay examines the role of creativity in the analytic process by comparing the moment-to-moment decisions that go into the process of composing a poem with the moment-to-moment decisions in an analytic session. In order to elucidate the analogy between the creative process in poetry and psychoanalysis, I will describe the making of a single one of my poems, "Asymptote," (Shaddock, 2012) and then I will describe a clinical vignette of the treatment of a 57-year-old man.

The permission for the analogy between the process of composing a poem and the process of psychoanalysis lies in my characterizing the composition process as a kind of dialogue between the poet and his own unconscious mind. The poet first "listens" to the products his imagination presents, and then he moves in to make aesthetic decisions that consciously shape the poem toward a desired form. In the language of dynamic systems theory (Thelan & Smith, 1994), the poem is an emergent property of the dynamic interaction of the two subsystems of imaginative flow and conscious intent. While the analyst's responses are not, or not primarily, driven by aesthetic considerations, the analyst's attitude (Coburn, 2009) – derived from theory, philosophy, and personal experience – plays an analogous role in shaping his responses to the patient. In practice, "real-time" compositional or therapeutic decisions may be so rapid as to blur the distinction between listening and responding. My method here will be to employ the luxury of retrospective inquiry to the composition of a single poem and a short clinical vignette.

I would make the disclaimer before proceeding that I am not trying to create a hard and fast analogy between the two different endeavors that I find myself engaged in on a daily (or almost daily) basis. Rather, I am exploring the overlap between the two activities in the hope that an examination of my process as a poet can shed light onto some unexamined aspects of the analytic process.

The making of the poem "Asymptote"

Contrary to the Romantic notion – as exemplified by William Blake's assertion that his poems were dictated to him by his deceased brother – that it involves an act of reception or surrender to a larger force, the creative process is more aptly characterized as an alternation between surrender (to the unconscious, to chance) and focused effort and attention. In order to illustrate this alternation, I will discuss the process of composing one of my own poems, "Asymptote" (Shaddock, 2012). I picked this particular poem to discuss because of its philosophical affinity with my approach to analytic treatment: the title evokes a hermeneutic, constructivist approach to human understanding, in which meaning making is a process, not a destination. The poem itself moves by fits and starts toward its conclusion rather than offering some great resolution or epiphany.

> **Asymptote**
> Little chickens jump on spoons
> to play a wineglass xylophone.
> I'd been reading a book on hermeneutics
> when Cartoon Network mysteriously clicked on.
> Puffy mice join in the raucous chorus.
> Is language, Gadamer asks, a bridge or a barrier?
> A bridge he maintains, through which
> we can know ourselves in the being of the other.
> When her husband left her my neighbor

> spent days sorting bolts and screws:
> number four hex heads, half round number sixes.
> It seems to me we're approaching God
> as an asymptote. Our calculate ions are getting
> ever more precise, but we are running out of time.
> Eventually she moved to Oregon, just kept driving
> until she found a place she liked, in, no kidding,
> Sweet Home. *The fusion of horizons* is Gadamer's telling
> phrase for the nature of understanding.
> The kitchen fills up with chicks
> and mice for the madcap crescendo:
> they pop out of drawers, poke
> through the flute of the teakettle.

The origin of this poem was a line that came to me a long time before I actually wrote the poem: "We are approaching God as an asymptote." I don't know where the line came from; it is not something I had been thinking about. Its source lies in the workings of what poets call the imagination and psychoanalysts have traditionally called the creative unconscious (Sachs, 1942). A discussion of the meta-psychology of this kind of inspiration is beyond the scope of this essay. Suffice to say, it is a mental product of the sort that Hans Sachs tellingly called "the community of daydreams." Whatever the source, I had the feeling that I was onto something as I copied that line into a notebook. So I made the decision to pursue the ideas the line presented with some reflection and research. This phase actually took me several months.

Now I had some idea of what an asymptote is in mathematics, but I decided to pursue the matter a little more formally. An asymptote is a line in a graph that approaches, but does not intersect, an axis. For example, in the graph of $y=1/x$, the line approaches the x-axis ($y=0$), but never touches it. No matter how far we go into infinity, the line will not actually reach $y=0$, but will always get closer and closer.

The idea of an asymptote serves as a metaphor for the relationship of faith (or at least my faith) to God: we can get closer and closer, but we will never get all the way there. To some this may seem disappointing, but at least for me it is quite a consoling notion. It also, I realized, mirrored some of the concepts of Kaballah, the Jewish mystical tradition, which I have studied on and off for years, that the highest levels of consciousness, those closest to God, are essentially inaccessible to humans.

In addition to the theological considerations the line posed, there was a philosophical dimension. I realized that the line reflected a hermeneutic approach to faith and understanding, in which meaning is never absolute, but emerges from engagement, through dialogue and mutual understanding (Orange, 2010; Stolorow et al., 2002). A hermeneutic sensibility informs my approach to therapy as well, in which I privilege dialogue over interpretation. So I decided to do a little reading up on hermeneutic philosophy, and while I was doing that research, the incident that became the point of departure for the poem took place. It would seem that, as

I started to write the poem, the ongoing dialectic between conscious intention and chance or indeterminacy needed rebalancing in favor of the latter.

It happened just as I describe it in the poem. I don't know if our TV picked up someone else's remote, or it had some kind of timer or alarm, but while I was reading or plodding along in a book on hermeneutics, the TV in the room next to my study came on to the Cartoon Network (which my then school-age son had evidently been watching) and an old-fashioned "silly symphony"-type cartoon came on.

Besides being funny, the juxtaposition of these two very different gestures of the human imagination, the philosopher and the cartoonist, struck me as enormously touching, as if we are all reaching out, across great distances, to someone – whether it is Gadamer's discussion of the possibility of human connection, or these cartoon chickens playing music on kitchenware. Hagman (2005) has maintained that the basic motive for artistic creation is the artist's wish to express and even perfect his subjective experience. While there is a great deal of truth to that, I think it misses an important part of the creative process: most artists find that at some time in the creative process, they adopt an attitude of surrender instead of control. Whatever the metaphysical conditions of this surrender, I think most artists would feel that they are open to the operation of chance. So it was here that I surrendered to this coincidence, and let it be the heart of my poem.

After some experimenting around, I realized that I would let the juxtaposition of these two events set the form of the poem: it would be a poem of juxtapositions, rather than explicit connections – a bit more postmodern than I usually allow myself to go. So then I associated (in retrospect, I must have been musing on the possibility, or impossibility, of language to create understanding) to a memory I had of dropping in on my neighbor soon after her husband had announced that he had fallen in love with another woman and was leaving her. I decided to include that memory in the poem, with its chilling image of her desperately trying to sort out her world by sorting a random collection of nuts and bolts into jars. (I added the happier, and true, ending to her story in a later revision.)

Next came a formal decision. In the poems about faith (or the lack of it) that I was writing at that time, I quite often buried a direct statement of faith in the middle of a poem, surrounded by observations or other associations. This formal device appealed to me because it mimicked my own faith – it was just one component of my thought stream – recurring (and sometimes reassuring me) from time to time.

One phrase I puzzled over was "But we are running out of time." I wrote this poem around the start of the Iraq War, so that anxiety and uncertainty was part of my condition. But I do think this is generally true to my experience of things: if we don't find a way through to each other, we may be doomed.

This poem is a gesture of hope in the face of anxiety, a gesture that indicates that, out of the randomness of events and the randomness of our intentions – poking our heads, as it were, out of the teakettle and singing like mad – some meaning emerges. Not certainty, or an overpowering belief in God, but at least a sense of process, that we are getting somewhere in our ongoing attempt to, in Wallace Stevens' (1978) words, "order the slovenly universe."

I have sought through this description of writing the poem to elucidate the dialectic in the creative process between intention and discovery. Guiding both sides of this dialectic is the poet's own aesthetic judgment. The poet seeks to facilitate the emergence of a language act that is coherent and aesthetically pleasing, and carries meaning. To examine the analogy between this creative act and the process of psychoanalytic treatment, I would like to present the following clinical vignette.

The case of Dan

Dan is a 57-year-old man, slight of build but very fit and well dressed, who works as an executive for a governmental agency. His presenting problem was dissatisfaction with his work situation, specifically with his boss, whom he described as highly narcissistic, unable to delegate authority or give credit where credit is due. At the time of this session, toward the end of the second year of therapy, the boss has just retired, and Dan is in the process of taking on many of his responsibilities. Dan's father is a retired theologian, but Dan has expressed doubts about how sincere his father's faith is. Dan describes himself as an agnostic, though he is interested in meditation and other New Age philosophies. His older brother is a prominent Buddhist teacher, but Dan considers him a hypocrite and narcissistic.

In this particular session, Dan begins by describing a phone call with his father in which he is telling his father how happy he is at work since the boss retired. His father interrupts to ask if that means he will become the CEO soon. This is something his father has said over the years and Dan feels injured that his father always holds out for something higher, rather than giving his approval to his present achievement.

Dan begins in a very controlled way, saying, "I wish I had the presence of mind to say 'That's your fantasy, not mine' to him." But as he talks about it more, he gets considerably more agitated and begins to denounce his father. After some time, the energy of this denunciation subsides, and, in describing his father's inability to recognize who he was, he says, "It's the worst thing that ever happened to me." Here, for purpose of illustration, is the scansion of these two different clusters of statement, with the "U" representing unstressed syllables and the backslash the stressed ones:

```
U  /  U  /  U  /
My father's not a man
 U    /
He's weak
  /  U  /
He's a punk
 U //   U
Hemophilic
  U  /   / U   /
You touch him he bleeds
```

versus

U U / U U/ U / U U /
It's the worst thing that ever happened to me

At a glance, one can see the contrast in the predominance of unstressed syllables in the statement of lament, and the large number of stressed syllables in the angrier statements of denunciation. I was struck by the contrast between these two clusters of expression, and how they each represented contrasting responses to the oedipal situation: one a world of Dan's anger and his wish to mock his father and be the oedipal victor, the other the disappointment and grief of the oedipal victim forever longing for what Kohut (1984, p. 18) called "the gleam in his father's eye."

I considered a number of possibilities in how to respond to this material. I was tempted to respond to the obviously deep world of feeling expressed in the "worst thing" comment, and my heart was tugged in this direction. Or I could have interpreted the dichotomy of the two responses and tried to bring out the inner conflict they represented. But I was pulled by the energy and music of the angry comments. I had an intuitive feeling to go in that direction – perhaps in the moment an aesthetic decision, analogous to the way the poet tries to keep the energy alive in his poem. The angry statements seemed to me to be the "forward edge" of the transference that Marion Tolpin (2002) describes as the "shy tendrils" of a new self-organization, yearning for mirroring and approval.

In the end, I said, "'He's a punk. You touch him and he bleeds.' There's a lot of energy behind those statements." I sensed a kind of relief in Dan to my response. It is as if we were saying that getting caught in the old grief was not the way to go. Dan's associations took him to describing an office flirtation he was having. He seemed to enjoy portraying himself as a bit of a ladies' man, even though he was married. In the transference/countertransference field between analyst and patient, something new was emerging, a willingness to seek again from me the "gleam in his father's eye" that Kohut (1984) described.

Comparing analytic and poetic decision-making

Both the presentation of the analysand's spontaneous material and the emergence of an inspiring line or idea for a poem require a series of responses and choices. Underlying these responses is a controlling intention: to create a work of art in the poet's case or to foster the patient's increased mental health in the analyst's case. This intention functions as a control parameter in the dynamic system that is formed between the poet and his work or between the analyst and his patient (Thelan & Smith, 1994).

Guided by his intention to help the patient, the analyst makes the fundamental choice between listening to or commenting on the patient's material. This choice has an analogy to the poet's choice between surrendering to the emerging material or trying to shape and control it.

For the poet, the primary material was the statement that he wrote in his notebook: "We are approaching God as an asymptote." For the analyst, the point of

entry was the patient's description of his father interrupting to ask:"Have you made CEO yet?"

The poet chooses to interrogate his material rationally – "What does this statement mean?" – and to do research to support that interrogation. He seeks to find out what the word "asymptote" means in mathematics, then examines the philosophical implications of this mathematical metaphor.

In the analyst's case, this interrogation happens implicitly, and with much more rapidity. His rational process is to review his understanding of the oedipal nature of the patient's material. Perhaps he has formed a strong theoretical understanding of the oedipal situation, or perhaps his response to oedipal material is more indeterminate, more shaped by his own family relationships.

The poet, in his shaping of the poem, chooses to let chance (in his choice to include the cartoons coming on the TV) and the process of his associations (in his inclusion of the *non sequitur* association to the neighbor) guide the emergence of the poem. Something analogous takes place in the analytic session, where the analyst doesn't try to grab any particular meaning from the patient's material, but allows him some time to express both his anger and his sadness.

Just as in my poet life I am not governed by compositional traditions or poetic rules, so in my therapy role I am not governed by rules such as the need for abstinence. So my choice to abstain from comment for quite some time as the patient reported his feelings about his father was an aesthetic one, rather than a technical one. It appeared that something important was taking shape without my guiding it or intervening.

A central act of compositional intention came when, as a poet, I decided to insert the line "We are approaching God as an asymptote" without comment or context in the middle of the poem. The poet's intention, which was to write a poem containing that line, led him to make (accompanied by much trial and error) an aesthetic decision to let the line stand alone. Behind this decision was a sense that after the poignant story of the neighbor, the poem was backing up and catching its breath, perhaps resetting itself.

There was a similar moment in the session with Dan. When the storm of Dan's story about his father subsided, I was faced with a choice as to what interpretive decision to make. Poets must learn to make such aesthetic decisions rapidly, so the energy of the work is not lost in indecision, but they also have the luxury of going back and revising. To some extent, in therapy, wrong or even injurious interpretations can be corrected as well, though it would seem the stakes are higher. Indeed, similar to the revision process of a poem, the attempt on the part of analyst and patient to get it right can be a very meaningful part of the work.

Teachers of creative writing workshops often speak of following the energy or flow of a poem, making comments such as "The energy kind of ebbs right here." It does seem in retrospect that the interpretive decision I made with Dan had something to do with following the more energetic angry statements than the sadder statement of the catastrophe of his father's disinterest. A poet's ear is, by long training, attuned to following the energy in language, along with the affective music it conveys.

Nonetheless, compositional decisions that lead up to the making of the poem are not the equivalent of the poem itself, which, if successful, takes on a life of its own and surprises even the poet with its eventual form. Similarly, the analytic decisions made in the session with Dan do not "explain" what happened in the session. The emergence of Dan's story of his workplace flirtation was new and unexpected. While not making any special claims for the "poetic" nature of Dan's treatment, it is possible that my long practice of both shaping and surrendering in the writing of poems created the right ambient mix of openness and authority that allowed Dan to risk making a bid at the end of the session for a fatherly response that would delight in, rather than crush, his newfound male pride.

References

Beebe, B., & Lachmann, F. (2002). *Infant research and adult treatment.* Hillsdale, NJ: The Analytic Press.

Coburn, W. J. (2009). *Psychoanalytic complexity and the forward edge: It's (almost) all about attitude.* Papers presented at the 2009 International Conference on the Psychology of the Self, Chicago, IL and the 2010 Conference for the International Association for Relational Psychoanalysis and Psychotherapy, San Francisco, CA.

Hagman, G. (2005). *Aesthetic experience: Beauty, creativity, and the search for the ideal.* New York: Rodopi.

Knoblauch, S. (1999). *The musical edge of the therapeutic dialogue.* Hillsdale, NJ: The Analytic Press.

Kohut, H. (1984). *How does analysis cure?* Chicago, IL: University of Chicago Press.

Orange, D. (2010). *Thinking for clinicians.* New York and London: Routledge.

Ringstrom, P. A. (2001). Cultivating the improvisational in psychoanalytic treatment. *Psychoanalytic Dialogues, 1*(5), 727–754.

Sachs, H. (1942). *The creative unconscious: Studies in the psycho-analysis of art.* Cambridge, MA: Sci-Art Publishers.

Shaddock, D. (2010). The opening of the field: Thoughts on the poetics of psychoanalytic treatment. *Psychoanalytic Inquiry, 30,* 243–253.

Shaddock. D. (2012). Asymptote. *International Journal of Psychoanalytic Self Psychology, 7*(4), 599.

Stevens, W. (1978). *The Collected Poems of Wallace Stevens.* New York: Knopf.

Stolorow, R., Atwood, G., & Orange, D. (2002). *Worlds of experience.* Hillsdale, NJ: The Analytic Press.

Thelan, E., & Smith, L. (1994). *A dynamic systems approach to the development of cognition and action.* Cambridge, MA: MIT Press.

Tolpin, M. (2002). Doing psychoanalysis of normal development: Forward edge transferences. In A. Goldberg (Ed.), *Progress in self psychology (Vol. 18)* (pp. 67–190). Hillsdale, NJ: The Analytic Press.

Williams, W. C. (1992). *The Collected Poems: Volume II, 1939–1962.* New York: New Directions Publishing Corporation.

A selection from the poetry of David Shaddock

Schema
For Mary Main and Erik Hesse

So we think there is something
inside us that talks
through our talking.

I push you away when I mean
to pull close, feel freest in the either
turn just a smidgen

when you come to kiss me.
It's a broken spirit level, a GPS
tuned to a falling satellite. It traces

a face in the failing light, not
your face, not, or not exactly
these fingers.

All Sports All the Time
Alone in my car with a diet cola
and a chicken burrito
driving between the therapy I provide
and the therapy I receive
I am trying to stay present
to the steady erosion
of all my permissions:
poet – not recently
father – not adequately
lover – of whom but yourself?
So it's a comfort to find I share
the opinion of Mike from Vallejo
about the Niners' quarterback dilemma
or of that unpretentious gasbag Jay
on a cellphone searing the Giants'
overpaid right fielder –
as if blather were the last place
a man could be gathered up
like peasants on the vast plain
below the walled city of Vezelay
off to take the Holy Land
they'd only heard rumors of.

Instruction
Try to resist the pull of your own tirade.
Look around, see what's happened
to those who let their internal argument get out of hand.
Not just the gesticulating people under the freeway
or overstuffed apoplectic congressmen from Kansas
but the mundanely tortured boss-haters
or those at war with their own tender longings.
Resist each Socratic-seeming mind loop.
Rotate your premises like crops.
These angry, shivering neural networks
gathered around burning trashcans
are your own people –
put down that beanbag-loaded shotgun.
Be your own Neville Chamberlain.
Give them one of the Balkans
a semi-autonomous protectorate
for the killers and weirdos inside you.

Vernal Pool
They were playing the hits from '66 on
KFOG this morning. I was meeting my wife
At the oncologist. Don't be alarmed it's
All good, they can go cell by cell to get clean

Margins these days. She doesn't even need much
Radiation. I was expecting something
Like Iron Butterfly, but it was all Otis,
The Byrds, Dylan. To celebrate we walked north

From Inspiration Point. Despite the long drought
There were orange poppies and forget-me-nots,
Vernal pools with a chorus of croaking frogs.

I thought of Cape Ann, years ago, how we listened
For hours to the bullfrogs and spring peepers
Convinced that we'd found the ur source of music.

Hornet

A gray and black hornet
longer than the word *hornet*
typed in 12 point on my computer screen
keeps whacking at the window
ignoring the open casement nearby.
I could squash it with *Couples*
Therapy with Trauma Survivors
which, though a paperback,
has plenty of heft for the job.
But some admixture of fear
and kindness has me looking
in my drawer for something
it might walk onto. What
I find is a postcard from the Art
Institute commemorating the loan
of Caravaggio's *Supper at Emmaus.*
The hornet walks its almost translucent legs
onto the head of Saint Luke
for the short trip to the window
and freedom, which seems
to surprise it. You keep
moving your eyes back and forth
from the subtly glowing Christ
to the illuminated face
of the astonished Apostle.

Live Oak Park

This beautiful streamside through overhung redwoods
Is populated by the affectively
Disregulated and those who fail to choose
Our consensual realities. They offer

My dog half of their breakfast, sensing something
Familiar in her animal needs. They
Lack the learned discernment of the propertied.
Half a McDonald's egg sandwich her reward

For impudence, but they wave off I'm sorry.
The poor share, the rich steal, so it has always
Been, though God groans on high. He gave this idyll

To fill with toothless laughter, a snail darter
In the still pool, an empty pack of Camel
Filters, a sea-green bottle of Mountain Dew.

After Psalm 23

Even on a sunny day death's shadow looms.
A car careens, a mugger lurks, something turns
Up on a routine lab test. Yet here I am
Across the street, ready to lead my old dog

For a run in the park, ready for a cool
Drink from the fountain. Why not believe it's your
Strength I lean on, that fear of your rebuke stays
My greed and malice? Even the dark valleys

I create for myself so far have always
Brightened, and the sharp pains of my losses have dulled
Just as your consoling voice in my mind's ear

Promised. Will my kids have jobs or stay off drugs?
Will my love and I have a few more unvexed
Years? It's your voice I hear saying yes, we will.

A Great Blue Heron at Boynton Beach

Camrys in the lantana shade
pock of yellow balls on green courts
splash of water aerobics
talk of total knees and hips replaced
the blind psychiatrist working his way
past the gauntlet of kibitzers to his favorite chaise:
all this is pleasing to the higher orders
who would themselves like soon to retire.
Tif'eret, compassion, *Binah*, the womb of the world,
are worn out at the end of a bloody century.
A great blue heron's six-foot wings
cast a shadow over the pool
granting a moment's respite from the sun
for the second-generation furriers and insurance men
whose five-year-old granddaughters in pink-frilled two-pieces
swim like a fish, their red-polished nails breaking the surface.
A *machaia*, really, to be ever so briefly in shade
to stop thinking about all that is lost
and believe, along with the Kaballists,
that the Eternal One's thirst is slaked by our pleasure.

3

MAKING WAVES

Linda Cummings

Searching for a clearer understanding of the nature of experience, and how images function within daily life, informs my dual practices of psychotherapy and photography. Words are an extension of both the patient and therapist in the treatment setting, connecting each to his or her individual experiences and to one another. My photographs are an extension of myself in the world, expressing my experience through the image created, and communicating that to others. As dreams mirror one's inner world through the residue of the outer world, my photographs mirror my outer world through the lens of my inner world.

For the past several years, I have been making photographs while paddling my kayak in a tidal river, beholding and stirring the water, creating photographic images of my impact on its surface, and the river's impact on me. Gliding through the water, images emerge as I touch and disturb the water, noticing subtle oscillations between recognizable and unrecognizable visual elements in the reflections of light and shadow, color and form, fragments and the whole. This experience finds its way into my work, as process, metaphor, and creative intervention. My subject is not water, *per se*, but impermanence, change, and the substance of light.

The beauty of the present moment is that it is truly ambiguous, unstable, and alive. Photography exalts the present moment, while simultaneously preserving the past. As in the therapeutic exchange, change occurs in the uncertain expanse of the present. My photography provides a way of being held psychically, just as I am held physically in my kayak – separate yet connected to the experience. I aim to touch my existence and be touched by the aliveness it carries. My inspiration for both practices is drawn from the reciprocal relationships between now and then, self and other, internal and external experience.

I gaze upon the river, seated in my kayak, an intimate space about the length of my body. From the safety of my office chair I behold the world my patient and I inhabit, held in the frame of the hour and the walls of the room. Each seat provides

support and orientation, allowing reverie and imagination to emerge within the cascade of experience. However, articulation of one's experience is only possible when specific feelings and perceptions can be structured, symbolized, and thus made thinkable, thereby enabling expression, transformation, and psychological change to occur (Stern, 2003).

Words and images are framing devices. They are linguistic forms created to signify, to give voice, to shape, and to share our experience and needs with others. Although operating within different parameters, words and images both organize human experience, and inform what we make of the world and what the world, in turn, makes of us. In this essay, I explore some of my thoughts about the image-making process from my perspective as a psychotherapist and photographer. My use of framing devices and language forms a kind of connective tissue between these two disciplines – sometimes tightening, sometimes relaxing, but essentially joining them together. I will share a process of inquiry and contemplation that has mutative relevance to each practice. In my effort to bridge the inevitable gap between experience and expression within two symbolic languages and dual professions, you will find my thoughts and observations reframed from multiple perspectives. Clinical examples are briefly noted to illustrate treatment possibilities.

Dual practices

In both practices, I seek to expand my capacity to see, to question what I see, and to comprehend how pictures of reality – past, present, and future – come to mind. Exploring how images are formed enlarges the scope of my creative apperception and facilitates mutative change. Making sense of visual experience, like verbal experience, requires an ongoing interplay between perception, recognition, and response – that is, perceiving sensual data, repeating and remembering, comparing, setting and questioning limits, arranging and rearranging priorities, gathering, discarding, and sequencing. Both require attending to change and frustration, boredom and breakthroughs, shifts and realignments, trial and error. Similar to a successful session, a successful photograph reveals a moment known, rescued, and recognized, set apart from the flood of undifferentiated surrounding perceptions, impulses, and time.

Making photographs elicits paradoxical and ambivalent feelings within me. In the process of making a photograph, I am both losing and finding the image. The exact moment an image is plucked from the stream of time by the camera's shutter is the exact moment the event disappears in life, only to be preserved, reviewed, and revived later as a photograph. In the flow of an analytic narrative, I pluck a word, gesture, or thought that calls out for attention. Choosing when to intervene, interrupt, or yield to the flow of experience reflects many conscious and unconscious decisions and desires on the part of both patient and analyst. Every choice is both a small birth and small death, marking the direction of a particular course of thought or action that influences or precludes a myriad other possibilities. The fleeting visual detail, word, or silence selected is what survives – and lays another stone in the construction, or obstruction, of meaning in the photograph or patient's narrative (Olson, 2000).

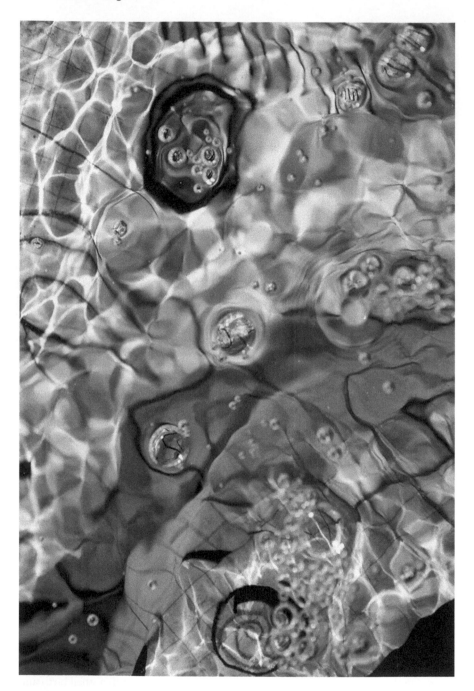

FIGURE 3.1 *Laughing Water*

Source: Linda Cummings ©2012. Archival pigment photograph

Roland Barthes (1982) refers to the dominant detail, or focal point, of the photograph as the punctum, "that accident which pricks me" (p. 27). Visually speaking, the punctum is the optical trigger point, the convergence of interest in the visual field where the image draws its power to engage the viewer. The punctum is the visual equivalent of a psychological moment when the emotional content of experience aligns with something in the physical scene to render a contact point between formlessness and form; cognition and connection are then possible, like a well-placed interpretation by a psychotherapist, a doctor's diagnosis of an illness, or a friend's warm hand in time of need.

I attend to my patient's narrative flow, looking and listening for the punctum. I notice my own response, both inside and outside of the moment, separate and connected, poised to respond, waiting for the moment when conscious contact between surface and depth materializes, or comes into focus – when something aligns, allowing me to see more precisely, or clearly, the patterns and elements influencing and interacting in the scene or the story.

Internal battles and choices emerge in both the studio and consulting room as I encounter my own internal objects, limits of imagination or endurance, and capacity to represent accurate formulations of both helpful and painful experience with my patient. Periods of ease, and unease, ripple through both practices. Working through challenges and frustrations with my artwork helps me navigate uncertainty and extended periods of doubt and quandary in the therapeutic process. I have a deep appreciation for the courage of my patients to face, question, and reframe experiences and mental images that have long caused pain and disturbance in their life, distorting their sense of self, relationship, and possibility. Working through periods of impasse strengthens and enriches us both, as does wrestling with creative blocks alone in my studio. The effort to see my patients as clearly as possible requires an open-minded, compassionate, yet critical distance, similar to looking at my photographs with a discerning yet curious eye.

Both practices require the maintenance of a tenuous balance between control and surrender - finding and losing the anchoring details, the edges, patterns of movement and stasis, orientation, the point where the image resolves or dissolves, in form and feeling. What would it take to balance or unbalance the image, the narrative? In the editing process, reframing, cropping, selecting, and reviewing the sequence of pictures can significantly alter their meaning. In therapy, words have the power to replace, or reframe the meaning and interpretation, to also survive the past and to recast future consequences of a particular event that has already occurred in the life of the patient.

Both disciplines beckon me to question my focus and perspective. I strive to develop more tolerance to chaos, imperfection, and human suffering, to see the pleasure and pain, the sense and senselessness, of ordinary life. To continually confront ambiguity, tragedy, indifference, uncertainty, and loss while remaining curious, engaged, and responsible to myself, and others, is difficult. I am often challenged to face what I do not understand, or dare to acknowledge. I muster my ability to recognize when I am seeing past memories disguised as the present situation. As

the present is apprehended anew, my view of the past is altered, thus opening new possibilities for the future.

Physically, the four edges of the photographic paper or surface frame the moment, creating an image set apart, yet connected to reality. By their nature and construction, photographs are not whole, are never complete, and have multiple uses and meanings. They are slices, glimpses, cut from the stream of life by four edges. They are containers of the past and what has been already been. They are also containers of meaning. Both practices – the making of a photograph and the participation in a therapeutic relationship – emphasize what feels most significant within the present moment.

Photographs can function as transitional spaces where the viewer can safely enter the conflicts and tension within the image without the threat or demands of reality interfering (Winnicott, 1971). From a safe distance, and given time to reflect, integration or relief occurs if feelings are linked to experience in this transitional space of the image. The process of review, analytically and aesthetically, opens an opportunity for reflection, a space to linger and ponder.

My photographs give viewers a chance to review. I want my photographs to function like pauses – sometimes to catch one's breath, sometimes to take one's breath away. Similar to my use of words in a session, I strive for my photographs to pose a question for viewers, to urge them to reflect, to feel, and ideally to connect with their own subjectivity. My photographs direct viewers' attention to that fleeting moment between impulse and action, when something new can take place in the form of a question, a choice, or an invitation to look again. Because the photograph remains after the fleeting moment of its capture, its potential to influence and reorganize meaning, during or after the event can be profound.

Mutative action

The objective of both my practices is the removal of obstacles to seeing, knowing, and caring – to renew agency, awaken the senses, and experience the world from an enlarged perspective. In the viewfinder I wait and watch for a picture to emerge – sometimes over minutes, weeks, or months, sometimes in an outburst of activity or emotion. Likewise, in the therapy setting I watch for unexpected twists and fluctuations of attention, interruptions, sudden shifts in content, affect, tone, or texture that might have correspondence to something in the patient's experience.

Looking is casual; seeing is intimate and draws me closer. Seeing implies a conscious connection to what is perceived, accompanied by an attraction, or desire to know more and respond. When a glimmer of something longed for in my inner world aligns with something I see in the world outside, a flash of recognition signals to me that a creative connection has occurred and I impulsively click the shutter. Something in my inner landscape is activated and enters consciousness, where the impulse can be released and translated into symbolic form through the photographic process.

Finding meaning through engagement with the external environment is what Meltzer (1988) refers to as symbolic congruence, or the pursuit of an epistemological

FIGURE 3.2 *Your Eyes*

Source: Linda Cummings ©2015. Archival pigment photograph

drive to know the inside by contact with the outside. Hagman furthers the idea of aesthetic resonance, in which the "artwork and the artist's subjectivity form a single inter-subjective field, in which *inner* and *outer* are, from one point of view, irrelevant" (author's italics, Hagman, 2005, p. 5). Press posits that aesthetic resonance, as a form of empathy, requires that inner experience should not become lost in merger or connection with outer experience, lest a loss of self occur (Press, personal correspondence, 2015). I find aesthetic resonance to be a dynamic relationship between inner and outer experience, in which one navigates multiple states of being, tethered and untethered to frames of reference that locate the artist in reality or imagination, self and other, so something new can be apprehended. The intrapsychic shifts and uncertainty demanded can be both highly pleasurable and, often, torturous.

Creative apperception assimilates and transforms the residuum of past experiences of an individual to form a new whole (Runes, 1972). Biologist E. O. Wilson describes a related phenomenon as "consilience . . . the jumping together of knowledge" (1998, p. 8). Each describes the transformational potential when practice, care, observation, and rigorous research lead to the awareness of something previously unknown.

My creative practice requires a constant negotiation between the physical forces I encounter on the river, my internal emotional states, the questions driving my artistic inquiry, and the scope of my technical ability. Through a meaningful resolution of these forces, a transformation, or synthesis, occurs, coalescing into an image encompassing the synergy of that moment.

Likewise, when connections between my patient and I are made in the process of treatment, something in my experience, or my patient's experience, steps forth, emerging in the relational field between us becoming accessible for conscious contact and expression. Melanie Klein (1975) observed such psychic signals and impulses as a "moment of urgency" when the patient is most receptive to an interpretation, and ready for a possible psychic shift. Through these visceral moments of urgency, patient and therapist collaborate in the messy struggle to bring formlessness into form, making formerly dissociated experience accessible to consciousness to be symbolized and communicated meaningfully.

Paying attention to visual and somatic information helps me better attune to nuances of affect, impulse, expression, and influence between my patient and myself. Sensitivity to somatic experience is key. I look for clues to my patient's embodied experience, just as my photographs reflect my sensual experience, thoughts, and intentions. I respond, silently or not, to minute details of affect and action, noticing where energy, desire, thought, or time gets stuck, or flows freely.

The value of working with images is particularly useful in treatment with patients for whom English is not our primary shared language. The following clinical vignette illustrates the discovery of an image locked within a patient's feeling of impotence and hopelessness, obscuring access to her self-care and pride in her professional accomplishment. My patient's native language was not English and her fears about words failing her may stem, in part, from cultural and language barriers she faced growing up. What we do share is a language of somatic experience,

from which we often draw images to help understand one another. After a long pause, in which my patient had been struggling with her inability to "just get up and do the things I set out to do the night before!" I asked her, "What are you feeling right now in your body?" She replied, "Tight, tired, why am I still here after all this work we've done?" I responded, "It sounds like you are feeling fatigue and frustration, that you've been here before . . ." "Yes, I feel so stuck and there's nothing more to say! All these words just make me feel worse – I know what to do and I can't!" I respond: "I hear how little faith you have in words to help you, to motivate you. Knowing something in your head and feeling something different in your body must be very confusing . . . [long pause] . . . Can you describe what your body is feeling right now?" She responded, "Well, I feel so small and stuck, in a dark place." I ask: "Small in relation to what?" She responded, "This huge mountain in front of me. I'm alone in a valley below and I know how good it will feel to get to the top, but it seems impossible, hopeless. This dark place reminds me of a place I got lost once as a little girl. I called out but no one could find me for a long time." Uncovering this image of a small, lost, terrified younger self no one could find gave us both a better perspective on her difficulties in the present. Previously, these images were buried and overshadowed by an unknowable darkness she could not articulate, perhaps due to the traumatic experience of having her calls unanswered. Once seen and shared, this image became a catalyst for us to listen, care, and transform her hopelessness and aspire to being found in the present.

Lines

Lines constitute a primary organizing structure of visual language. Following lines of thought or free association in clinical material, and following visual lines – pathways, sight lines, gestures, and linear movement – are methods to orient myself within both the relational field with my patient and the visual field of the photographic experience. Marks, edges, and strokes guide and orient the viewer through a visual composition. Lines are spatial cues to focus and to direct our attention, to separate and link things together, to delineate edges between objects, and to help contain the image. Making a mark on a sheet of paper, or the canvas of one's life, expresses a fundamental need to express oneself, to make sense, to communicate and connect, and to impact the world beyond one's reach.

Nature leaves its mark, its fingerprint, on the surface of the material world, just as experience leaves its mark on the psyche of the individual. A literal signature of touch, marking represents aliveness and movement, whether created by a human hand or the impact of nature, or the accidental collision of forces set in motion. The characters that make up words and the lines that make up images are the marks of a human need for self-expression and connection with others. In mastering the symbolic languages of words and images, we come to know and be known. Over a great distance, images and words have the power to speak. They will endure through time, in the presence or absence of the artist or author.

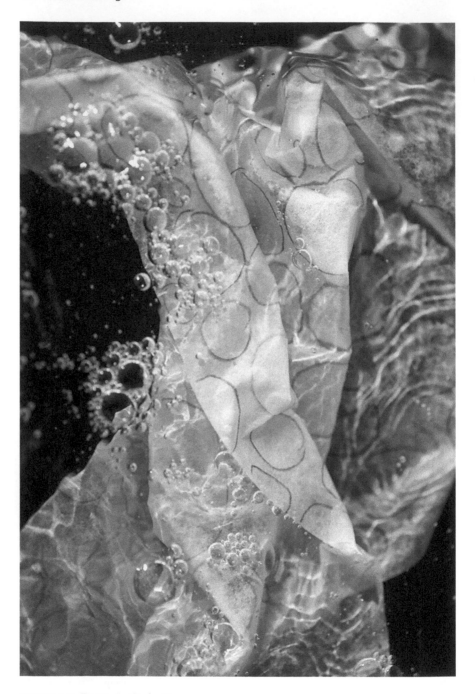

FIGURE 3.3 *Drawn in Circles V*

Source: Linda Cummings ©2012. Archival pigment photograph

A patient with severe depression due to neonatal loss began to produce drawings during a phase of treatment in which she could not leave home. The pain of "seeing all those pregnant women outside" was unbearable. As a tangible reminder of our connection, and physical evidence of her own creative powers, she began making loose sketches each morning when she awoke, usually a line drawing of her feelings about herself. Drawing appealed to her "as a way to keep my mind occupied so I don't sink into paralysis." Slight pencil drawings on scraps of paper emerged, mirroring her tentative attempts to "put something together" – perhaps a sense of herself no longer pregnant and now childless. Through wandering, searching lines, she explored her emotional states of being. From the start, she rarely lifted the pencil from the paper, as if she were afraid to lose the contact between them. The lines flowed into one another without end, almost as if she were writing.

Her eyes were focused inward, on her inner world, not on the world outside. Her only point of reference was an inner space. As she became more engaged in the drawing process, she committed to pens and colored pencils, making indelible lines and shapes she could not erase. She started a notebook to protect the drawings from getting lost or damaged. From time to time, she would send me snapshots of her works via email. I was struck by her expressive use of line to communicate feelings and attachments. Her weekly drawings became the lifeline between us, especially in the silence between sessions.

Drawings that began as outlines grew in size and complexity, as she inhabited the figures of her inner world with color and three-dimensional form. With more and more tenderness, her drawings bore witness to her pain. Through her drawings, she gradually mourned the loss and confronted the reality of an absence. As the delicacy and nuance of her drawings evolved, the figures depicted became more distinct, separate, and unique. Over the following year, she developed a more secure grasp of the possibility of integrating her traumatic loss, rather than rejecting the hurt and punishing herself. Her drawings, both a lone and shared activity in the treatment, helped her reclaim her imagination, and mobilize her creative potential. As new conscious and unconscious mental images emerged, they found their way into her drawings, and new projects, which in turn provided the basis for new forms of family, self, and relationships, to be imagined and created as well.

My patient used lines to draw her way through her life and death struggle. For several years following the death of her infant, her access to her creativity was severed, in part as retribution for daring, and failing, to create a child. By slowly and bravely reconnecting to the pleasure of the drawing process, she cautiously began to trust in her creative intuition to guide her drawings. Day by day and line by line, she tapped into a powerful flow of images arising from an emerging mental picture of herself as a woman, wife, and mother reborn.

In my patients' frustration and feelings of powerlessness, I recognize the familiar despair and fatigue of struggling with my own resistances and creative blocks. When I am in my creative flow, I experience time as alive, a measure of consciousness and vitality. In that space of imaginative possibility, time is fluid, to be denied, manipulated, measured, speeded up and slowed down, interrupted, sliced and fragmented,

but never broken, stopped, or separate. The notion of the present as the continuum of "going on being" calms and helps me disentangle from past memories, fixations, and conflicted feelings that remain part of my history (Winnicott, 1971). In times of conflict, I look closely for what remains vital and alive in the present moment and material. I attempt to find where the energy in the patient's narrative, my own thinking, or my photograph is coming together, and where threads are coming apart. When prompted by dis-regulation, distortions, and discomfort, I ask myself, "What's wrong with this picture?" and "What do I wish I could change?" Suddenly a mental image leaps forward to guide me. How I choose to act in response is uncertain. Nevertheless, my imagination has been mobilized as a catalyst for change.

Frames

How I interact within the frame of the photograph parallels my interaction with patients in the treatment frame. The intensity that drives my visual search as a photographer also guides my listening in the therapeutic frame. I look and listen for ways to embrace and expand the narrative and perceptual details, enlarging the scope of what is imaginable. My presence in the treatment can also be ambiguous – at times reassuring, and at times disturbing. My responsibility is to make waves, to stir things up in clinically useful and therapeutically productive ways.

How I make photographs involves intentionally disrupting the visual field to introduce new and unexpected associations within a familiar frame of reference. Like a participant-observer, I enter the frame of my photograph and change the visual field by my presence and actions that affect the composition and its meaning in subtle, sometimes drastic ways. Literally drawing on the surface of the water with my hand or paddle, or introducing drawn elements into the frame, my work points toward the ambiguous relationship between reality and imagination.

Equally important to creating frames of reference for the viewer and the patient is the task of creating frames of reference for myself as I attend to the needs associated with each practice. Managing the priorities, difficulties, and demands of two professions requires constant juggling of time and space. My love of water, of swimming, and of what water has taught me helps guide me through currents of the relationship between myself and my patients and my artwork. The immersion into the experience of both the analytic inquiry and the creative process demands a constant need to monitor and regulate my own feelings and needs – to come up for air, to be both separate and connected to the person and process.

I divide my week equally between my patients and my artwork, scheduling my clinical practice in a three-day block with three days for my art practice, and one day for everything else. Years ago, I converted my studio space in New York into a multi-purpose suite by constructing a separate sound-proof consulting room and waiting room out of half of what once was my larger studio space. The studio and consulting area are separate entities, with an adjoining hallway. Although the distance between the two rooms is physically close, they are worlds apart. Depending on my frame of mind, their proximity can be a source of comfort or distress. Negotiating

FIGURE 3.4 *Surface Notes I–IV*

Source: Linda Cummings ©2014. Installation view: *Natural Allusions*, Addison Ripley Gallery, Washington, DC. Four-panel photographic scrolls. Each 60˝ × 20˝. Archival pigment photographs

the demands of my private, professional, and public life is a struggle for integration and resolution that both my patients and I share.

The rhythm and pace of a session can sometimes feel to me like swimming in a great expanse of time. I sense both my and my patient's vulnerability and strength. The space of the room, our shared memory, and time are like layers of skin that enclose us as we explore the unknown expanse together. Locating myself in a purposefully designed space – whether the consistency of my consulting room, or the messiness of my studio space – helps limit the scope of my attention and allows me to focus upon the nature of the work at hand.

Adhering to structures of time and space helps orient me in one professional world or the other. To be held by the analytic hour or a project deadline provides necessary temporal limits within the limitless exploration of possibility. Neither an analytic nor creative process can be regulated by standard measures of time. To give the creative or therapeutic process the time necessary for perceptions and feelings to be integrated into form and action is a delicate, unpredictable, and difficult task.

Orientation is how we make sense of our place in relation to others, to time and to space, often characterized as a function of contrast and comparison. Oscillations between then and now, here and there, viewer and viewed, self and other, attraction and repulsion, light and dark, detail and expanse provide clues to guide one through the visual field or therapeutic narrative. Making sense of these relationship dynamics requires a suspension of time and certainty, whether therapist or patient, artist or viewer, because meaning is rarely straightforward, interpretations are relative, and feelings take time to cohere into form. Whether in the photographic or treatment setting, many months or even years may be needed to make sense of non-linear experience. Required is a willingness to loose one's orientation to discover something not yet known or perceived, to engage in experience that can only be understood later.

In the following vignette, I will touch upon a patient's use of words to frame anxious images that threaten his orderly world. My patient works in a very demanding climate by day and writes fiction by night. His use of words is very precise and selective. He occasionally sends me short stories in the middle of the night by email so we might explore them further in a subsequent session. We have come to understand his urge to write, and to write in the dark, as a rebellious act in which his forbidden and unbidden aspects reign. Both attracted and repulsed by this part of himself, he feels out of control, and recognizes "writing helps."

He reports, "My stories all start as an image or a phrase I can't get out of my head. Without that visual, I cannot write. The picture gives me something to look at, come back to." His images are usually quite complex, with contradictory layers of interpretation. Many nouns he uses also function as verbs (e.g., "run"), reflecting his deep ambivalence about his life, relationships, and work. By day, the strong, independent leader must dominate the social world and stand his ground, unfortunately built on a shaky foundation of childhood neglect. We look closely at the words he chooses to represent the conflicting images, feelings, and relational dynamics at the heart of his experience. His words point toward an image and the image points toward

core conflicts we untangle slowly in the realm of imagination and treatment, where his struggles and fears can safely be explored and held in mind until further action becomes possible. Words have power to either transform or concretize experience, to pull us in or out of habitual and limited ways of seeing and interpreting our world. When questioned, dismantled, and looked at again, the word, like images, prompts our capacity to imagine and create something "else."

Psychoanalyst and art therapist Arthur Robbins (1989, pp. 16–17) notes:

> Experience must involve us in a dynamic link with the world, always and continually impelling us to introduce new elements of disorder into the static and consolidating ordering of past experience. What this requires is that we relinquish our postures of omnipotence and recognize the potential inherent in accepting the complexity and indeterminacy of a world that is beyond our subjective powers.

For my patient, his night cycle of creativity brings disturbing fragments of his daily experience to mind when he is powerless to resist or repress them. His need to catch these images and impressions and express them in words helps balance his underlying anxiety of living in a world he desperately tries to control, and cannot.

Urgency and engaging danger, through taking risks, can be necessary for pushing through resistance and relaxing the psychic censorship of one's creativity. Some of my best pictures have been made in the fatigue and urgency after many hours spent bracing and pushing myself through inclement weather in my kayak. A raw, unfiltered focus emerges when my mind is no longer trying to compose, control, and direct the way I am seeing the world. I am released from the grips of my own past concepts of beauty and order, and free to respond intuitively, in the moment, to whatever I find there, beautiful or not. For my patients and myself, the need to disturb the waters of complacency and comfort, in order to bring about change, is a formidable challenge.

Conclusion: tolerating uncertainty

Tolerating discomfort, uncertainty, and ambiguity is key. Experience flows, changing, expanding the edges of the known, of the frame, bursting through and fading once defined edges. Frames of reference can be rigid barriers, or shifting networks of lines we dare and dare not cross, edges we deny or embrace. Frames anchor us in a world of chance and change. How can I act creatively and analytically, to hold myself, and my patients, together while simultaneously relaxing that hold? Surrendering to an open frame of mind that includes both knowing and not knowing is a leap of faith, a risk. Tolerating provisional knowledge strengthens my capacity to see glimpses of the expanding and contracting edge of experience, continually subject to change.

Increasing one's sensitivity to visual experience enhances the ability to catch glimmers of primary process material that might otherwise go unattended in the

more familiar symbolic world of words. British psychoanalyst Marion Milner, writing under the pseudonym of Joanna Field, notes that a significant achievement of treatment is "a joining of that split between mind and body that can easily result from trying to limit thinking and to thinking only in words" (2011, p. 157).

Change is facilitated when new images and frames of reference are revealed in the present, with the power to reshape and expand one's view of past events and imagine new possibilities for action. Offering a re-description of phenomenological events, a photographic image depicts new perspectives and associations for viewers to engage, if they are willing. Likewise, the re-inscription of psychic phenomenon during a successful treatment offers, for the patient, new ways of seeing one's self and the world.

Images with the power to challenge or recast the past are activated through interaction among participants. Without engagement and the desire to see something new, the consolidating order of the past remains dominant and the potential of the image is not recognized. Feelings of urgency, pain, confusion, discomfort, and vulnerability are often catalysts to mobilize the desire, or readiness for change. Pleasure, joy, and excitement are also powerful catalysts for change and the inspiration for creativity. The static order of the past, of seeing only the past, and believing only what one recognizes, will not change without making waves, without disturbing or challenging the prevailing image of what is possible and desirable. Change in the life of a patient requires managing the waves that are set in motion, impacting the individual, his or her family, and his or her world. As an artist and a psychotherapist, I must create disturbances in both the field of vision and the relational field between myself and my patient so that what is seen and recognized as reality, or inconceivable, might be stirred up – questioned, re-evaluated, embraced, and enlivened.

References

Barthes, R. (1982). *Camera lucida: Reflections on photography*. New York: Hill & Wang.

Hagman, G. (2005). *Aesthetic experience: Beauty, creativity, and the search for the ideal*. New York: Rodopi.

Kierkegaard, S. (1996). *Papers and journals: A selection*. New York: Penguin Putnam.

Klein, M. (1975). *The writings of Melanie Klein: Love, guilt, and reparation and other works 1921–1945 (Vol. 1)*. New York: The Free Press.

Meltzer, D. (1988). *The apprehension of beauty*. London: The Clunie Press.

Milner, M. (2011). *A life of one's own*. New York: Routledge.

Olson, N. (2000). Pictures into words: Visual models and data in psychoanalysis. *The Psychoanalytic Study of the Child, 55*, 371–399.

Press, C. A. (2002). *The dancing self: Creativity, modern dance, self psychology, and transformative education*. Cresskill, NJ: Hampton Press.

Robbins, A. (1989). *Psychoaesthetic experience: An approach to depth-oriented treatment*. New York: Plenum Publishing Corporation.

Runes, D. (Ed.). (1972). *Dictionary of philosophy*. Totowa, NJ: Littlefield, Adams & Company.

Stern, D. (2003). *Unformulated experience: From dissociation to imagination in psychoanalysis*. Hillsdale, NJ: The Analytic Press.

Wilson, E. O. (1998). *Consilience: The unity of knowledge*. New York: Knopf.

Winnicott, D. W. (1971). *Playing and reality*. London: Tavistock Publications.

4

SHAME AND ITS UNDOING

A performer's desire to be found

Rosalind Chaplin Kindler

This essay is dedicated with gratitude and love to my late husband, Alan Kindler, who was integral to the unfolding of this story.

The theme of "hide and seek" has been a strong and important thread throughout my life – the need to withdraw, blend in and fend off intrusion, countered by the wish to be affirmed, acknowledged and celebrated – has been prevalent both in my life as a performer and my professional life as a clinician. In my roles as both patient and analyst, I have wrestled with, and borne witness to, the struggle in myself and others, to retreat in fear, and to hide in shame. In my roles as actor and vocalist, I have known the exhilaration of creative expression and the joy of mutual resonance in performance, and that experience has allowed me a deep understanding of my young patients' strivings to hide and to be found, recognized and applauded. The point of "hide and seek" is not to hide for its own sake; the goal is to be sought, and to be joyfully found.

In my childhood musings, I never imagined myself with a career as either a therapist or a vocalist. I had zero aspirations of a career of any kind, but I did have fantasies. Since I was a good ice skater, and I was also the family entertainer (my Al Jolson impersonations were in high demand), I used to fancy myself performing (impersonations on ice?) for an appreciative audience that always insisted I take an extra bow.

These fantasies had their genesis in my early experience as a Jewish child growing up in a working-class Protestant neighborhood in Glasgow, where my family was viewed as both exotic and suspect. All the other kids on the street belonged to families where the Scottish Protestant work ethic was rigorously adhered to. The other kids went to Sunday school. Their mothers wore tweed skirts, sensible shoes and no make-up and their fathers went to work every day as bank clerks or policemen. In their families, no one raised their voice – ever.

I, on the other hand, belonged to a Jewish family where not only did I have a father who was ill and unable to work, I also had a mother who was from London, who spoke with a "posh" English accent and who went to work every day wearing high heels, lipstick, hat and gloves. Add to this the fact that my parents fought regularly and loudly, all of which could be heard several houses away, and you have the deadly and tenacious seeds of shame that took root early. My fantasies of performing and eliciting waves of appreciative applause served as an antidote to my shame and fueled my longing for acceptance.

Although I was a high-achieving student, my parents did not argue with me when, at age 15, I told them I wanted to leave school and go to work. This was an option open back then to all students at that age. In my fevered adolescent mind, this was my longed-for ticket into the adult world: I too would wear high heels and lipstick every day! Freedom!

Thus, I followed an almost Dickensian path out of the education system and into the work force. I got a job as an "office junior" in a large accounting firm. "Office junior" was an apt description for the person on the lowest rung in the huge office hierarchy in which I found myself. My main jobs were to make tea for everyone, lick stamps and wrap up packages of books, before taking them to the post office. I stayed there for two deeply unhappy years.

Those years were also marked by profound personal loss. My father died quite unexpectedly soon after I started work. I was the youngest of three girls. My eldest sister had left for Australia, following her fiancé, just days before my father's death. And within a year my middle sister went to join *her* fiancé in what was then Southern Rhodesia, now Zimbabwe. At that time in post-war United Kingdom and Europe, it was not uncommon for young men to leave for "the Colonies" to make better lives for themselves, to be followed later by their fiancées or wives. This was the case for both my older sisters.

After my father's death, in an effort to reunite the family, my sister in Australia began a campaign to persuade my mother and me to follow her and settle in Melbourne, which we eventually did. I still marvel at the bravery of my mother, widowed, leaving all that was familiar, in her late 40s, to begin a new life in Australia. For my part, at age 18, I left with hardly a backward glance, focusing only on the many positives I'd been told about life in the "Land of Oz." For me, Australia held the promise of a better life. However, in ways I did not understand until much later, I was taking with me a rich legacy.

In Glasgow, my father's Polish immigrant parents spoke Yiddish most of the time and heavily accented English only when they had to. So my grandfather, my Zaida, and I didn't do a lot of talking when we were together. However, I learned the Yiddish word "*beshert*" – which, loosely translated, means "destiny" – from him. He died when I was quite young, only four or five. He was a tailor by trade, and my memories of him are mostly of sitting around the Seder table at Passover, or in synagogue, watching from above where I sat with the women, as he *davened* (prayed) downstairs with the men. He would take me for walks to the Jewish deli near where they lived, but few words actually passed between us. However, there was a golden

thread that bound me to my grandfather that I did not discover for many years. On a visit to Glasgow years later, I was astounded to learn from my aunt that my Zaida had been a founding member of the Glasgow Yiddish Theatre.

Was it "*beshert*" that, in Australia, I would find my way into the world of theatre, following in the footsteps of my Zaida, and perhaps fulfilling some unarticulated legacy passed on to me by him? The fantasist in me likes to think so.

I cannot precisely say what it was that propelled me to that first audition. I remember I was at the hairdresser's and got into a conversation with a woman who told me about a local community theatre group she knew about, which happened to be holding auditions that very night. I had been consciously harboring no wishes, had made no plans, to find a way into the theatre. But as Freud (may have) said, "The unconscious is a wily rascal," so I went off that night to my first audition with trembling limbs, having no idea what to expect.

I can still vividly recall the experience of exultation that flooded through me when I finished reading and was handed the part. The experience of that audition allowed me to recognize something crucially important about my experience of myself. I can now identify it as a feeling of competence and validation. I knew with certainty I had found my niche. I loved the theatre and was happy as never before when I was performing. That first successful audition led to more.

I lived in Australia for the next decade, a time that covered a range of theatre experience at the community level, as well as the major life events of my marriage and the birth of our first child, followed by our move to the US when the baby was just weeks old. This move was for a three-year residency for my husband, and for me a time during which, when I could, I immersed myself in the local theatre scene and performed whenever possible. However, the birth of our second child was definitely our most important production during that time. During these years, I quietly harbored hopes of one day acquiring some legitimate theatre training. When the residency was over, we made the decision to settle in Canada for a few years, instead of returning immediately to Australia.

In Toronto, I found to my great pleasure that all things seemed possible, and my aspirations for training and education evolved and broadened. The avenue into university opened up before me, and after fulfilling high-school equivalence exams, I eventually gained entrance to the University of Toronto as a mature, and part-time, student. At "U of T," I was thrilled to find I could immerse myself in courses of my choosing, which satisfied my interests and were carefully scheduled to allow me to pick up the children from school on time. Finally, in my 30s, I had found a way to rectify my shameful lack of education. I was so happy to pick up where I left off at age 15.

That first year I took courses in French, English literature, and of course, theatre. The university had a wonderful theatre/drama department and a beautiful theatre, where I was able to expand my experience in productions of Shakespeare through to Molière and beyond.

Those years confirmed for me the direction I wanted to take. As much as I loved French and English literature, the theatre and all that it embodied offered me the

forum for self-expression that was right for me, as well as the experience of valida-
tion that, most of the time, came with it. I was a stay-at-home mum and a part-time
student trying to get an education so I would be able to get a job when the children
were older and needed me less. My hope was to be able to work as an actor and
perhaps teach drama/theatre on the side.

When I did move out of the protective bubble of the undergraduate university
setting and into the world of "real" theatre and television, I spent some years "pay-
ing my dues," working with a variety of theatre companies and doing the odd TV
commercial. I found myself an agent and became a member of Actors' Equity, the
union without which entry into the professional theatre world is impossible. During
those years, I worked in many productions, took a lot of workshops and gained
valuable experience.

However, of equal significance for me during those years was the unexpected
emergence of a new area of activity: creative drama with children. This began, simply
enough, when I volunteered to help in my son's Grade 1 class. I thought I would be
tying shoelaces and wiping noses, but someone had noted that I was an actor and
asked me to do some drama workshops with the children. Thus, in my first trial-by-
fire drama class, I found myself in a room with 30 highly active six-year-olds, trying
to keep them from climbing the walls, with Viola Spolin's book (metaphorically) in
one hand and all my courage in the other. However, as daunting as that first expe-
rience was, I was invited to do more, and I began to run creative drama circles at
different schools with children of all ages.

I found I loved "doing drama with kids."

One day, during an ambivalently attended audition for an out-of-town theatre
production (the young man who was auditioning me seemed barely older than my
kids!), I realized that I was actually dreading the possibility that I may be hired, so it was
not difficult for me to politely take my leave. I told myself I would audition no more.

However, when the opportunity presented itself to apply for a Master's program
in theatre at another Toronto university, I leapt at it. Here was the educational expe-
rience I wanted that would also provide me with the credentials I needed.

The program offered me the intensive studio and academic training in theatre
and drama that I had craved, and challenged me in ways I had not imagined possible,
from improvisation to clown to movement to voice. As a teaching assistant in the
graduate program, I also had my first experience of teaching undergraduate theatre
students. These MFA years proved to be a life-changing learning experience for me.
I emerged with much more than a graduate degree in theatre. I had by now acquired
an in-depth knowledge of the study and application of improvisation, a sphere of
knowledge that later proved to be crucial in my psychoanalytic work. The two-year
program also offered the opportunity and the necessity of working in close and
intimate contact with a small group of classmates, something that taught me a great
deal about group dynamics, and that stood me in good stead later when I entered
the world of psychoanalytic training.

With my new credentials, I found I was busier than ever, teaching drama and
improvisation to children in a variety of settings. I now knew that I truly loved this

work, and was particularly taken with pre-schoolers, the most authentic communicators on Earth. I was thrilled when I was hired to teach drama at an integrated pre-school for children with physical and neurological disabilities. I found these children so uniquely engaging that my interest in teaching drama quickly blossomed into passion. This setting was particularly fascinating because it allowed me to work with two populations: children with a wide range of disabilities, and their siblings. These siblings, the "able" children, inevitably had their own stories to tell – stories that desperately needed a forum for expression. For example, four-year-old Charlie, whose sister had been born with cerebral palsy, always had a disaster lurking somewhere in his imaginary trips. Annie, who had spina bifida and who had spent much of her life in and out of hospitals, always needed bandages and medicine to feature somewhere in her stories. I was captivated by these remarkably creative and insightful pre-schoolers, who often seemed to possess a kind of wisdom seldom found in adults. But the stories they told, the choices they made in our drama sessions, left me hungry for a better understanding of the meaning and function driving their narratives.

I had been in personal analysis for several years by this time. I was married to an analyst, and so had become familiar and comfortable with psychoanalytic concepts. I realized that I could satisfy my hunger for a better understanding of the children with whom I worked by training as a psychoanalytic child therapist. I was fortunate that just such a unique training institute existed in Toronto and I was delighted to be subsequently accepted as a candidate in the Toronto Child Psychoanalytic Program (now re-named the Canadian Institute for Child and Adolescent Psychoanalytic Psychotherapy).

Perhaps it was another example of "*beshert*" that, in my search for like-minded drama specialists, I attended a conference in San Francisco on the expressive therapies where the keynote speaker was an inspirational woman, clearly sent to me by some guardian angel. I was already into my second year of psychoanalytic training, and I needed to find some way to bring my two seemingly incompatible worlds, drama and psychoanalysis, together. With her presentation, Dr. Eleanor Irwin built bridges between psychoanalytic theory and drama therapy practice that spoke powerfully to me. Eleanor was, and still is, an eminent psychologist and much-published professor at the University of Pittsburgh; a psychoanalyst of both adults and children, as well as a psycho-dramatist, and a registered drama therapist. I introduced myself to her after her presentation. We liked each other immediately and to my delight she agreed to supervise me by phone.

Thus began my simultaneous dual-track training as a drama therapist and psychoanalytic child therapist. Lacking any drama therapy training in Canada, I received my training long distance with weekly phone supervision, plus visits to Eleanor in Pittsburgh. Back then, in the early 1980s, before "Relational" was an identified psychoanalytic model, Eleanor's "Object Relations" approach to drama therapy and her budding interest in the newly emerging ideas of "Self Psychology" was a perfect union for me. This supervision lasted four years and was an invaluable bridge between the two worlds of drama therapy and the child and adolescent psychoanalytic training I simultaneously received from the TCPP.

As I worked and studied in these two fields, I began to write and present my work as a drama therapist at psychoanalytic conferences, as well as present and introduce a psychoanalytic perspective at drama therapy meetings, alternating between the heretical and the evangelistic. Thus, from early in my career, the notion of bridging between the two spheres – one rooted in the creative and expressive and the other in psychoanalytic theory – was central to my thinking and my experience.

As a child therapist trained in both psychoanalytic and drama therapy principles, it has been my experience that these two therapy models work powerfully together, and have much to offer each other. On the one hand, I believe that psychoanalysis can learn something from the "action" orientation of the drama therapist. On the other hand, drama therapists can very profitably reach into psychoanalytic and developmental theory to deepen their understanding of the therapeutic relationship.

Many drama therapists subscribe to the notion of drama *as* therapy. They reject the value of insight gained through verbal interpretation and believe that the therapeutic value of the work is in staying with the patient within the dramatic metaphor; that the healing, growth and mastery is contained within the creative act, and achieved without the use of verbal intervention. Some feel that it is important to make interpretative comments and therefore carry the work outside of the metaphoric, symbolic realm. This will have a familiar ring to those of us who struggle with the issue of the use of interpretation in work with children: when to speak and when to keep quiet?

However, I believe a broader, more inclusive conceptualization of these "either/ or" questions would allow a transformation into "both/and" answers, thereby opening our experience and deepening our understanding. In my work with children, drama becomes a tool to be used *within* therapy, as are talking, play, music, movement and art. The word "drama" is derived from the Greek "*dr*" meaning "I do" or "I struggle." Surely the task common to us all is to facilitate the "doing" and "struggling" of our patients by containing, supporting, understanding and explaining (Kohut, 1971).

I graduated as a registered drama therapist at around the same time I gained my diploma as a psychoanalytic psychotherapist. This marked the beginning of my life as a mental health professional and what I imagined to be the end of my life as a performer. Apart from a gig doing the voice of Emma Goldman in a documentary of her life, I had not performed in ten years. I think the performer in me was satisfied by the experience of teaching, writing and presenting my work.

However, ten years after graduating as a psychoanalytic child therapist, I was looking for a singing teacher. I had done some singing while doing my MFA – a Cole Porter review and a few other things – but had never had any formal tuition. Now, paradoxically, at one of the busiest times in my life, with a busy practice, teaching, supervising and writing, I felt impelled to find a singing teacher. My husband came home one day with a flyer he'd picked up promoting a woman who taught jazz vocals. He wondered if this teacher might be good for me. Perhaps this was the "*beshert*" factor again at work in my life. I only know I had found Rita Di Ghent.

Scene: 2001. Rita Di Ghent's music studio.

[Ros and Rita meet for Ros' first singing lesson.]

Rita: So let's hear you sing something, Ros.

Ros: Hmmm. I can't really think of anything I know well enough to sing.

Rita [starts to play "Ain't Misbehavin'" on the piano]: Do you know this?

Ros: Oh yeah. But not really. Well maybe, sort of . . .

[Ros starts to sing along, and finds to her amazement she knows the song way bet-
ter than she thought; the melody, the lyrics and even some of Ella Fitzgerald's
phrasing are somehow all available to her.]

Ros: Wow! Who knew I knew that song!

Rita: Well how about this one . . .

My relationship with Rita – a superb jazz vocalist, teacher, musician and composer
– proved to be the most influential, enduring and sustaining in my career as a jazz
vocalist.

Growing up in a home where the radio was the main source of entertainment, I
was lulled to sleep every night by the sounds of Ella Fitzgerald, Rosemary Clooney
or Billie Holiday singing Cole Porter, George Gershwin, et al. My parents loved
jazz and the popular big band music of the day. With Rita, I found to my joy
that those tunes still resided inside my head and seemed only to be waiting to be
summoned. I think those tunes from the 1930s and 1940s also evoked warm memo-
ries of my parents, home and comfort. I embraced each song as an old, long-lost
friend.

I studied with Rita for many years. Through her, I learned invaluable technique
and, eventually, found my own voice. Over the years, with her encouragement, I
went to lots of jazz jams and open mikes, until I developed enough confidence and
got hired for the occasional gig. I was now being paid to sing.

Over time, something gradually consolidated in me, until one day I realized I
had begun to think of myself as a singer. That was when I got a second set of busi-
ness cards, and created a second website: one for my "therapist" self and one for my
"vocalist" self.

These were the years when I was deeply immersed in my life as a psychoanalytic
child therapist: teaching, writing, presenting, running a busy practice and also serving
as faculty and ultimately as director of the institute where I received my training.
Thus, my use of the terms "therapist self" and "vocalist self" is not random. I truly
did feel that, concerning these two aspects of my life, my self was split into two
separate beings. I simply kept my life as a vocalist strictly private and separate from
my life as a therapist. Indeed, I spoke about this aspect of myself to only a very few
trusted colleagues who were also close friends. In fact, I struggled with a crippling
sense of shame when I thought of divulging this part of my life to those in my
professional milieu, certain that they would think less of me if they knew.

I had always known that my psychoanalytic work was informed in important
ways by my experience in theatre and drama. I have written about my understand-
ing of how the "improvisational" in theatre and drama parallels, in many ways, the

psychoanalytic encounter (Chaplin Kindler & Gray, 2010). For me, these two worlds were integrated and informed each other in important ways.

How, then, to explain the difference in the way my psychoanalytic self was impacted by these not-so-very-different forms of creative expression?

On reflection, the "shame barrier" that separated my two working worlds with such power was gradually dismantled by the emergence of a new level of awareness.

In my work with children, I have found "hide and seek" to be a lively and always fascinating source of crucially important information about the child's experience of self and self with other. Although the underlying issues may vary enormously from child to child, one element never varies: the child hides. The child desperately needs to be found.

I believe that my clinical work during this period had a profound effect on the working through of my own game of "hide and seek" that was, at that time, playing out in my life as a vocalist. My capacity to recognize and understand the meaning of my patients' needs to remain hidden, as well as their desperate need for my delighted response on finding them, allowed me to overcome my own shame, to show myself and celebrate that part of myself.

I have come to recognize that the way I work with children is shaped by my personal journey – my own "hide-and-seek" experiences of the push and pull of holding myself back, and thrusting myself forward, variously wanting to reflect and observe, and then eagerly wishing to participate. I am keenly aware that had I given in to my shame, had I not actualized my need to perform both as a singer as well as a teacher and presenter, I undoubtedly would have been much less sensitive to my patients' needs for such experiences, much less able to celebrate with them. Had my strivings been frustrated and unrealized, I would have been far less responsive to the inchoate strivings of the young, and not-so-young, people I treated.

In time, this understanding helped me identify the source of my shame. I believe the unease and lack of integration between my therapist self and my vocalist self had its roots back in those early years in Glasgow where, for me, experiences of shame were endemic.

I came to realize that much of this past experience was somehow evoked by the emergence of my jazz vocalist self. Despite my early role as the family entertainer, I had to do battle with a derisive voice from my past that said: "What a show-off! Drawing attention to herself like that! Who does she think she is?!" And so I kept my life as a vocalist a secret, trying to make sure that no one in my professional world would know and, therefore, think less of me. Interestingly, I found that the voice was absent when it came to presentations of my academic work, which I performed with pleasure and confidence.

There is a commonly held notion that, for many performers, the act of performing is one of extreme narcissism: "This is all about me. I will now show you all how great I am and you will reward me with your applause and your admiration." This scenario stands in stark contrast to the analytic situation whose focus is: "This is all about you. I am here to listen, to try to understand, and to help." However, all of us who have sat in an audience can understand the dynamic process that is essential

to all mutually satisfying evenings at the theatre or concert hall. As with the psychoanalytic encounter, every live performance depends hugely on the quality of response, interaction and chemistry that occurs between performer and audience. To better understand how this works, let us look for a hypothetical moment inside the performing experience of a jazz vocalist:

> The singer stands before the audience with the sole focus and responsibility of delivering the material in the best way she can: interpreting the song without violating the composer's intention; phrasing it just so; attending to pitch, tempo and the arrangement; listening and responding to the musicians; allowing the coming together of all of these elements to produce some spontaneous moments of improvisation where we can all be together and in the groove.
>
> But, most important of all, telling the story.
>
> If any or all of this is achieved, she's done her job. She has provided the audience with what they came for. She hopes they leave feeling satisfied.

None of this can occur unless something mutually positive has happened between the singer and the audience – some "moments of meeting" (Stern, 2004), just as in any dyadic exchange. Thus, the performer–audience relationship can be understood to contain many of the same dynamics as the therapeutic encounter. Further, the experience of creative expression in any form, undertaken inside or outside the consulting room, ultimately enhances the capacity of the analyst to be more effectively "in the moment" in the therapeutic exchange.

My life as a vocalist burgeoned alongside my increasingly busy professional life as an analytic psychotherapist. Over time, as gigs became more frequent, my vocalist self took up residence in the foreground of my life.

My "coming out" was precipitated by the release of my first album, *I'm Alright*, which coincided with the Self Psychology conference of 2011. I found to my delight that when colleagues heard that I was a jazz vocalist, they showed interest and often excitement, rather than derision. I was incredibly moved by the warm response from many of my friends and colleagues at that conference and later from my colleagues at home.

I am now more adept at blocking out that miserable voice from my childhood, and enjoy the thrill of victory each time I step up to the mike to sing.

My second album, *Sugar Blues*, released in 2014, allowed me to embrace and integrate yet another discrete part of myself: my more than 50 years as a healthy Type 1 diabetic.

It would appear that I am "hiding" less and "seeking" more, as time goes on. I plan another album in the near future.

Note

Both albums are available on iTunes and CD Baby under the name Ros Kindler, and can be sampled by visiting my website www.roskindler.com.

Bibliography

Chaplin Kindler, R. (2005). Creative co-constructions: A psychoanalytic approach to spontaneity and improvisation in the therapy of a twice forsaken child. In A. M. Weber & C. Haen (Eds.). *Clinical applications of drama therapy in child and adolescent treatment* (pp. 87–103). New York and Hove: Brunner-Routledge.

Chaplin Kindler, R., & Gray, A. (2010). Theatre and therapy: How improvisation informs the analytic hour. *Psychoanalytic Inquiry, 30*(3), 254–266.

Kohut, H. (1971). *The analysis of the self.* New York: International Universities Press.

Stern, D. (2004). *The present moment in psychotherapy and everyday life.* New York: W. W. Norton.

5

ANALYST-ARTIST

Diane Lawson Martinez

The common factor linking my careers as a psychoanalyst and as a writer is a passion for stories. As a child, I loved both reading and writing. I'll be forever grateful to my mother for driving us the 15 miles to the library in nearby Carthage, Missouri twice each month. La Russell, our own town with its population of 128, could not begin to support a library. For fear of running out of something to read, I made a point of checking out the longest books I could find; as a result, I read Dickens, Dostoyevsky, Tolstoy, and the like. Books were my entertainment, my companions, and my glimpse into a world bigger than what surrounded me.

I spent a great deal of time alone during my childhood, which only promoted my capacity to daydream. These would be long, involved narratives with a version of me as protagonist that could go on for days or weeks. My well-developed imagination also provided material for writing stories. Most vivid in my memory is a whimsical collection of stories based on my family and other La Russell-ites in the style of John Lennon's short pieces (1964). As eminent author and teacher of creative writing John Gardner (1983) said, "Often one finds novelists are people who learned in childhood to turn, in times of distress, to their own fantasies or to fiction, the voice of some comforting writer, not to human beings near at hand" (p. 62).

I would never have envisioned a career as a writer from the vantage point of my childhood. However, the image of a more exciting, sophisticated world came directly from my exposure to literature. Inspired by that view, counterpoised to the material and intellectual poverty surrounding me, I vowed to make my own good living so I might elevate myself into that realm.

I owe my career as a psychoanalyst to an occupational aptitude test administered in my junior year in high school. I recall that there was quite a bit of excitement among the faculty upon acquisition of this new tool. At that time in my life, my ambition was to become an attorney, a vision inspired largely by the weekly television show *Perry Mason*. Our guidance counselor Mrs. M. met with each student

to deliver the results of our individual assessment. I was stunned at her announcement that my future lay in the mental health field. According to her, that was an absolute certainty. According to her. My only choice was which of the jobs along a continuum from psychiatrist to mental health aide I preferred.

> "Well," I said, "I'm going to be a lawyer."
> "No. No, no. You can't be a lawyer. You can, however, choose a job from this group. A psychiatric nurse might be good for you."
> "No, thanks. I'm going to be a lawyer."
> "You are going to have a job in mental health, Diane. That is determined by the test. And you will be going to the state mental hospital for your occupational field trip."

True to Mrs. M.'s word and despite my vociferous protest, I was denied a spot on the trip to the Missouri State Legislature in Jefferson City. I can still see that yellow school bus carrying the other members of my debate team turning left toward the state capitol, while my bus made the right turn to Nevada, Missouri.

In the late 1960s, the Nevada State Hospital Insane Asylum #3 was still a true asylum, a place where people with chronic mental problems or disabilities went to live out their lives. The main building, constructed of red brick, was the largest single building in Missouri when it was completed in 1887. My memory is that the hospital was home to about 3,000 patients at the time of our visit. The facilities stretched out over the countryside, providing jobs for patients able to do productive work. There were gardens, an enormous institutional kitchen, a dairy barn, poultry houses, a blacksmith shop, a laundry. And all this glory overseen by a single psychiatrist.

My group toured the wards, this solitary psychiatrist our guide. The patients consistently received him like the messiah. By and large, the people we saw were submerged in their illness. I remember a naked woman sitting on the floor rocking a rubber baby doll in her arms, and a vacant-eyed man continually mopping the same spot on the floor. I was enthralled. As we walked up a stairwell, I asked a fellow student if he knew the difference between a psychiatrist and a psychologist, the professions at the top of the mental health continuum.

> "One goes to medical school and one doesn't," he said. "But I don't remember which is which."
> "I'll be the one that goes to medical school," I said. "That will make my mother happy."

Back at school, I combed the small psychology section of the library. A book titled *The Interpretation of Dreams* caught my eye, as I'd always been fascinated by my own dreams. I couldn't put it down.

I reported back to the counselor.

> "The test was right! I'm going to be a psychiatrist *and* a psychoanalyst."
> "No, no, no," she said. "A psychiatrist goes to medical school. You're a girl.

Girls can't go to medical school. For example, my son Andrew will be going to medical school.You, however, cannot."

"I'm going to medical school, Mrs. M. Just watch."

As time went on, I had reason to thank Mrs. M. for her discouraging words. Whenever I felt tempted to give up my goal, I'd imagine the satisfaction my failure would give her. As it turned out, Andrew and I were both ultimately accepted to the University of Missouri School of Medicine.

Love inspired my transfer to the University of Illinois Abraham Lincoln School of Medicine for my clinical years. My fiancé matched his Internal Medicine residency at Cook County Hospital, a hotbed of social consciousness at that time. The move was fortuitous for my career, as most of the faculty members of the Department of Psychiatry were psychoanalytically trained. I made the most of my elective fourth year, getting as much exposure to psychiatry and psychotherapy as possible.

In my psychiatry rotations, it was the stories that intrigued me rather than psychopharmacology. I remember J. D., an African-American laborer with paranoid schizophrenia, who was prone to non-compliance with his Stelazine. Since I was nearly a fixture in the outpatient clinic, he was assigned to me for ongoing psychotherapy. J. D. had pleasurable recurrent dreams about flying, which, we came to understand, reflected the intensity of his psychosis: the higher he flew, the more suspicious he was of the people in his life.

"Hey, Doc. I had one of them flyin' dreams last night." He gave me a wary look.

"Hmmmm," I said, trying to manage my concern and disappointment.

"No need to worry though," he said, smiling. "I'm taking my medicine. I was only flying about two inches above the ground."

On the Psychiatric Liaison Service, I was sent to see Gloria, a short, rotund middle-aged woman, on the Neurology floor. She answered my questions about her headaches, for which the neurologists could find no organic cause, then asked if I'd like to see her wedding album. I struggled to keep a straight face as we went page by page through the first and only nudist wedding portfolio I've been privileged to view.

My psychiatric residency at Michael Reese Hospital was a virtual pre-school for the Chicago Institute for Psychoanalysis. Dr. Roy Grinker, Sr., an analysand of Sigmund Freud himself, was chairman of the department, and my supervisors included many of the best minds of psychoanalysis. As residents, we were encouraged to do long-term psychotherapy, both inpatient and outpatient. The opportunity we had to immerse ourselves in the patient's narrative and co-author the revision was a training experience that sadly is near non-existent today.

In the first year of my residency, my inpatient supervisor made the bold suggestion that we treat Esther, a majorly depressed, Jewish widow, using only psychotherapy. The clinical director of the hospital was skeptical, but gave me the go-ahead for a three-month trial of this treatment plan. If it didn't work, he made clear,

antidepressants or ECT would be instituted. Esther's symptoms were entirely somatic. She denied having emotions or feelings other than concern about her undiagnosed physical problems. She was fond of repeating the joke that the tombstone of the hypochondriac says, *I told you so.* My supervisor helped me understand the significance of the evolution of these symptoms as she improved: difficulty swallowing gave way to constipation, which gave way to gynecologic aches and pains. Finally, she developed hysterical blindness, which had been a symptom suffered recurrently by her husband. This experience, a clear identification to him, finally ceded to raw grief for his loss. Ultimately, Esther began writing extraordinary poetry, depicting the previously unexplored emotional landscape of her life.

While the curriculum of our residency program was designed around classical Freudian theory, it was the late 1970s and Heinz Kohut was developing his ideas on narcissism. Most of our supervisors were enthused about this new approach to conceptualizing problems of personality and conducting treatment. We residents were privileged to be audience to the often heated theoretical debates that strained the Chicago Institute for Psychoanalysis. Ultimately, that experience provided me a model for considering and making use of differing theoretical perspectives, of viewing theories as tools for understanding versus doctrines requiring sworn allegiance.

Analytic training, of course, involves ultimate attention to the structure of the patient's narrative. While, as I would later learn, there are major differences between creative writing *per se* and the writing that goes into case reports (which is often more "creative" than many analysts want to acknowledge), psychoanalysis is above all about narrative. Dr. Louis Shapiro, known around the Chicago Institute as "the analyst's analyst," persistently encouraged us in our case presentations to "follow the red thread," the predominant theme flowing through the patient's story. Interestingly, Gardner (1983) says, "theme is elevated critical language for what the character's main problem is" (p. 52). Or as my MFA advisor Domenic Stansberry says, "A character is oriented around a single idea. As an example, the idea for Hamlet was uncertainty." It is of interest here that Gardner contrasts specifically the mindset of the writer and that of the psychologist:

> writers learn, by a necessity of their trade, to be the sharpest of observers. That is one of the joys, as well as one of the curses, of the writer's occupation. Psychologists perhaps get some of this same pleasure, but psychologists, whatever their claims and intentions, are essentially interested in the aberrant mind. Writers care about all possibilities of human nature.
>
> *(1983, p. 38)*

In 1984, I moved from Chicago to San Antonio to marry my second husband. At that point, I had finished the clinical requirements of my psychoanalytic training and had a full-time private practice of psychotherapy and analysis. The process of closing my Chicago practice was one of my life's most wrenching experiences. Chicago's Institute of Psychoanalysis had candidates write a publishable paper as one of the non-clinical requirements for graduation. I had an idea for mine – one that totally

escapes me now – but when I began to write, I found that all I was able to put down were thoughts about the "forced terminations" of my therapy patients. I decided that I probably needed to write a simple article about that experience first "to get it out of the way." Instead, that paper not only fulfilled my graduation requirement, but was published in the *Journal of the American Psychoanalytic Association* (Martinez, 1989). I continued to publish professional articles over the next few years, but gradually lost interest in using narrative to make or expand a theoretical point.

What was a life-long fantasy of doing writing of a creative nature began to nag me more intensely as my 50th birthday approached. My career as a novelist began the day my most reliable patient did not show for his session. The only explanation that occurred to me was that he was dead. Over the next 45 minutes, my imagination went wild. *What if he actually was dead? Then what if another patient died? Then another? All in different and apparently unrelated ways? How would I convince an overworked homicide detective that these events were worthy of investigation?* In this flight of anxious fantasy, my novel, *A Tightly Raveled Mind*, was conceived.

Conception is one thing. Gestation is quite another. I started writing. I wrote and wrote until it became clear that I had no idea how to write a novel. I signed up for classes at Gemini Ink, San Antonio's literary arts center. I was more scared walking into my first fiction workshop there than I was starting medical school, but I stuck it out. In a series of classes, I got constructive criticism and encouragement from my instructors and fellow students.

The most intense learning experience at Gemini Ink was a mentorship I won with the novelist Robert Boswell. In our first meeting, we reviewed the draft of an essay about a trip to Croatia and Bosnia, where my experience with Muslim refugees set in motion a grief process for my first marriage. Like my paper on forced termination and my novel, that non-fiction piece demanded to be written. In retrospect, the writing in the draft I first gave Boz, as he prefers to be called, was quite poor. However, he said toward the end of our meeting, "I see what your story is about." From there, he went on to summarize the heart of my narrative. I don't remember the details of what he said; I only remember feeling so profoundly understood that tears came to my eyes. When he finished, I said to him, "All these years I've been talking to analysts to figure myself out. Maybe I should have been talking to a writer instead."

The semester I spent working with Boz first gave me the sense that I could become a writer. The piece we worked on, titled "The Road to Kotor Varos," was ultimately published in the *Bellevue Literary Review* (Martinez, 2006) and cited as Notable Travel Writing of 2006 in *The Best American Travel Writing 2007* (Orleans, 2007). An excerpt follows:

> The blurred image of my younger self stared at me from within the glass. *Yes. Nick left her. He left because she'd been selfish. Because she's neglected marriage for ambition. Because she begrudged him a separate self. The loss she most feared happened. And for this, she was both victim and perpetrator.*
>
> The woman in the mirror was crying. I watched her, considering all I'd come to know in those past two days: unimaginable cruelty, unbearable loss.

My tragedy ranked insignificant in comparison. My crimes were misdemeanors. But it was *my* tragedy. And they were *my* crimes. And then I understood. If I could not bear the complexity of my history, grieve for my careless loss, and confess to my unacknowledged transgression, then I did not merit audience with the Mladics and the Nuras and the others who had no choice but to suffer that which was insufferable.

Above all, my time at Gemini Ink taught me there was a craft to writing that I needed to master. I realized that, at the rate I was going, the novel I wanted to write would not be finished in my lifetime. I began to look into MFA programs, but was discouraged as there seemed not to be a program that would allow me to keep my practice going. Then one day, I heard mention of low-residency MFA programs: a dream come true for someone who needed to keep her day job. For the next two-and-a-half years, my vacation time – two weeks, two times per year – was spent at the Vermont College of Fine Arts. In between residencies there, I worked with an advisor. At home, every minute of my discretionary time was spent writing and reading the work of authors chosen to help me develop my skill. My third semester, I wrote my required critical thesis on the use of back-story. My fourth and final semester, I finished my required creative thesis, the novel I'd conceptualized so many years before: *A Tightly Raveled Mind*. I graduated from the MFA in Writing program in 2007. I can honestly say that, save slipping on the treacherous ice of the Montpelier winters, I enjoyed every moment. Never before had learning been so pleasurable.

I, like most, assumed being a psychoanalyst would make me a better writer: *all that incredible material!* I did not expect that becoming a writer would make me a better psychoanalyst. In particular, the focus on the development of a well-written narrative gave me a different perspective on the stories my patients told. I'll give you an example. I began work with Phillip (not his real name), a young man in his 30s, who taught English Literature. He came to see me for help resolving a stalemate with his wife around having children. When Phillip was seven, his father decided he couldn't abide Phillip's mother and the upper-class lifestyle he'd been born into and left the home. A soon-to-arrive stepmother physically abused Phillip during visitations. The father sided with his new wife, abandoning Phillip to live full time with his mother, an exquisite narcissist. When we met, Phillip had not had contact with his father for almost 20 years. He knew through the grapevine that his father had long ago divorced the stepmother and had re-married a decent and kind woman. Still, he wanted nothing to do with his father. Phillip suffered from terrible depression, low self-esteem, and the conviction he was ill-equipped to be father to a child.

Feeling that we were stuck one day, it occurred to me to talk to Phillip about his life narrative as if we were revising a story together. Given his literary interest, he was intrigued. I proposed to him that the characters in his alternating story lines were unsatisfyingly two-dimensional: either he was a wretched, unlovable person or his father was a heartless ogre. Also, his competing narratives lacked a plot, a sequence of

events. (A plot involves cause and effect. An often quoted example: *The king died and the queen died* versus *The king died, and the queen died of grief.*) And neither of Phillip's life stories included a process of transformation or resolution.

Phillip began to re-write his narrative. He considered his father's unhappy situation with his mother and their stifling social milieu. He began to look at his past self through the eyes of a child with relevant developmental considerations, even considering how he might have played a role in provoking an either/or scenario with his abusive stepmother. To paraphrase Lisa Albers, one of my MFA teachers: protagonists who make interesting mistakes and take responsibility for them are preferable to protagonists who are largely objects of impersonal forces or the actions of other people. This holds true for the life narrative we develop with and for our patients. Phillip's life narrative took on a worthy complexity. Gardner (1983) says, "In the best fiction, plot is not a series of surprises but an increasingly moving series of recognitions, or moments of understanding" (p. 47). Is there a better description of the therapy process?

Phillip and his wife agreed to get pregnant. He prayed for a girl, as he especially mistrusted his capacity to father a son. However, his wife delivered a healthy baby boy, to whom Phillip proved a naturally attuned father. He sent a birth announcement to his own father, whose delighted response made for a positive, but satisfyingly complicated, re-engagement.

Would I have been successful at treating Phillip had I not been studying to be a writer? Probably. That's not the point, really. The point is that my writing studies made me aware of what patients told me in new ways. Thinking about my patients' life narratives from a literary perspective – considering character development, the coherence of plot and theme, voice and point of view, setting and details – provided me a different and powerful perspective. And this is a joint effort. As William Carlos Williams said, "An important part of a physician's life is spent listening to people tell you their stories; and, in return, they will want to hear your story of what their story means" (Coles, 1989, p. 105). Recent research into the differing psychological impact of the use of first versus third person when referring to oneself provides tangible evidence of the therapeutic power of narrative (Kross et al., 2014).

On the other hand, did my being an analyst affect my writing? Of course. One can't *not* benefit from being told stories hour after hour, day after day, year after year. But I had to learn to stop thinking like an analyst, or at least not as I'd been trained to do. Rather than synthesize/categorize/integrate, I had to learn to unravel, to take things back to the words/actions/attitudes from whence my understandings and interpretations came. Gardner describes this process:

> Anything necessary to the action's development must be shown dramatically. For instance, if a man is to beat his dog, it is not enough for the writer to *tell* us that the man is inclined to violence or that the dog annoys him: we must see how and why the man inclines to violence and we must see the dog annoying him.
>
> *(1983, p. 87)*

Often, people would say how lucky I was to have all my experience with patients to write about. But I didn't. I couldn't and wouldn't use my real patients as fictional characters. That said, I did take fragments of real patients (as well as of a wide array of friends, family, and strangers) – a look, a particle of history, a quirky way of expression, a behavior – that could seed or enhance full-blown characters, like my reliable patient who didn't show up that fateful day. (By the way, he was not dead.) For my novel, I knew I needed a mix of pathologies to make the story interesting and the characters distinct. I began to imagine fictional patients with borderline personality disorder, perversion, post-traumatic stress, narcissistic personality, attachment disorder, Asperger's syndrome. I knew I needed to have both male and female patients. Gradually, my characters began to take shape, first rather two-dimensionally; as I kept writing, they developed depth.

Even then, I worried my real patients might be convinced that they recognized themselves in my yet-to-be-finished, much less published book. When I had the good fortune to meet Dr. Irvin Yalom, the well-known therapist/writer, I asked if his patients ever recognized themselves in his fictional writing. "Of course," he said. "All the time!" My heart sank. "But," he said, eyes twinkling, "they never see themselves as the characters they actually inspired."

Again, Gardner's advice to would-be novelists seems a very apt description of the analyst's attitude:

> To be psychologically suited to membership in what I have called the highest class of novelists, the writer must be not only capable of understanding people different from himself but be fascinated by such people. He must have sufficient self-esteem that he is not threatened by difference, and sufficient warmth and sympathy, and a sufficient concern with fairness, that he wants to value people different from himself, and finally he must have, I think, sufficient faith in the goodness of life that he can not only tolerate but celebrate a world of differences, conflicts, oppositions.
>
> *(1983, p. 32)*

Most especially in these days of the internet, there are very real professional and personal struggles for an analyst/writer, particularly for one who chooses to write creative works. Patients have easy access to all sorts of information about their therapist, including what their therapist publishes. Some patients will wisely consider the potential impact of the intrusion into the therapeutic space and avoid such exploration. Others can't resist the temptation, which leads to boundary issues and other complications. I've had more than one patient use tools like Google Alert to keep abreast of me. Often, these findings prove traumatic to this kind of patient, who by definition has difficulty with boundaries and does not consider the impact of information he or she may not be equipped to manage. Of course, this can all be analyzed and interpreted, but nevertheless can make for an impingement on the therapeutic process that it is not always possible to metabolize.

Writing also wreaks havoc with friends and other non-patient readers. There is the perpetual problem of being equated with one's protagonist, even by people who are quite literate. On the issue of autobiography in fiction, Salman Rushdie said in an interview with Ameena Meer (1989), "People assume that because certain things in the characters are drawn from your own experience, it just becomes you." A few years later at the 2006 Texas Book Festival, in an interview with *Texas Monthly's* editor Evan Smith, I heard Rushdie say he had grown so tired of being asked if his characters were him that he'd come to just reply with something along the lines of, *Yes, yes, yes! The* [here he inserted along list of contradictory and odd characters] *are all entirely and exactly me!!*

I, of course, made this common problem much worse for myself by having my protagonist be a female psychoanalyst who lives in San Antonio. The strength of this tendency was made painfully clear to me recently when I, after much and prolonged pleading, allowed a close girlfriend who is an avid reader access to my manuscript. I pointed out that she had been skittish and weird around me after having finished the book.

> "Well, I just can't imagine you doing those things," she said.
> "I *didn't* do those things. The character Nora did those things."
> "But you thought of them."
> "Yes. It's called writing fiction."
> "But I never would have believed you could even *have* thoughts like that."

Of course, a writer has to be able to find resonance with her characters, has to be able to evoke and inhabit the fictional subjectivity of even the most disturbed or perverse. Gardner says:

> One has to be just a little crazy to write a great novel. One must be capable of allowing the darkest, most ancient and shrewd parts of one's being to take over the work from time to time. Or be capable of cracking the door now and then to the deep craziness of life itself.
>
> *(1983, p. 57)*

In the experience of most writers, if things go well, there will be a moment in which the fictional character takes on a life of his or her own. (I recall a celebrated author saying that he didn't feel he deserved praise for his writing, since his contribution was merely to get up in the morning and write down what his characters told him.) This process feels near magical to me. I remember the first time this being taken over happened to me. I was on a long flight, writing away. (There may be no better place to write than on a plane – at least before inflight movies – where you have to stay in your seat and the place you create in your mind is reliably more fun than where you are.) There was a point where I was just recording what I saw my character doing. When I deplaned and met up with my traveling companion, who had been seated in another row, I said, "You won't believe what Nora has gone and done!"

Being a writer profoundly altered my life. The time required to write is a major factor. As Gardner says, "No human activity I know of takes more time than writing" (p. 46). If it's not how you make your living, it takes your discretionary time. Writing contributed to the ending of a long-term romantic relationship, which I knew was over when he referred to my avocation as "your selfish writing thing." Writing is a solitary activity. Your friends do not understand. Their feelings are hurt when you choose to stay home with your laptop and made-up characters rather than spend an evening with them. An analyst's day job, like that of a writer, is both solitary and sedentary, meaning there is always the tension between those activities and the equally essential needs for intimate and social connection and physical exercise. Gardner (1983) advises the writer to "find some kind of congenial work that will not eat up all his energy and time" (p. 116). Doing therapy can be congenial work, but it of necessity eats up a great deal of energy and time.

In some ways, it's easier to be friends with other writers, but even then there is the problem of having the time to invest in growing a relationship. A writing group might seem like the answer, but the reality is those groups are quite unstable. There is envy, competition, wounded narcissism. People who are better writers than you may inspire, but they also can discourage. Reading the work of people who are worse than you can feel like a waste of your time. Basically, you have to be fine with being alone. If you're lucky, you find a person or two whose opinion you respect and ask them to read your work.

Being a writer profoundly affects your relationship with family. A friend whose spouse is a writer said, "I don't know what's worse – when I think her writing is about me or when I think it's not." My adolescent children came to my MFA graduation weekend. Every graduate did a reading of their work. I chose a segment of my novel that had what I considered a rather tame, but still somewhat erotic, encounter between my two main characters. My son, who was 21 at the time, came up to me afterward.

> "Mom," he said, "that was really good. Your writing has gotten a lot better. I'm really proud of you."
>
> "That means so much to me. Thank you." Tears filled my eyes.
>
> "But, Mom," he said, "for future reference. I can go the rest of my life without hearing you say the word 'nipple'."

An unusual affirmation of my creative writing ability came in an unexpected setting, an analytic meeting in Amsterdam. The night before our workshops were to begin, my friend asked which of my cases I would present. Taken aback, I asked whatever did he mean. Although I knew this was the usual structure of the meeting, I'd somehow managed to overlook the part of the announcement that included this requirement. *I'll do it from memory*, I thought. *No, basically that would be creating an act of fiction.* Then it occurred to me that I could extract "sessions" from one of the patients in my novel manuscript. I informed the workshop of my oversight, giving them the option of using my time in another way or going along with my fictional

case presentation. The group chose the latter. It was pleasing to find that my "case" held up under this scrutiny, to the point that I had to keep reminding people who asked for more history or process that this was fiction.

Writing a novel is one thing. Getting it published is quite another. For years after my graduation from my MFA program, I worked at revising my novel with my literary agent. I soon learned that the immediate irritation that came upon hearing his ideas about what needed improving was merely my frustration at wanting to be *done*. In reality, the book was always better for following his advice. Ultimately, *A Tightly Raveled Mind* found a home with Lee and Bobby Byrd at Cinco Puntos Press (Lawson, 2014). I've yet to tire of doing readings of my book for groups. For the most part, I'm pleased with the writing, to the point that I sometimes find it hard to believe I was the author.

The nature of the gratification I derive from my clinical work has evolved over the three-plus decades of my being a therapist. Early in my career, I was enamored to some extent by a growing mastery over the technical aspects of my work. This source of gratification has faded over the years. Currently, the progress I see in my patients is primary to me. I'd like to think of this change as being in the realm of Heinz Kohut's comparison of doing therapy to learning to play the piano: initially one is preoccupied in mastering the technical aspects of the process; once that is accomplished, one can give oneself over to making music.

Writing provides a more private pleasure. I derive a great deal of enjoyment in the entire process, from finding just the right word, to crafting a sentence, to developing a story line and watching it grow in complexity. (An aptitude test I took several years ago, which was much more sophisticated that the one that led me to being an analyst, suggested I'd be a very good copy-editor.) There is more personal challenge for me in writing than in doing therapy at this point. The experience of being "in the zone" or "flow" that occurs when I'm deep in the writing process is like nothing else I've experienced. Psychologist Mihaly Csikszentmihalyi (1990) has shown that this mental state has to do with the brain being fully engaged in the creative process, so that there is no "bandwidth" available for taking other stimuli into account.

Until I did my MFA in Writing, I'd not experienced a true passion for learning. Choosing to be a physician and an analyst was in keeping with interests and skills of mine, but it was also infiltrated with the need to please (and on a deeper level to understand/cure) my mother. Writing was entirely for me, and, since I never expected to gain fame or fortune in this way, the process was also unburdened of the need to support myself or sustain a level of standing among my professional peers. On the other hand, writing can be very frustrating and often requires much time and effort to get to a place of satisfaction with a piece. My work as an analyst can be restorative in a moment like this, as in general I feel competent in my therapy role, a sanctuary for my self-esteem.

My ambitions for myself as a writer are modest. I would like to write another novel, although I took comfort in reading that 70 percent of published novelists do not write a second book. I won't feel a complete failure as a writer if I don't do

another. From my own experience and that of other writers, I know that, with rare exception, publication doesn't change one's life beyond the personal satisfaction of having completed a creative piece. I feel fortunate to have a day job that provides a way to be helpful to people and a good income.

At this point of my life, I don't harbor ambitions related to my work as an analyst beyond helping my patients make the most of their lives. Early in my career, I achieved some success in the political and public arenas of psychoanalysis. While I took pleasure in being invited to participate in these aspects of our analytic organizations, as well as being asked to present professional papers, these activities ultimately lost their appeal. Perhaps because I had a fairly solitary childhood, I find group process extremely tedious and frustrating. And while I was well regarded as a teacher and supervisor, these more generative activities failed to evoke a sense of passion in me. My place as an analyst is behind the couch, or more accurately these days, in the chair facing my patient, crafting therapeutic life narratives.

References

Coles, R. (1989). *The call of stories: Teaching and the moral imagination.* Boston, MA: Houghton Mifflin Co.

Csikszentmihalyi, M. (1990). *Flow: The psychology of optimal experience.* New York: Harper & Row.

Gardner, J. (1983). *On becoming a novelist.* New York: Norton & Company.

Kross, E., Bruehlman-Senecal, E., Park, J., Burson, A., Dougherty, A., Shablack, H., Bremner, R., Moser, J., & Ayduk, O. (2014). Self talk as a regulatory mechanism: How you do it matters. *Journal Personality and Social Psychology, 106*(2), 304–324.

Lawson (Martinez), D. (2014). *A tightly raveled mind.* El Paso: Cinco Puntos Press.

Lennon, J. (1964). *In his own write.* New York: Simon & Schuster.

Martinez, D. L. (1989). Pains and gains: A study of forced termination. *Journal of the American Psychoanalytic Association, 37*(1), 89–119.

Martinez, D. L. (2006). The road to Kotor Varos. *Bellevue Literary Review, 6*(1), 54.

Meer, A. (1989). Interview with Salman Rushdie. *Bomb, 27*(*Spring*). Retrieved from http://bombmagazine.org/article/1199/salman-rushdie

Orleans, S. (Ed.) (2007). *The best American travel writing 2007.* Boston, MA: Houghton Mifflin Co.

A selection from the writings of Diane Lawson Martinez

A Tightly Raveled Mind

Chapter 1

Psychoanalysis is not and has never been the fashion in Texas. It's a pull-yourself-up-by-your-cowboy-bootstraps kind of place where psychiatrists are for *crazy* people. Texan psychoanalysts like to say they *grow their own* analytic patients, meaning people come seeking a quick fix for emotional pain, and learn about the enduring value of self-knowledge as a by-product.

In no small part, my own success was due to several advantages provided by my former husband Richard, as he would have been the first to tell you. There was the money, of course—the plump cushion of his inheritance, on top of the income from his high-end psychiatric consulting—which allowed me the luxury of being selective about patients I took on. My office on the grounds of his childhood home was in a classy part of town, and, although I'd kept my maiden name for professional purposes, enough of the right people connected me to Dr. Richard Kleinberg and his old San Antonio bloodline to ensure my business card would be handed out in the best places. In Texas, as in most of the country, Jews are well enough regarded, as long as they're doctors, lawyers, or accountants.

On the other hand, I'd given up a lot for Richard. My career was just getting going in Chicago when he started lobbying to move back to San Antonio. From what I've observed, Texans must get a homing microchip implanted in their brains at birth. I'm not talking about everyday nostalgia for one's home town. I'm talking about some primordial imperative for return. I'd agreed to relocate if, and only if, I could have my ideal practice. I would not, as too many psychiatrists have come to do, run patients through the office at fifteen-minute intervals with only a prescription to show for the encounter. I would restrict my work to psychoanalysis, the real five-times-a-week kind, not some watered-down version. Richard, under the influence of the migratory urge to reinhabit his birthplace, swore that he wouldn't dream of pressuring me to make money. I should have known better. His complaints about me not pulling my weight and my other numerous faults grew like weeds in his native soil.

However, after a few years, despite domestic turbulence and brutal summers, I'd settled into a comfortable, if not blissful routine. I was good at my job—or thought I was. And I liked my work: listening each day to the details of the lives of my six patients, exploring the intricacies of their minds, trying to help people like Professor Howard Westerman get comfortable in their owns skins. So much for my good intentions. Like Private Investigator Mike Ruiz says, that and 99 cents will get you a breakfast taco at Panchito's.

★ ★ ★

The Monday that my patient, Howard Westerman, blew himself to kingdom come started out like any ordinary workday: like the kind of everyday day that feeds our communal delusion that everyone we care about will live forever. I'd felt my standard urgency to be at my station for Howard's eight o'clock session. Once, early on in my work with him, I'd dawdled over the newspaper, reluctant to plunge into my routine, only to emerge from my back door to find him pacing the balcony of my converted carriage house office. He'd flat refused to use the couch that session, circling the room instead, talking in fragmented sentences, rolling a cat's eye marble—the "lucky" one he always carried in his pocket—around in his fingers. I got the message about his desperate need for order, and, from then on, I'd done my best not to disrupt him.

This in mind, I'd pushed through the weekend's worth of stale air in the waiting area that day to switch on the lamp and straighten the magazines before closing myself into the consulting room. I'd registered my usual irritation at the sight of the glass-paned door, a choice Richard had insisted upon for aesthetic reasons. It was that wavy kind of glass—some fancy Italian something, totally opaque of course—but it always struck me as posing too permeable a barrier for the situation.

I'd gone about my morning ritual: making coffee, adjusting the blinds for the morning sun, fluffing the pillow at the head of the couch, and covering it with a fresh tissue. When I finally looked up, the clock read 7:56, which was late for the painfully punctual Howard. I held my breath, anticipating the strike of his heavy black wingtips on the metal staircase would break the eerie silence. As if to provide a substitute sound, the resident redheaded woodpecker started pounding the tree by the window. The clock rolled to 8:00. I poured some coffee; burned my tongue on the first sip; thumbed through a psychiatric journal full of articles on schizophrenia, PET scanning, and the thirty-one flavors of bipolar disorder, before tossing it in the trash. There was no possibility of missing Howard coming up the stairs. I'd checked the waiting room anyway. Empty.

In theory, a patient coming late constitutes resistance to treatment. Not necessarily a big deal, just something to talk about once he or she arrives. Part of the process. Grist for the mill. Under ordinary circumstances, the analyst can even afford to experience a patient's tardiness as a small gift. There are always calls to return, letters and bills to open, private thoughts to savor, fingernails to file. But I knew deep down this event was far too un-Howardly to consider ordinary.

Howard came seeking analysis when his socialite wife, Camille, put the divorce gun to his head. Their twin boys were fast approaching college age, and she'd told him she didn't *fancy* spending the rest of her life with a human robot. Howard, having grown up in rural West Texas, came by his lack of emotion honestly. He'd survived the bleakest of childhoods—seventh child of twelve, an emotional cipher for a mother, a hellfire Pentecostal minister for a father—by making feelings irrelevant. I'd immediately understood Camille's complaints about Howard. The man possessed no vocabulary for feelings, much less a clue as to what might require one. He was maddeningly and irrationally rational. All the same, I'd come to be quite fond of him, certain there was a tender guy inside him awaiting rescue. My rescue.

I paced around the office as Howard's minutes ticked by that morning, doing what an analyst does, letting my mind free associate about what had been going on in his treatment. I recalled that a chink had appeared in his defensive armor in our previous session, his Friday appointment.

"My wife said to tell you that I made her coffee this morning," he'd said.

"What makes that important?"

"Usually I just make it for myself. I don't know what got into me."

"And?"

"She kissed my head." Trained to know that I want to hear about feelings, not just behaviors, he'd squirmed and added, "It felt okay."

It made sense that he'd be shut tight in reaction to this lapse, but it wasn't his style to be late. By 8:15, I was fighting down the urge to give him a call. I knew it would be to quiet my nerves, not for him, so I cleaned out my purse instead. I took my time, throwing out the wadded credit card receipts, paper clips, and even one desiccated lipstick I'd bought on impulse but never wore, because the color made me look sallow.

I hate patients no-showing. Always have. It makes me feel that I've screwed up in some way. In an attempt to soothe myself, I began to circle the consultation room, looking out each window in sequence: the two parking spaces just off the street, the elm with the frenetic woodpecker still hard at work, the view of the back of the house screened by a huge, flaming pink crape myrtle and the old live oak cradling the children's tree house in its branches. The beauty of our backyard raised the ugly question of what I'd do for a workspace should Richard and I go through with the divorce. There was no doubt I'd have to relinquish the house, a consideration that only served to ratchet up my agitation.

I remember the accusing gaze of my life-sized bust of Freud, a graduation gift from the Chicago Psychoanalytic Institute, following me from his spot on the book-shelf. To appease him I'd asked myself what the good Dr. Sigmund would say about the situation. He'd say, of course, that Howard's defenses were loosening. That this was a great opportunity for insight! I'd rolled these ideas around in my mind like worry beads. It didn't help.

In retrospect, I was far too concerned about things that had no importance: like whether I'd made some therapeutic mistake, or whether Howard's absence presaged my losing a hard-earned analytic patient. In retrospect, I wasn't concerned enough about things that really mattered: like the fragility of the human psyche and life itself, or the potential for one terrible event to start a destructive slide down a slope made slippery by fear and selfishness to full-blown catastrophe.

For all the good that retrospect does.

<p style="text-align:center">★ ★ ★</p>

I learned Howard was dead on the nightly news. I was putting dinner together, cook-ing being one of few downsides to Richard's and my separation. The kids had been fighting over which show to watch for their thirty-minute television allotment. As punishment, I made them endure the wrap-up of the day's traffic jams, city council spats, and detailing of San Antonio's intractable summer heat. They wrestled around on the rug, keeping the bickering just below the threshold of what would set me off again.

"Mom, look! It's your patient." Alex jumped up, knocking his Cherry Vanilla Dr. Pepper onto the rug, the beige and sage green oriental Richard had haggled into possession on our Turkish honeymoon.

Professor Westerman's face on the screen, the stunned photo from his Trinity University Chemistry Department ID badge, was unmistakable.

"Hey, stupid. Mom can't say who her patients are." Tamar was smug. "It's called con-fi-den-ti-al-i-ty."

"Dwarf-brain, it says he's *dead*. If he's dead, she can say. Privacy Case Law. It was on Dad's TV show last week."

"Whoa! He blew himself up." Tamar's eyes opened wide. "Maybe it was a *suicide* bomb."

"He wasn't a terrorist. That's so stupid," Alex said. "They think it's an accident, Mom. Can we change the channel now? Pleeeese?"

I thought about the voicemail I'd ended up leaving that morning. Howard's wife would find it: her husband's analyst politely, but firmly, inquiring as to his whereabouts. I imagined her return call: *This is Camille Westerman, calling on Howard's behalf. He regrets not being there for his appointment, but he was in smithereens. Do you charge for sessions missed due to unanticipated death?*

I soldiered through the motions of our dinner routine, total numbness alternating with gut-ripping waves of guilt. The word *blindsided* kept looping around in my mind. As if somehow I could have seen it coming, which maybe I should have. Mike Ruiz says people get blindsided because their eyes are closed. I take offense at that, or pretend to, a private investigator presuming to teach a psychoanalyst something about denial. About repression. About the power of the Unconscious to put our head up our butt and keep it there. But the fact is that I didn't see Howard Westerman's death coming. Or the death of my second patient, as Detective George Slaughter, SAPD Homicide, would take great pleasure in pointing out. Or even that of my third patient, which I would witness with my own eyes. Despite years of experience as a psychoanalyst, I failed to anticipate each and every one of those fatal events, not to mention the violence I would prove capable of myself.

6

I'VE GOT A ROCK 'N' ROLL HEART

Reflections of a musician-analyst

Heather Ferguson

Intro

Rhythmicity shapes us – from our mother's heartbeat to our inner pulse, from our earliest interactions as infants to the sophisticated give and take of adult conversation. Recently, contemporary analysts have taken up the project of embodied communication, the implicit register, and how co-rhythmicity, synchronous and dyssynchronous interactions, communicate and inform the analytic exchange – the relational flow (Black, 2016; Ipp, 2016; Knoblauch, 2000, 2011, 2015; Lachmann, 2001; Nebbiosi, 2016; Nebbiosi & Federici-Nebbiosi, 2008; Orfanos, 2016; Sapen, 2012; Shapiro et al., 2016). As Nebbiosi and Federici-Nebbiosi (2008) write, "rhythm is the element with which our body is in relation with the process" (p. 232).

As a rock drummer for over 30 years, my career as an analyst developed in tandem, each identity subtly informing the other. In this essay, I trace my experience as a percussionist and my subsequent clinical work with rock groups, musicians, and therapy groups. For me, the quintessential spark in music-making and psychotherapy is the immersive, collaborative exchange. With my musical or relational partner, when the sense of connectedness or interplay dims, the experience loses an essential vitality.

Banging on a drum

My first week of Seventh Grade, as I witness the high-school percussion ensemble in performance, I am transfixed by the explosive energy. Rich marimbas, resonant tympani, and piercing snare drums thunder as the high-school boys sway to the beat. It is love at first sight.

I have never played an instrument before but, after signing up for lessons, I play in the concert band, the orchestra, and the percussion ensemble, and accompany various groups on drum set for the next seven years. Responsive to my budding

interest, my parents help me purchase a used drum kit and host my fledgling band rehearsals. I discover the perfect antidote to my good-girl impulse: a punk band with the individualistic, smart boys from high school. Our sweaty, sexually charged jam sessions create space for my emerging adolescent self. Eager to perform, we play at my brother's elementary school dance. Our perplexed audience does not know what to make of our thrashing, but we are invigorated. And this first act of "bandhood," a bonding twinship experience, takes root.

Although I love drumming, I suspect something more complex motivates my choice. Six months earlier, my father's younger brother commits suicide. After my uncle's tragic death, my father's own latent depression emerges, a mood disorder he will struggle with for the next four decades. Drumming brings raucous aliveness into my home, a full-body solution to the "nameless dread" in my family, as I find expressive freedom and energetic release. "Banging on a drum," I discover, is a potent remedy for the helplessness I experience but of which I am only dimly aware.

My father, a college fine art professor, introduces me to students forming an experimental band. At 16, I am thrilled by the creative process, performing and recording an album, a connection to my father and his esoteric art world.

Drumming offers a Winnicottian transitional space in which to explore potency, assertiveness, and embodied sensuality. Although I play in many underground bands during high school, I am drawn to psychology in college, reflecting the humanistic values I cherish. Deterred by the single-minded discipline required of a professional musician, I do not continue further training in music. After completing an undergraduate degree, I pursue a graduate degree in Social Work where the pulse of music draws me once again: between lectures, I study African *djembe* drumming.

After two years of graduate work, I return to Canada for my first clinical position at a college counseling service. My first patients are female students with disordered eating and self-harm, depressed and body preoccupied. As I listen intently to their psychological struggles, I hear tales of neglect, invalidation, and suppressed passion. Although I understand the complex, multidetermined nature of eating disorders, my patients' felt pressure to accommodate to others, at the expense of their own desires, leaves a lasting impression. As I track their stories, I recall my adolescent experimentation and encourage their hunger – for food, relationships, and connectedness. These early clinical encounters inspire my commitment to eating disorder treatment for the next three decades.

Out of the closet

By 1990, I take a staff psychotherapy position at New York University in the Student Counseling Service while performing in numerous indie rock bands. We produce albums, tour in cramped cars, and gig at rock clubs around New York City. Band life, an opportunity for community and creative self-expression, exposes me to an array of artists and expands my clinical worldview.

Much of the time, my rock 'n' roll extracurricular activities remain separate from my life as a therapist. For a period, I store my drums in the counseling

department closet, as I fear colleagues will not take me seriously if they know about my late-night adventures. As my identity as a therapist solidifies, the shame around the "wildness" of drumming diminishes. I begin to share my musical projects with colleagues who become supportive fans, mingling with bandmates and friends after the shows. In these moments, the divergent aspects of my self-identity feel more integrated.

Long rehearsals and gigs, however, are challenging to balance with clinical responsibilities. Late one evening, during a rehearsal, my on-call beeper goes off. As the overnight crisis counselor, I interrupt the session to assess a student's suicide risk and then return to my unsympathetic bandmates. I struggle, feeling inadequate in both realms: inferior to my full-time musician collaborators and second-rate to my psychoanalytically-trained colleagues.

After seven years on the mental health team, I establish a full-time private practice. With more flexibility, I fulfil a long-held dream: to study diverse drumming styles with a world-class faculty. While performing for an Afro-Cuban masterclass in front of my classmates, I experience my first bout of stage fright. Anxious that I have not "internalized" the multilayered rhythm, cortisol floods my system, rendering me flush and stiff. Feeling exposed and foolish, I privately exhort myself, "Healer, heal thyself!"

To settle myself, I embrace my dual identity, drawing on my clinical skills to devise a framework for managing performance anxiety. As I explore feelings of inferiority, a common but disabling judgment that affects many performers, it is this struggle that gives me greater empathy for my patients. A few years later, I bridge my therapy and music worlds by leading performance-anxiety workshops at the Drummer's Collective, sharing my experience and teaching self-hypnosis to address hyperarousal and negative self-percepts.

Group conductor

Now performing regularly, I undertake analytic group training, inspired by years as a group therapist. The dynamic flow and interaction among group therapy members reminds me of the spirited and sometimes aversive tension in bands. The group "conductor," like a bandleader, provides scaffold and support so members can express themselves creatively and authentically.

During this time, an all-female rock band in crisis is referred to me; they are about to sign their first record contract. The referring clinician shares my alter-identity as rock drummer in an effort to encourage the reluctant participants. This provides me some unexpected street-cred, although my role as therapist is primary.

I readily empathize with the band's powerful transference reactions and vulnerabilities; the members are a surrogate family in need of repair. Familiar with the affective upheaval evoked in creative relationships, my personal experience serves as an emotional template from which to understand and offer constructive solutions. As Lankford (1997), in his memoir *Life in Double Time: Confessions of an American Drummer*, states:

Nothing is as unstable as a band. People must get along to play music. The slightest unresolved argument can wreck months of work. A band is a collection of volunteers and represents democracy in its purest form. This freedom to play is what makes the songs sound so lively.

(p. 40)

During months of consultation, we explore power struggles stirred by the challenging negotiation of producing an album. The high stakes dictated by a corporate recording contract heighten already complex dynamics. Two members of the trio have been lovers and now work as platonic co-writers. The third member, an emotionally sturdy bass player, serves as peacemaker, exasperated by her partners' unresolved tension. The drummer, though extraordinarily talented, is prone to dysregulation, ratchetting up the emotional tone of our meetings. In response to narcissistic injury, she explodes, but she allows me, her drummer-ally, to help her calm down and articulate her concerns more adaptively.

The explicit goal is for me to guide the members to set aside their differences, lose themselves in the music, and focus on the adjustments necessary to record a great album. I encourage direct expression of feelings, in a productive, non-accusatory fashion. Like a couples' therapist, I help modulate, soothe, and reframe heightened reactions. After three productive months, we end treatment with the group reporting greater emotional stability, grounded in the shared task of completing their first album.

As a vote of confidence in their therapeutic experience, the band refers another group to me: musicians who have just broken up and seek a reparative, final session with a therapist. I offer to help them express unresolved hurts to facilitate further resolution. As I welcome the colourful ex-bandmates into my office, the guitarist and I recognize each other from a gig we played together a year earlier. The group decides to proceed with me as their consultant despite the potential conflict and I lead them in what turns out to be a tearful outpouring of hurt and loss. In this poignant session, members articulate painful feelings about their rupture and decision to disband.

A musician's self-esteem is often intrinsically tied to artistic output and its reception. The act of creating music in a group can provide powerful psychic glue, replicating feelings of synchrony, but at other times, when creative differences arise, it can overwhelm and tear at the fabric of connection. Bandmates, like therapeutic partners, comprise a mutually influencing dynamic system, evoking heightened affective states with important relational meanings.

In both bands and therapy groups, conscious and unconscious processes can abound, often unacknowledged. Unresolved tensions can erode the safety needed to risk collaboration and ultimately contribute to a band's dissolution. As a member of my band, Homer Erotic, attests, "We didn't handle differences well. Tempers would go through the roof, egos would clash, and no one would be heard. We would feel silenced, squelched" (Ferguson, 2002, p. 277). It takes commitment by all members to secure the integrity of the group by working through conflict and, at other times, by surrendering to the larger group goal: the creative project.

Inspired by my encounters with band dynamics, as musician *and* therapist, I explore the application of group theory to musical groups for my final analytic group project. Finding few clinical reports on the dynamics of creative groups, I discover research on a large sample of successful string quartets (Murninghan & Conlon, 1991). The authors propose three organizational tensions – leadership versus democracy, lead versus second-fiddle status, and confrontation versus compromise – that, when managed productively, predict the group's cohesion and longevity. I explore how these paradoxical tensions apply to pop/rock groups by interviewing a number of New York City bands (Ferguson, 2002).

One finding congruent between the string quartets and the rock bands is the value in absorbing conflict, without direct discussion of differences, in order to solidify band cohesion, a marked contrast to the philosophy of group therapy. Kim Gordon (2015), in her memoir *Girl in a Band*, describes this dynamic: "A band almost defines dysfunction, except rather than explaining motivations or discussing anything, you play the music, acting out your issues via adrenalin" (p. 136). Emboldened by the intersection of my worlds, I present these salient issues at a *College Music Journal* (*CMJ*) conference with a panel of fellow arts-oriented mental health clinicians to an audience of rock musicians eager to discuss their collective struggles.

In the consulting room

Although I feel kindred with many of the young artists who fill my practice, I rarely disclose my dual identity, respecting their need for a non-intrusive listening presence. Late one evening, I am surprised to receive a tearful message from a patient: "Heather, was that you playing drums tonight? You must tell me so I don't think I am going crazy!" Addie and I have been working together for one year. She is a young singer-songwriter who stumbles into a Lower East Side club and witnesses my other life: drummer in an all-female rock band.

In treatment, Addie works diligently to address her substance use and purging behavior, signs of significant emotional dysregulation. She is aware of the impact of her unstable childhood, tossed between divorced, self-absorbed artist parents. More than anything, Addie hopes to actualize her dream of performing her songs in a New York City club.

Initially, I feel excited that Addie has discovered my "secret" life. I hope I can be a positive role model; one can make music while having a stable, multi-dimensional life. But my hope is dashed. She prefers the image of me sitting quietly in my office with close attention paid. In response, I keep my subjectivity on the back burner and encourage Addie's self-reflective process. She fears our bond will break with me in the transference role of preoccupied father or fragile mother.

I deeply empathize with Addie's internal conflict and her desire to connect with and differentiate from her artist father, having negotiated my own version of this dilemma. I encourage her to explore this complex issue to little avail. I imagine I am ahead of her, the twinship transference not yet mobilized. Shifting my stance

to follow Addie's lead, I come to recognize my primary analytic role: to provide a sturdy maternal holding experience sorely lacking in her early life as she served as emotional caretaker to both parents.

Addie shares her tender, well-crafted songs and actualizes her wish to record an album and to perform on a New York City stage. Triumphant, she takes on another risk: she moves to Europe to pursue music full-time. I wonder how our chance encounter contextualized our work. What remained unfinished or not yet composed? What did she see in me or in herself that fateful night? Did she deny or minimize competitive feelings, too dangerous to share? Was her departure a needed self-assertive, developmental striving?

In contrast, Sadie, a long-term patient, directly expresses curiosity about me and the workings of my mind as she carefully tracks my reactions. We meet in her last year of college as she struggles with dysthymic feelings, intensified by the deep alienation in her fragmented family. Sadie feels her self-worth diminish; unwanted child in her father's newly configured family and painfully invisible to her brittle mother. When her new family fails to celebrate her accomplishment upon graduation, I bring her flowers. Sadie sobs at my small gesture and the evident neglect in her family.

Six years later, in a stable relationship and blossoming career, Sadie excitedly shares her latest venture: piano player in an all-female country music band, resurrecting her childhood love of playing. She is improvising for the first time in music and life! Fortifying confidence in her musicianship and supporting her self-assertion, we carefully track her anxiety over establishing her place in the band, and I decide to share my own experience as a female musician. Sadie lights up, tearful and touched that I disclose this part of myself. She relishes the idea of fellow travelers. She then enthusiastically shares her first recording. For Sadie, sharing my story strengthens our therapeutic tie, offering a needed experience of twinship and modeling sorely lacking in her distant family.

Another college student, Andrew, a talented young jazz musician, is referred after a suicidal gesture in response to a romantic rejection. With him, my musical life remains in the background as I focus my attention on his immediate struggles. Disclosing my musical history might intrude on his unfolding journey. Socially awkward and romantically inexperienced, he is missing an emotional vocabulary. We focus on the development of affective regulation and greater tolerance for musical peers he perceives to be lacking in skill or purity of intent. Andrew's unrelenting perfectionism often causes intrapsychic and interpersonal conflict.

As our work progresses, Andrew expands his responses to the perceived limitations of others while understanding his singular devotion to music. Over detailed discussions about the jazz world, Andrew surmises that I have studied music. As I share with him resources to assist in his preparation for a national jazz competition, he appreciates my empathy for his self-criticism and his performance anxiety. Having recalibrated my earlier blindspots, my musical perspective – shared but different – softens Andrew's general mistrust of authority and adds to the unspoken understanding between us. When Andrew completes an album of original

compositions, it is particularly meaningful to us both when I attend his show as first-time bandleader.

Self-states as drummer and therapist

Listening, creating, and performing music can conjure powerful self-states providing the soundtrack for a particular moment. A song or musical composition can grab our attention and transport us back to a specific moment in time. When we hear a familiar or long-forgotten piece of music, an emotional association or a sense memory gets evoked. As Stern (2010) suggests, "Dynamic forms of vitality are part of episodic memories and give life to the narratives we create about our lives" (p. 11). In Sheffield's memoir, *Love Is a Mix Tape* (2007), he movingly describes songs as musical witness and memorial to who you were and what you were thinking at the time of listening – a slice of self-history.

I readily recall the flush of excitement and the rush of adrenalin as I enter a rehearsal room or ready for a performance and palpably connect to the anticipatory anxiety, exhilaration, and pleasure of playing together. Heart racing, limbs moving, and moist with sweat, I feel excitement as I lock eyes and converse with my fellow bandmates.

Sometimes described as the "driver of the bus," drummers carry the rhythm, maintain a steady tempo, and "keep the groove" by rhythmically supporting the other players. This role is not unlike an attuned therapist who provides emotional scaffolding so the patient can articulate her emotional experience, discover her creative voice, and take center stage.

Percussive accents add vitality and excitement that organize the phrasing of a passage and influence the song or musical form. In treatment, we might think of these moments of accentuation or surprise as "violations of expectation" (Lachmann, 2008). In stalled treatments, therapists often engage in creative strategies or unconscious enactments that awaken the dyad, infusing urgency into the treatment that perturbs or shakes up the expected flow.

"Vitality dynamics": emergent properties in music and therapeutic listening

After years of juggling my commitment as a therapist and a drummer for various groups, I take a break from band life, opening room for psychoanalytic training. My time spent dialoguing in a musical context expands my interest in the non-verbal, sub-symbolic, and sensate level of experiencing (Cornell, 2011). As a drummer, I attend to acoustic and non-verbal signals: a bodily gesture, a head nod, or an accentuation of a note or a phrase that provides a crucial prompt. In a micro-moment, I respond to the signal in a singer's movement or articulation.

Similarly, my eyes and ears are primed to pick up information from the vitality affects embedded in my patients' communications, including bodily signals that reverberate bi-directionally, often beyond conscious reflection. Knoblauch (2000)

aptly calls this non-conscious process "the musical edge of therapeutic dialogue." The meter, phrasing, and accentuation of words enlarge our sense of what is being communicated. This non-verbal dimension, with its acoustic qualities – what Stern (2010) calls "vitality dynamics" – adds shape to semantic meanings.

What is the feel or sound – tone, cadence, and rhythmicity – of a patient's language (Knoblauch, 2000; Ogden, 1999; Nebbiosi, 2016; Stern, 2010)? As Orfanos (2016) suggests: "What is analogized by music is the waxing and waning – the onsets, the peaks – that characterize the experience of many kinds of feelings" (p. 29). By listening to *how* the patient tells his or her story, we attune to the rhythmic patterns – accents and silences – the affective tone, and the musicality behind the words (Nebbiosi, 2016; Odgen, 1999). We feel our way into our patient's experience with all our senses, opening to *our* bodily and affective associations and reveries.

What are the arousal states evoked by *this* patient? Is my heart racing, my tummy tight, or my words rushing? With Addie, I notice overexcitement as my words rush, pressing forward for articulation, just ahead of the beat, a millisecond ahead of her experience. In these moments, when I become aware of my timing, I consciously slow down and ground myself to quiet my excitability, a parallel that I see in my own music-making. My overexuberance can push the tempo or rush the beat.

"Somatic awareness," as Cornell (2016) describes, is a therapeutic tool – a conscious intention to bring focus back to the analyst's body to further affective and bodily regulation. Nebbiosi (2016) offers an example of embodied attunement, miming his patient's rhythmicity, her movements and vocal patterns, in order to enter her phenomenological experience to regain an empathic foothold and creatively loosen an impasse.

Vitality affects are bi-directional as we "feel" our way into our patient's experience and they absorb our bodily communications. This two-way process of mutual regulation deepens empathic attunement and hopefully leads to a richer sense of "being with" the patient. The contemporary relational analyst is instructed to tune into *her* states of arousal by using *her* body as a resonating instrument to pick up affective signals about dissociated material or the interactive flow. Sletvold (2014) argues for "embodied intersubjectivity" as co-created arousal states lead to deep empathic resonance or, in moments of dyssynchrony, contribute to therapeutic derailments and misattunements. Fellow musician/psychotherapist Sapen (2012) describes a synchrony, or groove, between analyst and patient that can restore and offer healing by "means of the intersubjective rhythms of a holding relationship and its reverie" (p. 184).

Vitality forms are the emergent property of the interactive gestalt, what Shapiro et al. (2016) call the "acoustic field." Does the interaction feel dead, alive, muted, or flowing? Is there a sense of relational improvisation, a dialogic call and response? Can this patient play, "squiggle" (Winnicott, 1971), riff, or elaborate on themes or jointly constructed metaphors?

In playing music and doing therapy, we need to stop thinking and "feel" our way into the shared experience and let ourselves be swept away while remaining mindful and grounded in the here and now. As Lachmann (2001) writes:

Analyst and analysand are both performers and listeners, co-composing an analytic interlude to celebrate the unique individuality we prize: our dissonant natures, our chromatic emotions, and our atonal self-states. In the improvisational duet of analysis, faint voices get amplified, and blaring strident voices get muted, inner voices become themes, and themes modulate into other themes. Rhythms are shared and syncopated. Music emerges previously unheard in either participant.

(p. 177)

I have come to appreciate that rock music and psychoanalysis are both subversive activities that engage my "rock 'n' roll heart" (Clapton, 1983)! At their best, both enterprises question the status quo, push boundaries, and challenge the rules that constrict expressive freedom and liveliness.

Outro

After a hiatus, I recently return to performing and re-inhabit my younger drummer self. As I reflect on my initial attraction to percussion, its dynamic vitality, I realize I rejoin a band after the death of my parents, perhaps because I am grieving. Does drumming reanimate the episodic memories of my youth, the positive tie with my parents, offering a continuity of connection as I remember a life? Does it provide an antidote to aging now that I am a middle-aged mother to a teenage son, to whom I have passed on a love of music? Does it make past loss and future change more palpable? Physically and emotionally, the full-body engagement of drumming offers a welcome juxtaposition to the mental demands of life and clinical practice. Music and its promise of vitality offers a familiar embodied space – a perfect accompaniment to my rich life as a psychoanalyst.

References

Black, M. J. (2016). Making music together: Discussion of Gianni Nebbiosi's paper, "The Smell of Paper." *Psychoanalytic Dialogues, 26*(1), 17–25.

Clapton, E. (1983). I've got a rock 'n' roll heart. On *Money and cigarettes.* [album], Warner Brothers. (www.youtube.com/watch?v=bV2tH6QP2w0&list=RDbMiBbAvsFfY&index=3&nohtml5=False)

Cornell, W. (2011). Samba, tango, punk: Commentary on paper by Steven H. Knoblauch. *Psychoanalytic Dialogues, 1*(4), 428–436.

Cornell, W. (2016). *Somatic experiencing in psychoanalysis and psychotherapy.* New York: Routledge.

Ferguson, H. (2002). In search of bandhood: Consultation with original music groups. *Group, 26*(4), 267–282.

Gordon, K. (2015). *Girl in a band.* New York: HarperCollins.

Ipp, H. (2016). Interweaving the symbolic and nonsymbolic in therapeutic action: Discussion of Gianni Nebbiosi's "The Smell of Paper." *Psychoanalytic Dialogues, 26*(1), 10–16.

Knoblauch, S. (2000). *The musical edge of therapeutic dialogue.* New Jersey, NJ: The Analytic Press.

Knoblauch, S. (2011). Contextualizing attunement within the polyrhythmic weave: The psychoanalytic samba. *Psychoanalytic Dialogues, 21*(4), 414–427.

Knoblauch, S. (2015). A culturally constituted subjectivity: Musicality and beyond: A discussion of three offerings from Aron, Ralph, and White. *Psychoanalytic Dialogues, 25*(2), 201–207.

Lachmann, F. (2001). Chapter 14 words and music. In A. Goldberg (Ed.), *Progress in self psychology (Vol. 17)* (pp. 167–178). Hillsdale, NJ: The Analytic Press.

Lankford, M. (1997). *Life in double time: Confessions of an American drummer.* San Francisco, CA: Chronicle Books.

Murninghan, J. K., & Conlon, D. E. (1991). The dynamic of intense work groups: A study of British string quartets. *Administrative Science Quarterly, 36*, 165–186.

Nebbiosi, G. (2016). The smell of paper: On the usefulness of musical thought in psychoanalytic practice. *Psychoanalytic Dialogues, 26*(1), 1–9.

Nebbiosi, G., & Federici-Nebbiosi, S. (2008). In F. Sommer Anderson (Ed.), *Bodies in treatment* (pp. 231–233). New York: The Analytic Press.

Ogden, T. (1999). "The music of what happens" in poetry and psychoanalysis. *International Journal of Psychoanalysis, 80*(5), 979–994.

Orfanos, S. (2016). Nebbiosi's third: A discussion of Gianni Nebbiosi's "The Smell of Paper." *Psychoanalytic Dialogues, 26*(2), 26–31.

Sapen, D. (2012). *Freud's lost chord: Discovering jazz in the resonant psyche.* London: Karnac.

Shapiro, Y., Marks-Tarlow, T., & Fridman, J. (2016). Listening beneath the words: Parallel processes in music and psychotherapy. *IJP Open, 3*(21), 97–108.

Sheffield, R. (2007). *Love is a mix tape: Life and loss, one song at a time.* New York: Three Rivers Press.

Sletvold, J. (2014). *The embodied analyst: From Freud and Reich to relationality.* New York: Routledge.

Stern, D. N. (2010). *Forms of vitality exploring dynamic experience in psychology, the arts, psychotherapy, and development.* New York: Oxford University Press.

Winnicott, D. (1971). *Playing and reality.* New York: Routledge.

Discography

Null Set. (1980). *New job.* NSCAD Press.

Homer Erotic. (1998). *Yield.* Creme de la Femme.

Homer Erotic. (1999). *Homerica the beautiful.* Depth of Field. (Listen to tracks on: www.youtube.com/watch?v=143Dq_t3PRY and www.cdbaby.com/cd/homererotic2)

Went. (2001). *Parachute.* (Listen to tracks at: www.cdbaby.com/cd/went)

See Heather Ferguson drumming for The Balboans in 2012: https://vimeo.com/42464573.

7

WRITING, HEALING, AND BEING HEALED

My life in poetry and psychoanalysis

Lee Miriam Whitman-Raymond

One of my earliest memories is that of my father teaching me to write my name. I must have been three, since my parents divorced when I was four. I still remember sitting on his lap, bending over the paper on his desk while he traced out the letters: L-E-D-A. "That's you," he said, looking at me and pointing to the squiggles on the page. "That's your name." He passed me the pencil and I labored to construct the letters just under his. "You!" he said triumphantly. And I felt a heady joy and recognition throughout my body – I am seen! I am me!

The twin passions of my life, language and relationships, are embedded in this memory. There was a feeling of discovery that I find occurs over and over when I read certain poems or novels. The intensity of seeing into another human being is also realized in the process of therapy, when I am privileged to explore another's life experience and perhaps to help them "write their names" on their own lives.

As a little girl, growing up among writers and academics, I was writing poetry from the time I was four. It wasn't a self-conscious act, at least as I remember it, but a need to put something in the world that wasn't there, to say something that needed to be said. I can remember having my stories read aloud in class in Second Grade. Language could connect me to others, and gave me a bit of sorely needed kudos with the other kids. I wrote a story about God when I was 11 and decided to give Him an Irish brogue and a mischievous sense of humor. I remember the startled laugh from my father when I read it to him.

Here is a poem I wrote at 11 which was printed in the *Boston Globe* – my first publication:

> **The Mirror**
> I looked in a picture.
> I smiled.
> Strangely, she smiled back.

I offered my hand,
she gave me her left.
I looked behind the picture.
She was gone.

At this point in my life, there was no question of "wanting" to be a writer. Writing was in me, of me, a command that organized my often chaotic childhood experiences. Moreover, everyone in my family (there were many stepparents) was a writer or an artist of some type. So while I didn't even think about my writing, so intrinsic was that form of expression for me, I yearned to be a musician. Music was the art that spoke to me most deeply and passionately, and I tried very hard to learn piano while my sister took ballet, and my brother proved gifted at both writing and music.

At the same time, there were many puzzling and frightening events in my culturally enriched childhood. These episodes and behaviors pulled equally on my anxiety and empathy. My father had undiagnosed bipolar disorder and self-medicated with alcohol. My mother suffered from a fragile sense of self, and was prone to unpredictable rages and erratic behavior. I had two stepfathers, one of whom was alcoholic, and both of whom could be quite abusive. I also had a stepmother whom I adored (she had been my babysitter before marrying my father, her professor). She suffered from juvenile diabetes back in the 1950s. Several times in my childhood I can remember finding her close to a diabetic coma on the floor of the kitchen she shared with my father. Each time she was able to tell me to get her some juice, which helped, and then begged me not to tell my father, who would be very angry. I kept that promise, but worried about it incessantly, especially at night.

I felt in prison when my father left for Greece when I was five, taking my babysitter – his new wife – with him. I was alone with my deeply preoccupied mother, my dissociated sister, a sense of aloneness and lack of connection that nearly drove me to madness. The birth of my younger brother when I was six and my mother's newly enlivened sense around him only reinforced my isolation – and my sense of defectiveness.

This psychic cell was walled in by my loss of connection, by an inability to predict how or whether others would respond. From nine on, I spent increasing amounts of time in "unreality" – my term for the depersonalization and derealization I experienced – as the chaos and periodic traumas of childhood continued. I broke out of this terrible imprisonment when I read Deutsch as a 12-year-old. Although I understood little of the theories, the case histories were as strange and fraught with pain as I felt my own family to be. And yet there were words and ideas to encompass, to explain these difficulties. Words, then, saved me. My reading of Deutsch was followed by Freud, Szasz, and Laing. Suddenly everything had a name, even the terrible atomization I had been experiencing since I was nine: depersonalization. I kept the books under my bed, and told no one of my psychological odyssey. I was burrowing out the underground tunnel to freedom! I analyzed everyone mercilessly, and kept discovering the accuracy of the theories I was trying to master. Almost immediately

the periods of unreality stopped, and when I learned the words for these phenomena, my joy knew no bounds. I was not trapped in my aloneness after all.

With this new-found perspective and the certainty of youth, I determined that artists of all types were narcissists unable to respond to the needs of others. I would not be like my parents and their cronies; I would help to heal the suffering of the world. Art was simply a frivolous pursuit in the face of all the pain I saw in and around me. I became drawn to the underdogs of life. At 14 I began volunteering for Headstart, and at 16 I was volunteering at McLean Hospital. I also canvassed for Eugene McCarthy. These excursions into the world of social injustice, inequity, and mental illness were more painful than joyous – yet transfixing and absorbing, nonetheless.

Still, I never stopped writing. As a teenager and a young adult, I continued to write poems. I often woke in the middle of the night to write poems that had been buried all day. Here is one I wrote when my first therapist died, when I was 21:

Intransitive
Breath turns in the throat,
words turn on the tongue,
I suffer to utter the brave
you are

 come down from the mountain,
the dark German hills, with a skin
as soft and pink as old dust. Your secret name
I discover is Peach.

A twitch of five fingers and sidelong glance.
The pupils contract, remembering light.
The lip will thin, words turn in the skull,
the tongue stutter a slow
he was.

Both of my parents were poets, though my father was first and foremost an academic. Each was highly critical of me as a writer, but for my father, at least, there was also some pride in my abilities. He assumed I would be a writer of some sort, probably an academic like himself. During a very painful period of my teens and early 20s, I tried to tell him how drawn I was to helping others, and that I really, really liked psychology. His response to this was very negative: "You want to work with the Great Unwashed?" he demanded at one (probably inebriated) point. His quarrel with psychology was partly intellectual: he disagreed with what he had read of Freud's drive theory, and was not familiar with many of the theorists I was reading. But, too, I think psychotherapy cut too close to the bone for him: it was the reason he gave for my mother's divorcing him, and I think he felt it was a dangerous enterprise (as, indeed, it is). After two years at Northwestern University, I had to declare my major, and I knew my father would be very angry to hear I wanted to

be a psychologist. To mask my ambition, I tried to be premed, thinking eventually I would become a psychiatrist and a psychoanalyst. But I could not comprehend the mysteries of organic chemistry, and so my plan was foiled. I secretly applied to Clark University, which gave me a full tuition scholarship. Then I confessed to my father that I was transferring, and that I was, in fact, declaring myself a psych major. As I had feared, the fallout was pretty bad: he refused to help pay for tuition and strongly disapproved of my choice. He no longer carried my phone number and address in his address book, and the dialogue between us when I visited was very strained.

Perhaps in part because of his reaction, I kept the two career paths quite separate in my own mind as well. I did not like psycho-biographies, which explained people's writings as being "because of" their sexual orientation or other private aspects of themselves. I felt the literary lens was much more accurate for seeing into people's psyches than the psychological one. Tolstoy to me was the greatest psychologist I had ever read, and the nuances of his characters became a goal for me in trying to capture the fullness of another as I worked with clients in therapy. I think in both my writing and my practice, I tried to see the subject – or the client – through the literary lens, which I trusted (like my father) more than the psychological lens I had been exposed to. It wasn't until I finally had direct experience of psychoanalytic material, through my own analyses and through supervision, that I had a kind of explosion of creativity and integration of my clinical and creative writing.

When I fell seriously in love at 24, I began to allow myself to write more poetry. I think it helped that I was on the career path to becoming a psychotherapist. But also the experience of a rich and reciprocated love allowed me to be less rigid with myself, especially those parts of myself that I had first prized so highly and then disavowed. Here is a poem from that period:

The Body
He lies before her like a prayer.
She kisses his eye, his finger.
His heart begins to break, pours out
milk or honey. She licks his wound,
they are both the mother.
The body speaks in tongues.

(Whitman-Raymond, 1978)

I planned for my MSW to fund my writing aspirations. Early on, I hoped to be a good therapist and a great writer. As I was drawn into the work with clients and exposed to clinical and technical aspects of therapies, my ambitions shifted to wanting to be a top-drawer therapist – that is, someone who actually helped people to transform their relationships with their selves and with their world. My ambitions did not take the form of craving adulation and fame as my mother did; I saw how she suffered from not being as famous as her colleagues and I did not want to live a life of unmet needs and frustrations. Moreover, I have always felt quite private about my writing, and, as we know, therapy itself is a very private endeavor.

Though I went to graduate school in social work excited to join the ranks of helpers, I soon found my classes boring and my placements overwhelming. My courses seemed overly simplistic (though I appreciate the wisdom of people like Perlman much more now), and no match for the level of suffering around me that I believed I was there to alleviate. Like many of us, when I went to graduate school, I hid so many aspects of myself, it was small wonder I found the experience boring. I certainly didn't dare to come out as a poet. Indeed, I made up a fake genogram rather than reveal the complexities and dysfunction of my family tree which I feared might push me out of the program. In my second-year internship, I was on the NICU at Boston Children's Hospital as well as a pediatric oncology unit. At times, suffused with sadness and outrage, I would bolt out of the hospital on my lunch hour and dash over to the Museum of Fine Arts where I comforted myself by gazing at the rosy Renoir children who were reading, or playing in meadows near their placid parents. These tableaux of health and beauty restored a sense of rightness in the world, and gave me some courage to return to the hospital ward.

At 28, it was not lost on me that the same art I had rejected as irrelevant was in fact buoying me up to do work I could otherwise barely tolerate. In my first job as a school social worker, I added "arts" into the substantially separate classroom I ran with a special education teacher. We made puppets and acted out plays that the kids wrote. Though I had some success in helping the students back to mainstreamed classrooms and to more stability, I continued to feel deeply out of place as a social worker. I didn't yet feel I had the chops to be a psychotherapist (and psychoanalysis was not even an option then for those of us with MSW degrees). But I remember the vivid pleasure the students I worked with and myself felt at putting on "plays" for which they had designed the sets, the puppets, and the scripts. One very disturbed little boy had a "play" in which he, the egg, was sat on by me, the mama puppet, silently for a long minute. Then he arose, shrieking with joy. It felt like he was asking to be reborn, and I was providing a way for that to happen metaphorically, reaching a state that he could never have experienced in a face-to-face discussion.

Secretly, of course, I still thought of myself as a writer. I had always been in writing workshops – some wonderful, some not so great, but always there was a feeling of shared commitment toward making each poem as good as the group could make it. But at a certain point, I felt that the workshops were not actually helping me to grow, and as I felt myself demoralized by the school social work setting in which I worked, I longed to have the freedom to take writing more seriously. After two years of being a school social worker, I applied to Brown University's MFA program and was accepted with a fellowship. Those two years at Brown were deeply satisfying, as I learned more of the craft of making poems, found a community of writers, and read as widely as I could.

My experiences earning the MFA at Brown were complex. Most of the students were in their early 20s, fresh from undergraduate programs. I was 30, and became a mother in graduate school. Influenced as I was by Roethke, Sexton, Plath, and Snodgrass, I tended to write rather straightforward lyrics, which tried to grapple with the difficulties of being alive and feelingful. Many, if not most, of the

others in my class were influenced by Ashbery and Forche and wrote pieces that were influenced by the so-called "language" poets. Despite these gaps between our experiences, there was real camaraderie between us all in the workshop, and most of us had the capacity to enjoy each other's writing. There was some good-natured parodying of one another, and I remember a day we all decided to wear sunglasses, mimicking Michael Harper's eyewear during class. I also sent poems out to be published. Here is a poem from when I first realized I was pregnant at 29:

> **Quickening**
> just a hunch, really
>
> a handful of pebbles
> > shivers open the pond
>
> one thrush fluting at first light
>
> a lot of little leaves
> > rustling
> > > *(Whitman-Raymond, 1985)*

At the same time, I also began to do fee-for-service psychotherapy. My husband had been accepted to graduate school in social work, and I needed to earn some money to help with all the expense. Fee-for-service work introduced me to therapists in private practice and gave me the idea to return for more training. I studied gestalt therapy, narrative therapy, and self psychology, each of which gave me tools to work with in my new job. And at last I began to see substantial results of working with clients in psychotherapy. The greater my own psychoanalytic understanding, the more effective I saw I became. Psychoanalysis, which I had first studied alone at 12, and then in undergraduate classes at Clark, now became a key to open the creative and metaphorical aspects of therapy even further for me. Not long ago a patient accused me, only partly joking, of enjoying her dreams more than she did!

When I first began to write about my experiences in therapy, it was at a time that was personally very difficult for me. Conflicts in my family of origin, the birth of my first child, and my husband's depression had returned me to familiar isolation. In that context, I began working with a client who had been rejected by her former therapist for "lying" about her continued use of drugs. I suspect we both were experiencing some feelings of rejection at the time, as she used to call our treatment office the "[therapist's name] Memorial Therapy Office." I loved her humor, her sarcasm, her defiance. I sensed her tremendous vulnerability (as I did not yet acknowledge my own) and wanted very desperately to help her. One day, as I was driving back from work, I began to hear a poem in my head – about her. As I had when a teenager, I fought against the impulse to write the poem. It was intimate, a love poem, and I was frightened by my own feelings. I wondered if I might be breaching a boundary with her by even writing the poem. Nevertheless, the poem

took shape, almost against my wishes. I did not write it down for several days, but watched myself editing it in my mind, to make it as tight as possible. Finally, I wrote it down. Here it is:

Your heavy eyebrows

your speckled hair
 pulled back tight

your wide cheekbones
your missing tooth

your thin wrists jutting
 from your sleeve cuffs

your bitten nails

your grunt of surprise
your sudden stare

your body leaning out to me

As I thought about this poem, I wondered what made it so powerful, so important to me that I had to write it down. I had been reading Petrarch's *Scattered Rhymes,* which I adored, as a sumptuous display of unrequited love and gorgeous lyrics. The poems are intricately crafted sonnets, ballads, and other forms. It is fascinating to me that Petrarch chose to write in the vernacular, which, to me, is much more of this world than the Christian high-minded writing of Latin poets (just as Dante chose to write in the vernacular). In a way, this spoke not only to my interest in plain-speaking poets like Yeats, Roethke, and Frost, but also to my preference for the "real life" of working with people rather than the academic life my father had wanted for me. Yet it is also deeply spiritual and even mystical at times. Wikipedia reports:

> The central theme in the *Canzoniere* is the love for Laura, with whom Petrarch fell in love at first sight. Laura was already married and turned down all of Petrarch's advances. It is unknown if the two ever spoke. They met on Good Friday and Laura allegedly died on Good Friday. Laura, of course, recalls the Roman goddess Laurus, the goddess of poetry. This leads on to the essential paradox of Petrarchan love, where love is desired yet painful: fluctuation between states is a means of expressing this instability. The changing mind of man and the passing of time are also central themes, as is the consideration of the art of poetic creation itself. Some other themes are desire, isolation, unrequited love, and vanity of youth.
>
> *(Wikipedia, n.d.)*

I seemed to be writing the very opposite: a celebration of a woman with heavy eyebrows, bitten nails, not elegantly coiffed, but poor, unself-conscious, struggling. Moreover, as I thought about it, I didn't really subscribe to the idea of spending one's entire life in a passionate embrace with the idea of a woman. I wanted a woman who spoke back. I began to wonder about the idea of writing a poem that was a dialogue – certainly a trope that has been used successfully. But in this case, it would be within the confines of the therapy relationship. And just like the mores of courtly love, there were clear and firm boundaries to the love and intimacy we might achieve. There is to be no touch, no consummation in therapy. Whatever is felt may – or must – be expressed, but for the purpose of greater understanding and development of the patient. Thus, the therapist is a devoted knight, committed to delivering the patient from her destructive and self-destructive pain, not attending to (his) own needs first or even reciprocally.

I'm not sure I thought of all of this then; it was more that I knew I had found a foil in Petrarch against which to write my own poems. With increasing daring, I wrote about this client, and others who moved me deeply. I was developing what I thought of as a feminist dialogue in which both voices could be heard, each could influence the other, though in very different ways, and there could be some sense of really knowing between the two – knowing that would sustain and enrich both patient and therapist.

One of the ways I managed the deep feelings I was having as I wrote these poems was to work on copying some of the Petrarchan forms I admired so much. Since English is not conducive to many of the forms he used, I also tried to make use of English forms (sonnets and couplets), to suggest closeness, and a variety of rhythms and line breaks to suggest conflict and alienation. I think my attention to mastering these forms helped me to keep boundaries in my thinking about the project as well as in the actual treatment of clients.

By this time, I was engaged in a much deeper form of psychotherapy myself. I knew that what was lacking in the long poem was the client's experience of therapy as transforming. I had witnessed this more from the vantage point of therapist than client. But in my two analyses, I began to feel the deep connection, intimacy, risk, and exposure that were already beginning to happen in the therapy I was conduct-ing. This opened me up to writing stronger poems from both the client's and the therapist's position. Now I was truly excited by the prospect of having a unique work of art, which was also a document of an analysis – not exactly mine, but certainly of experiences I had either as the client or the therapist.

At the same time, I worried a lot about breaking client confidentiality, about the ethics of this sort of writing. I sent a copy to Adrienne Rich, who responded nega-tively, not about the quality of the work but about the idea that I was co-opting the client's voice. I think she may have assumed that the client was of color, as I tried to use my client's urban ways of speaking.

I was very disheartened by her reply. I turned to my advisor from Brown, Michael Harper, who had supported the idea of my dialogue and read many of the early poems. Unlike Rich, he felt the writer had not only a right but an obligation to

imagine what wasn't known and that the value of the work should not be gauged by the color of the writer's skin, or her gender.

I think the difference between Rich's point of view and Harper's perspectives is that the former considered it her moral duty to impose a political agenda onto her great lyric gifts. Like other feminist writers of that time, she suspected language itself of patriarchal concepts and wanted to strip it of its seductive lyrical qualities, which were seen as co-optations of true feminism. My long poem, a dialogue between therapist and patient, was seen as a dangerous piece of writing, in which I imposed my voice onto that of my client and thus exploited and betrayed her. I was devastated by this response, as I thought I had written something that allowed the voice of the other to also be heard in all its complexity. Was I not allowed to speak in that voice, even if I shared that role (as patient) through most of my adulthood? Old feelings from my mother's criticism of my work left me feeling stunned and silenced.

Harper, on the other hand, saw my idea for dialogue in poetry as an exciting new step away from more insular writing into something more complex and emotionally rich. I don't think he assumed that the patient's voice was a person of color – as he is – but I'm not sure he would have cared, either. I remember him insisting that all poetry was political and to force it to espouse some specific cause was a kind of perversion. He admired Bishop's use of vernacular, and had no set of rules for what a writer might imagine or write. "Listen to what the poem wants" was his main admonishment to us.

Now I can see value to each of these points of view. But for me, damaged as I felt by my parents' critiques of me and my writing, I needed Harper's inclusive and accepting attitude to flourish.

Despite my doubts, I continued with the writing of this long poem. At times, I very much wanted to show the poems to the clients who had inspired them, and once or twice I did do so. I did so gingerly, and with supervision, always aware that I was complicating already complicated relationships. There were no disastrous outcomes. But after a couple of these experiences, I wondered if I was looking for too much gratification from my clients, and also if I somehow magically thought that my words could heal them. For these reasons, I stopped that practice. I did and do, however, introduce poems occasionally into my work with clients, if I think it might be useful. For a woman who had a tremendous grief reaction to having an abortion, I gave her the poem "The Mother" by Gwendolyn Brooks. Robert Burns' "To a Mousie" is a wonderful poem for those who obsess fearfully on the future. So I suppose there are many ways of allowing the words of another to help with the healing process. The beauty of using others' voices is that the transference/counter-transference is not so charged, so that the actual words can come through to the patient.

Though I had been in therapy of one kind or another most of my adult life, it was only after I began my own analysis that the connections between writing, healing, and being healed deepened immeasurably. As I think about this now, I suspect that it was not only the wonderful experience of having an analyst who loved music and poetry so much, but also a sense that he could be a psychic protector against the part of me that feared becoming like my parents and, in equal part, feared retribution

from my mother. My mother was always extremely jealous of my abilities (though she herself was a gifted poet) and found insidious ways to undermine my confidence. For instance, she would say, "That is almost good enough. But you're not ready to send anything out yet." Even after I won first prize from the Academy of American Poets for my manuscript, she maintained that I hadn't matured enough to publish. I wish I hadn't taken her advice. But it took a lot of therapy to realize that she was undermining under the guise of supporting.

Despite these internal conflicts, I continued to write and to publish fairly regularly, and even won some prizes. In 1990, at 36, I gave birth to my second child, Rebecca. When I was 40, she was diagnosed with significant developmental delays. At this point, my grip on writing projects began to slip away. The stress of trying to help Becky get what she needed, without completely ignoring my eldest daughter, became my greatest calling. After that was my work as a therapist, which not only helped to pay our bills, but also stabilized me as someone who could still offer something of use to the world.

I believe in this period I felt that Becky was my "bad poem," the thing I had made that was wrong in the eyes of the world. I was wracked with guilt about her problems. Miraculously, I was not only bonded to her, but somewhat besotted with her, as I was with her older sister. My time with her was painful, but also wonderful, as I learned how to reach her, first utterly non-verbally, by eye contact and touch, and then gradually through words. This consumed an enormous amount of creative energy. I also felt, as I had as a teenager, that I had no right to write my own ideas when someone, now my own child, was lagging in the world. Moreover, I was older and more tired, and didn't want to get up in the middle of the night to write poems – though I often got up with Becky at 4am, when she rose for the day.

Eventually, Becky stabilized, and our family began to heal from the enormous pain that we had all experienced. I began a part-time PhD program at Simmons, and also an analysis, eager to return to the world of ideas and language. My first analysis was a disaster, as the analyst became ill early on with Pick's Disease, and died shortly after I began working with my second analyst. But the first analysis gave me the opportunity to write poems from a position of alienation and anomie, as well as to document some of the less helpful interventions of the psychoanalyst. I began to form an idea of creating a poetic dialogue between therapist and patient but not of their actual words so much as their internal experiences of one another and themselves. I could perhaps record the arc of an analysis, and how each party might be changed by it.

The project tightened as I now had deeper insights into the experiences of both parties, and I was eager to create not only a work of strong poetic beauty, but also a work that would capture the deep vulnerabilities of the dyad as they engage in the arduous work of healing one of them. I still remember the deep pleasure I had when my second analyst read the work and exclaimed, "But this is a document!" He championed the work when I was unsure whether it was too personal or too revealing. A lover of poetry himself, he gave me that experience I had had with my father learning to write my name – that I mattered, and that writing was a shared

enterprise. After his death in 2010, I wrote this poem for him. Once again, I think I was trying to fill a space, this time that he left empty.

(missing)
your slate eyes your
voice, soft gravel under a wheel
your mouth wide and lovely when
you smiled.

Each afternoon we blew
air back and forth as we discussed what
seemed so crucial. But truly, was our breath not
entering each other's nostrils, exchanging our molecules?
Did not those atoms meet
between our two chairs, grapple and embrace
merging into palpable heat,

not like poetry
always fading to a single
note, but here
and there bits of you speckling
my cells, multiplying within me?

How your hand came up when
the words failed. How we sat silently staring
after the poem made so much trouble. Breathing
together is what saved us, what saves you now
from death is me, curating each breath
you blew into my lungs.

My book was published in 2000 and I was lucky to be able to put a copy of it into my analyst's hand. He was very generous and pleased for me, despite already being quite ill. Colleagues and even people I didn't know responded well to the book once it was published. But I did not get the recognition I had hoped for in the psychological world. A friend and colleague of mine loved the work, and encouraged me to send it to the book reviewer at APA. I did so, and received a baffling reply. Despite my reassurances in the introduction to the book and in my email to him that this was a composite patient and therapist, he insisted that it felt too revealing of a client and that it was too revealing of a particular therapy. He refused to even review the book. Here is what I wrote to him about the work, hoping to persuade him to be open to it:

So, toward a discussion of your concerns: I must say, I also felt an odd kind of pleasure in your worry that the analyst is too enthralled with the patient's

voice. In all seriousness, this work is an amalgam of myself and various patients as the patient, and myself and two analysts as the analyst. So the idea that the patient's voice has enough internal coherence for you to be worried about makes me feel hopeful that the work is, in that way at least, a success.

In fact, I hope that what I reveal is a kind of interaction between two people in deep intimacy, in the safety of real boundaries and a therapeutic framework, exploring each other and themselves, and both changing. We write about patients all the time. This, however, is a different structure, as it is an attempt to have both voices – internally – reflect upon their impact on each other's lives. It reminds me a bit of how I first discovered psychological writing, taking a volume of Hélène Deutsch down from my mother's book-case, and becoming fascinated with the vignettes. In a way, these poems are like the vignettes, sans lit review or discussion, and, once again, with the two voices available to the reader in an immediate way. I think in this way it's kind of a new genre and that is always uncomfortable when we first confront it.

I worked hard on making a narrative of the analysis: that initially the two don't know or understand each other. The patient in particular becomes increasingly detached and self-destructive as she recalls painful memories of her childhood and doubts her own lovability. This precipitates the drug over-dose. After that episode, and the analyst's willingness to allow the patient into his/her being, as a child or even a baby in the womb (*Vigil*), the transference/countertransference heats up quite a bit. By the end of the series, I hope that the patient's voice has become stronger, and she now has two poems for every one of the therapist's. As it should be in life, she is learning to speak for herself.

This is not to say that I haven't worried over the ethics of publishing the work. In truth, when the first poem came to me ("Your heavy eyebrows"), I remember resisting it strongly, and finally writing it down just to get it out of my head. I then got me to a supervisor rapidly to talk about my coun-tertransference and that case in more detail. My first commitment was and always is to the safety and well-being of my patients. And my attention to that led me to my PhD, my own analysis, and my training. All throughout these years, poems have come to me about different points of treatment with dif-ferent patients and analysts, relationships, and what I believe is the mutuality (however asymmetrical) of change.

I have been much encouraged by friends, my supervisor, and my analyst to present the relational experience of therapy as I understand it, in the poetic meditations of each member of the pair. It seems to me that if I have been faithful to that experience, without identifying anyone in particular (other than myself), then the work may be helpful and moving to some others, patients and analysts. You have the opportunity to invite therapists and ana-lysts to consider their own feelings about what we do as it is presented in an artistic, immediate form. My hope is that this can be a way of expanding our perspectives on what we do, and the impact on our patients – and ourselves.

I did not receive a reply. I felt my book had been mistaken for a blackbird by parrots and as a parrot by blackbirds. As someone who lives in two different worlds, engaging both poetry and psychoanalytic process, it seems at times I offended the sensibilities of those in either world. Also, I was not good at marketing and, as part of a small literary press, this was part of my job. I was invited to give a talk about the book at the Rhode Island Association for Psychoanalytic Psychology, in which we read and discussed the poems as a way of understanding the development of a treatment. That was truly one of the most wonderful evenings of my life. Also, one of my professors at Simmons used the book in her advanced clinical class to help students understand the difficulties of an analytic therapy, and had me come and speak about this each year until she retired.

Since the second edition of the book *The Light on Our Faces and Other Poems* came out in 2009, I have felt a distance between myself and my own poetry. Always eager to read poems, I don't feel the same confidence to write, and I rarely hear that insistent little voice in my head which used to drive me to writing. I don't know how much this is a function of aging, of having a more realistic appraisal of my gifts, or of the very real disappointment I felt at not being received more openly in the psychoanalytic world. Perhaps it was the loss of my analyst/protector in February 2010 that has made me far more hesitant to believe in the value of what I am doing.

My current project is a prose piece, but, like *The Light on Our Faces*, it is a book that fills a space in the world. It is the story of raising my second daughter, who has significant developmental disabilities. It is told in three voices: my own, my eldest daughter's, and my husband's, as we each grapple with the strangeness and deep human-ness that is Rebecca. I hope to include Becky's voice as well, in the telling of our story. The project began as a series of vignettes that my eldest daughter Jessica (who is also a writer and poet) wrote while she lived in England for a time. She called the series *Where's Becky?* after the many times one of us would ask that question because the house had gone too quiet, and Becky was up to no good. After a time, she invited her father and me to write vignettes as well. I feel it is a worthy enterprise, and I am excited by the collection of differing voices in the work. I continue to be compelled by this lifelong challenge of integrating elements of my own psychological experiences in life and my artistic voice. I hope that these twin passions will be realized in a new form in *Where's Becky?*

I notice that in my work as a therapist, I sometimes feel the presence of a deep aesthetic unfolding in the hour. It is as though the patient and I are co-creating a kind of poem that is beautiful in itself (the patient being heard, perhaps) and also suggests an opening into another kind of thinking/feeling yet to be explored. Of course, this is a somewhat mysterious process to me. It often happens when I work with patients who are artists, who use metaphor freely, and whose language I begin to learn. The danger here for me is that I begin to wish for each session to follow a kind of aesthetic form, and I have to watch out not to foreclose on the unclear and unformed parts of the conversation. In the same way, it occurs to me now that I need to approach my own writing with that same curiosity and openness.

Transitioning from one kind of work to another is excruciating. Writing requires silence, solitude, and a sense of free psychic space around. Psychotherapy is, for me, an exercise in partially inhabiting the other person's experience and then returning to myself in order to consider and evaluate that experience with a view to what might further his or her self-development. They are both extremely creative, in the sense that I am engaged with something that I both passionately want to take shape and, at the same time, often have little clue how it will evolve in the moment. Both require a development of craft, and a willingness to forego craft in the interest of following an unknown path. Indeed, I think both my best poems and my best sessions come out of a deep sense of not knowing what is next, and yearning for a kind of truthful or viscerally real experience to present itself to me (or us).

I will close with an excerpt from my sequence of poems "The light on our faces" and the introduction.

These poems have been with me for the last 23 years. They represent the thoughts, inspiration, and deep feelings engendered by psychotherapy, both as a patient and as a psychoanalytic psychotherapist. The poems were originally inspired by Petrarch's *Scattered Rhymes*, which I deeply admire. But I wanted, both as a feminist and as an artist, to have the Muse – Maura – speak and develop her own poetic voice.

The following sequence of poems attempts to embody the power of language to touch, to change, to harm, and to heal. Begun before intersubjectivity had become current in psychoanalytic circles, it expresses the powerful interplay between two people and the ways each of them are changed in the process of intimate healing.

Despite the ethical risks inherent in such an endeavor, I believe the therapeutic relationship, as one of the most deeply humanistic relationships left in our postmodern world, deserves to be written about. Although I am inspired by many patients' struggles and courage in the face of great pain, the words here are those of an imagined therapist and patient. I have tried to write about the engagement of words between two people, in which both have the chance to change.

> Hidden beauty is sweetest . . .
> Where I most sorrowed, another sorrows,
> and by sorrowing makes sweet my sorrow
> > *(Petrarch,* Scattered Rhymes, *#216 in Durling, 1976)*

> ★ ★ ★

> [The italicized voice is that of the patient.]

> Finding you

> *When a baby girl doesn't get tenderness*
> *from her mama's hands and voice*
> *she learns to hit back*
> *grab her bread*
> *turn away from the ones she needs.*

You grew up fast,
ponytail pulled the softness
right back with a rubber band

you don't smile
you talk tough
say Later Babe
for Please don't go
swaggering out every door I open
big in the shoulder and under the jaw.

By the time I find you
you're under a pile of snow
nodding out and frozen
stiff
saying Hey what happnin
pretending you're not scared
your life's stepping out of you
like a long shadow.

When I find you
I want to be warm hands
but all I have is the voice
say Wait up
say Slow down
say Turn around
Maura.

When the tenderness touches you
the brash goes right out of your voice,
you look away
touch the plant growing to your left
check me with a quick glance,
say
 Unnh
real soft.

Who's he

suited up and tight
long limbed under the candy clothes
moves like a panther from waiting room
to office, but twitches when he sits

smiles like he knows me
asking and asking
what about the coke,
what I'm gonna do

like I know what I'm gonna do.
His eyes, brown like mine,
hurt to look in.

Your heavy eyebrows

your speckled hair

 pulled back tight

your wide cheekbones
your missing tooth

your thin wrists jutting

 from your sleeve cuffs

your bitten nails

your grunt of surprise
your sudden stare

your body leaning out to me

Early today

so I'm out in the woods behind his house.
Weird not to hear the wheeze
of cars and the sirens
to do my screaming for me.
Pine trees loom like crazy phone poles
over my head, while the sun is big
and red as a drop of blood
coming up over his roof.
Haven't seen this much grass
since before Dad left, since before
Depot Street. How does he stand
the silence?

Maura, your voice

beats on me like wings,
or the thick black raindrops
of a sudden storm.

Where are you now? What
are you thinking? You cup
your face in one hand,

flash that cockeyed grin
and answer, Nothin, except,
if I put on the bearskin

and dance with bears
who knows? maybe someday
I'll be a bear.

Leaves like hands

tap the clapboard outside.
Inside, on the third floor
our words hang

balloon in the stillness, your voice so soft
I feel a lurch in my gut. Why is that? you whisper.

The elm outside twists
her frantic mime: she shakes her arms,
flings gusts of leaves on the pane.

Driving away from your lamplit room,
my hand on the wheel remembers the grip of yours,

my truck brushes yellow black oak leaves,
the trembling palms of the maples.

Ode on Gus

Today I'm picking his fur
out of my rug, hairs long enough
for a woman's curled into the beige pile
in my office, the palace of healing.

On hands and knees I extract
what's left of him, remembering

his single sharp bark
bringing Maura off the couch
and on her knees where I am now.
She stroked him with long elegant pulls,
smiling awkwardly and calling him
love names, her cold hands vanishing
in his fur. He let his head loll back,
allowed her to rub his wolf ears and chin.

One time he backed under the couch
staring with narrowed yellow gaze,
I thought Hellhound and was afraid.
Now I think he knew his time was up,

while Maura, faltering, smiling,
recalled another day ten years ago
when she spoke of missing the voices
of aunts and uncles, of her father, long gone.
Could I help with that? The longing
to hear those voices again?

It was that afternoon or the next,
or maybe it's only today I decide
I will give up treatment planning, scientific technique,
all my big ideas. I will be commanded
by the sharp cry to listen, to remember,
kneeling, in a way, until our time is up.

Wishes

When my words spill out,
wingless wishes darken the room.
The doctor says he is listening
but I see a milkweed pod
trodden on the path
split shamelessly open.
Oh there was silk there once,
a million winged wishes spinning up
light as a breath.
In my mind I'm running down the path

away from this sealed room where sound
is always muted, white noise hissing
so my wishes don't get mixed up
with the three o'clock's.
I'm back in his meadow, watching a late Monarch
butterfly, as she hangs upside down from a purple
thistle, drinking nectar. I can see
her tiny black lips working,
her wings slowly folding and unfolding,
before the winter chill. I begin to be again,
until I think I hear the doctor say
mourn your wishes.
Could that be right? Does it matter now?
Since anyway it's time to go
to the real meadow and find
the milk pod grounded, the dying butterfly,
the crickets making their own white noise.
Where is there to go where a hollow wind
doesn't sweep my words away? I must give them back
to the doctor. Wish. Dream. Longing.
Here, they are yours.

M'aura

okay, a breeze tonight
of sorts, but not
Zephyr's cooling breath, hell
no
a hot wind

slaps along my chest, my
arms:
I lie empty-hearted
in this dark suburb
listening to the peepers nattering
like wind-up toys in the vegetable
silence,
turn and turn

I know you're awake now
– you hate the heat –
in your two rooms overlooking
the main drag, in the dark, stabbing
butts into a can of soda,

staring into the yellow sky
while trucks clank past your window

Telling

Aw christ.
I told him
he don't know
about pain, my pain.

He said
then I'll just listen
what I told him
I couldn't stop telling

til I was out of my chair
holding onto
his plant, no I didn't
break down

his skin behind spectacles
white as a bone.

Today your being

Today your being
spreads across the world:
fog blows grey-brown up the coast,
your hair scattering over the back
of your chair; your voice here
in the wind, muffled by ordinary
traffic and exhaust.

Last week you sat, gathering force,
then spat out these elements:
how you were tricked just once
by kind words, lured in the broom
closet, trapped in the dark

how the word mother lies
like a stone on your heart
your voice a gale in the air between us,
your eyes black with ghosts and tears.
I dreamed I went to find you.
Steering between the mall
and the highway, my car shrank

down to a bicycle, I pedaled
hard up dirty snowbanks
back to the city, the bike folding
into a scooter, the buildings
rearing above me. I called
your name in a wispy voice, Maura,

but when I found your street —
a collapsible row of tenements,
the road jammed with children
doing handstands on the ice —
some storm in me broke, I howled
over your door for

you, who stole into my dream,
who have been my weather all week,
a cold spring aching with buds
all opening too soon —

[I will close with two poems from the end of the sequence.]

At thirty-six

the skin begins
to pull away from muscle
dragged by a darker force,
the chin turns
pale as a moonsliver.
Your face takes new shape

like canvas stretched over bone:
the ligaments of your cheeks
bunched and knotting,
nosebone jutting,
your electric brow shining.

Even so, in late summer
leaves begin to curl back,
tree limbs stand
black against the sky
the foliage lets go
pale greens
tipped with yellow. Once you said,
I want to be lost off the face of the earth.

Below your town, stalks
of marsh grass will brown and stiffen,
the hidden cricket keen.
Halfway to nightfall, you show me

each one of us does no more
than to hold the light here, on our faces,
one illuminating the other.

The wisteria is gone,

uprooted and thrown
on the plastic barrel, banished
by the gardener. "It winds up
everywhere," he says.
No more thin fingers
brushing my knees
as I bound up the wooden steps
to your study.

I turned away from you
to turn deeper toward you
and into you –
or no, I stretched out
tangled,
on your rug-draped couch.

I stared at nothing, felt the sun through the window
and the shadows stripe my face.
The robin called her ordinary song.

In a silence that moved
like a rain cloud between us
your voice picked up,
rustling in the wind.

We told a story.
First I said a word, then you another.
Cloud. Mountain. Little rain.
Was it my fingers or yours winding through my hair?

Our words spun out together
on the carpet of green and blue,

gliding out the window and into the garden,
veering, almost slipping
off the edge more than once –

Here's what remains behind my closed lids:
your eyes saying yes,
the couch holding me close,
wisteria wrapping us in its ceaseless embrace.

References

Durling, R. M. (1976). *Petrarch's lyric poems*. Cambridge, MA: Harvard University Press.

Whitman-Raymond, L. M. (1978). The body. *Sojourner: A feminist journal of the literary arts for women*.

Whitman-Raymond, L. M. (1985). Quickening. *Sojourner: A feminist journal of the literary arts for women*.

Whitman-Raymond, L. M. (2000). *The Light on Our Faces and Other Poems*. New York: Pleasure Boat Studio.

Wikipedia (n.d.). *Il Canzoniere*. Retrieved from https://en.wikipedia.org/w/index.php?title=Il_Canzoniere&oldid=700286005

8

RECLAMATION AND RESTORATION

Heroes in the seaweed

Sandra Indig

Paint pulls me into the present and into a state where everything feels connected. I like the corporality of paint and the way it can be moved, its plasticity and its colors. Perhaps, in the world of the imagination, where all is possible, feeling more aligned with my water and earth astrological sign (Scorpio) may help explain my love of movement, particularly dance and poetry-making. In this essay, I attempt to concretize through the telling of my thoughts and actions how and why, perhaps, I grew into the person I believe I am today.

Ambiguous loss emerged as a theme in my practice as both a psychoanalyst and an artist. The term "ambiguous loss" first caught my attention in connection with the 9/11 destruction of the World Trade Center. In total disbelief, I had watched the towers, one by one, disintegrate. I also stood with the many ready to help at the now non-existent St. Vincent's Hospital in Greenwich Village, New York City. It seemed that there were hundreds of blue canvas stretchers ready for the bodies that never arrived. In time, empty coffins were offered for burial, containing perhaps no more than a memento of the deceased. With this great tragedy, the feeling of safety – perhaps an illusion, but a comforting one – fell away. Many of us, particularly analysts and artists, were asked to write about how we experienced that dreadful morning, an election day capped with a very rich blue sky. I never shared my personal response and I only saw the "pile," as it was called, at a distance while doing critical incident work to those near to or on the site. Because the pain is still so great, I have not visited the new tower; I am not ready.

However, I am still processing, through my personal creative work in the arts, extensive self-investigation, and psychoanalytic practice, the vicissitudes of my own, as well as those of patients, the challenges of living with ambiguous loss, and the rewards of achieving post-traumatic growth.

Some time ago, I treated a woman with whom I identified and whose story uncannily resonated with my own. This synchronicity or co-incidence helped me to be a most empathic listener and, I believe, as a consequence, our work progressed

at a rather accelerated rate. Doris (not her name), then in her early 30s, was seen twice a week for three years. She lived alone, was at the time unmarried, and worked as a moderately successful, self-employed illustrator and copywriter. Doris gave me the opportunity to discover more of the often illusive and ephemeral links between art and memory. At the outset, her story of unbearable, persistent, and gnawing "soul-ache," caused by her longing over perceived losses, were almost impossible to translate into spoken language. In time, her feelings took on both form and meaning through her visualizations and her growing willingness to verbalize her story in a safe and predictable environment.

As I had used letter-writing as a therapeutic tool (not meant to be sent), where direct communication was either impossible or contraindicated, I suggested to Doris that she might find this exercise productive. Her wish was to curtail her almost compulsive reveries about her long-ago ex-boyfriend of her college days from intruding and interfering with her sleep, work, and present relationship. She brought in the following letter to her ex-boyfriend:

Dear David,
You are one of the few people with whom I feel a kinship; a soul mate.

FIGURE 8.1 *S. Indig's Painting of Her Patient*

Source: Sandra Indig. Oil on canvas, 12in × 16in

PLATE 1 *PINK LADY*

Source: Karen M. Schwartz. Mixed media on linen, 2014

PLATE 2 *Linear Veil III*

Source: Linda Cummings © 2012. Archival pigment photograph

PLATE 3 *Guests of the Sleeping Mind*

Source: Sandra Indig. Acrylic on linen canvas

PLATE 4 *The Market*

Source: Anna Carusi. Oil on aluminum, 2013

PLATE 5 *many ways to see*

Source: Julia Schwartz. Oil on canvas, 2014

PLATE 6 *Trudy*

Source: Dan Gilhooley. Colored pencil on paper, 2001

PLATE 7 *Drawing from the Edge, Bhutan, Man*

Source: Donna Bassin. Photograph with oil pastel and pencil, 2015

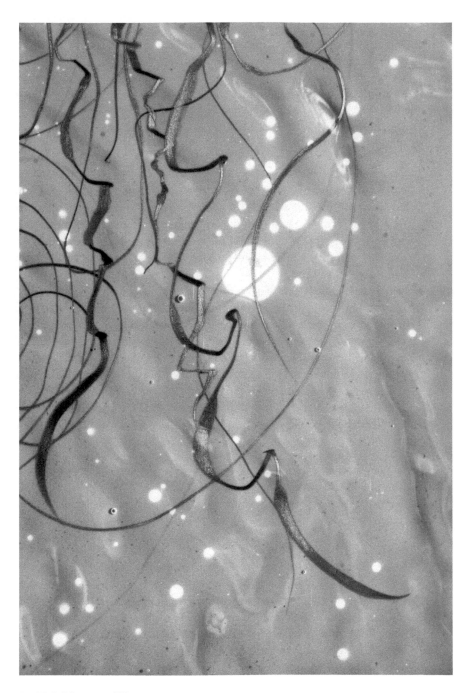

PLATE 8 *Movement IV*

Source: Linda Cummings © 2014. Archival pigment photograph

This simple sentence seemed to thunder across an endless sky of mirrors. I visualized multiple but indefinable images. I continued to listen, tried to deepen my shallow breathing, and so relax into her words and images. My aim was to become the "floating" analyst; I wanted my unconscious to communicate with her unconscious and vice versa. I visualized this internal process and then went on to record it as a painting I called *Fire and Ice*.

Doris continued in a register slightly deeper than her modulated but often pressured speaking voice:

> Sometimes, you are like my mother whom I have embroidered with every conceivable combination of lies, truth, ideas, and feelings that only a mummy now stands before me wrapped in endless dressings hiding a wound so deep that the mere impulse to go near it is enough to set in motion endless activity; anything not to feel or think about the terrible pain. I think you were the scab that formed over that terrible wound left in my child for the terrible shame she was given to bear.
>
> I imagine that the fact of her birth was not the large belly which announced her coming. It was the beginning of the shame fed to her in that watery sac. It was an undeniable admission that a sexual act had occurred. Her suckling must have been experienced with a mixture of self-disgust that this was happening to her and the pleasure at the mere hope that she was sharing some of the poison that had entered her body. She forced herself on the newborn, trying to feed when no hunger was present. First it was milk, then it was food, and then it was her. She wanted to smother the life she had given so that she would not be reminded of her shame. So the baby developed allergies, eczema, and asthma plus a thousand fears, many unnamable.

The following sessions explored the content of the above letter mostly through the modalities of free association, poetry, and painting.

Well into the second year of working together, Doris decided to write a letter to her father. She wrote:

> Dear Dad,
> Even when you were home, you were an absent father. After all hope of a relationship with you was gone, I replaced you with an imaginary person. I would handle future losses by recreating the absent person in fantasy and in dreams. I did this with Ben. I first met him while I was still in high school. Then he was lost to me; I loved him while I was married. My entire emotional life seems to be built upon bedrock of misconception, lies, half-truths, and rationalizations. My mother, your wife, chose not to tell me that Ben, then in college, wanted to marry me. She told me this while I was sitting in your bedroom in front of the mirrored dresser readying myself for my wedding. At that time, I chose to concur with her that Ben was mad; it wouldn't work out. Now, I am still shocked and dismayed and still ask myself, "Did she really tell me that on the night of my wedding?"

In sessions, we explored the possibility that the theme of the secret and unobtainable lover replaced the absent father – that is, stood in place of the absent father much in the way that a repetitive dream can be regarded as an attempt to change what occurred in reality.

In another letter to her father, Doris wrote:

> I was at Pratt when I heard of your sudden death in that horrifying car accident. Mom's not taking an action when you failed to come home bewildered and confused me. I was so shocked that it left part of my face paralyzed for almost a year. I asked myself, "Just who was this woman who called herself my mother?"

This memory triggered explorations about her loss, feelings of abandonment and betrayal, and ongoing struggle to process her life trauma through use of fantasy and non-verbal expression. Eventually, Doris was able to struggle through and come to understand how it was that she felt deserted, abandoned, and alone with ambiguous loss. She was able to differentiate between what part her immediate family played in her conclusions or belief system about them and about herself. She took greater and greater responsibility for her recovery by, in large part, not seeking to place blame outside herself, valuing her considerable strengths, and having trust in herself and others.

By way of illustrating therapeutic gain, evidence of post-traumatic growth, I wish to refer to her association to the phrase "underground, silent springs":

> I am beginning to feel reborn; perhaps I have a chance at a life lived, not endured. I've begun to talk to other people – I've begun to tell my story, to let others in. The other day, in the subway, I watched what looked like a young Slavic mother regarding her baby son with absolute love on her face. She touched the child's face and blonde hair with tenderness. It must have been 100 degrees in that train. My eyes stung with hot tears. I felt a great welling in my chest. I know that my mother never looked at me that way. I believe she never did.

Doris concluded by saying:

> I think I am entering the flow of my life. I've swum into safer waters. I have a sense that I am no longer alone but have your voice in my head to guide me.

At this point, you may well ask what this has to do with being an artist and a therapist/psychoanalyst. I have noticed that in both roles, I can acquire tools with which to mold, shape, and direct my energy, thoughts, and actions. Through practice of both psychoanalysis and art, I can acquire, at the very least, the illusion of control, fluidity of mind, and sense of ownership in having a place, purpose, and context in the world without which significant growth in either or both fields is impossible.

In my early adolescence, when I learned to attach names to feelings, I realized that I needed what I call extra "skin" both to defend myself and deal with loss. I was called overly sensitive and later on became aware of constructing boundaries, emotional, psychological, and physical. I found out that some of us are born neurologically more vulnerable to sounds, smells, allergens, etc., than others.

The extra "skin," my protective cushion, tended to distance me from the world in which I lived and worked. It was one way to avoid engaging, interacting, and even understanding and verbally expressing in words my needs, thoughts, and dreams. The groundwork for being an artist who could work alone and enjoy her own company was set. Conditions were such that I could make art, although not encouraged directly by my family; I was not forbidden or denied from doing so. My grandfather took my sister and I to the Metropolitan Museum of Art, my uncle bought us *La Traviata*, and my grandmother made me clay pigs when I was ill and kneaded, then braided dough for challah, on Fridays. My father made us a big wooden work table and my mom once made me a crown of dandelions. There were good books in the house, and nice things to look at, like plates painted in Europe by a cousin before I was born. One day, I was fortunate enough to meet a young man who told me that there were colors in the shadows, and I saw the colors in the shadows. My world changed. It appeared that I had moved from a world where I could not find adequate descriptive words to the quite specific world of choices, definitions, limits, and responsibility.

For example, I began to recognize that memories were like flowers in that they grew from seeds and, in dying, created seeds. Seeds or information received from any of the five senses, together or separately, took root in my memory to either grow or wither depending on how often they were "awakened," consciously or not. The artist–analyst in me learned to recognize the bridges I formed from "seeds" or, more accurately, early memories. Those informational bridges enabled me to become a more consciously creative person.

The opportunity to travel on my own while still relatively young reinforced and strengthened my desire to somehow make a contribution to the world in which I found myself. Becoming temporarily part of cultures other than my own brought with it a sense of a larger and more diverse knowledge of the world as I had known it. Other colors, climates, languages, and artwork I had only seen in books, and meeting people who knew things I had never heard of or seen before changed me. My first trip to Switzerland brings back a conversation, the strangeness of which I can still hear in my head. My hosts and childhood friend's in-laws were relating stories about the nudist camps that they enjoyed in summers. As a rather sheltered and, by comparison, prudish person, newly arrived from the United States, I had trouble reconciling these members of what is sometimes referred to as the Russian intelligentsia and nudist colonies. I was later to stay with my friend in her home in Paris, where I discovered Russian artifacts and heard stories told by the grandchildren of two famous literary families (Tolstoy and Andreyev). Through them, I came to recognize what it meant to me to be a first-generation American of a Russian father: that my artwork was peopled by reconstructed images from that culture and that I found the atmosphere of Dostoyevsky novels oddly familiar.

The accumulation of ongoing exposure to a world that was me and yet not me led to the always evident but not often recognized reality that I was, in part, a product of the culture into which I was born, the environments to which I was exposed, and the persons who had peopled my life. So, when I think I understand the patterns forming in a patient's story, I must account for the "bridges" in my own mind. We, the patient and I, are the complex result of the stories, myths, dreams, and wishes from which the seeming truth emerges.

These perceived "truths" – whether forms, lines, shapes, or colors – form a quilt of collected events constructed by the patient and are informed by our separate but mutual histories. What emerges in a session can be regarded as an event that may motivate a response, whether thought or unthought and only partially processed. This is the processing container; the analyst is processing – publicating. Then further exploration and development are possible.

It appears to me that in the process of creating, whether in the therapeutic role of the empathic other or inside the artist's head, the continuation of a conversation, whether in images or words, is always the goal. To be clear, creativity does not exist unless it is externalized. It is not a question of what creativity is but where creativity is.

Where is creativity?

"The answer to the question 'Where is creativity?' rests in the interaction between a person's thoughts and a socio-cultural context" (Mohl, 2014, p. 13).

My patient Mark awakened to his own process. Suddenly and without warning, he burst out with, "I am painting and painting and then I saw, 'Oh, I'm not using color!'" The underpinnings for his choice to use black and white are complex and multi-determined by bio-psycho-social dynamics. Within the context of our work together, he discovered that his aesthetic sensibility significantly resonated with an eleventh-century Italian painter. The black-and-white paintings of Fra Angelico inspired him to connect his personal needs in the present with the iconography and coloration of the master's works of the past.

The historic memory located in the hippocampus of the brain is our means of making deep connections not only to the personal past but quite often, as was the case for my patient, with the past of other cultures. Take, for instance, one of the greatest painters of the twentieth century. Jackson Pollock's "gestural" and "living" line transcended not only his personal dynamics but "merged both eleventh-century aesthetics of Chinese calligraphy and contemporary Western art" (Indig, 1988).

Today, we know that in the psychoanalytic process that incorporates the viewpoint of neurobiology of the mind, the brain and mind are two intertwined entities that inform each other and change each other constantly. There is no "visual image" as we knew it 20 or 30 years ago. Neuroscientists who are researching visual systems are using new terms: what were formerly called "visual images" are now referred to as "visual percepts." We thought we were seeing with our eyes. We know now that we are actually seeing with our brain. That visual percept is defined by the contour,

color, and shape of the original point of interest, is now infused by meaning, and has various labels pulled from prior experiences, encounters, and memories. This is how the image appears. This image, by a stroke of a brush, can be translated to the canvas, computer screen, or a concrete wall (Rozentsvit, 2014).

As a psychoanalyst, I continue to struggle with new concepts such as mentalization, neuroplasticity, and neuro-integration. As an artist, I can see that each of these new terms requires new forms. For example, I am convinced that mentalization, which is meant to be a product of the verbal brain, can be achieved utilizing visual imagery.

Just to illustrate my idea, I would like to share with you the case of Helen, a victim of childhood abuse in recovery from addiction to substances, who came to work with me after two prior unsuccessful analyses. During treatment, she produced on paper images of herself as a "little thing" sitting in a uterine sac. By the time she terminated treatment, unfinished but transformed, she was visualizing herself no longer in utero (Figure 8.2(a)) but in a green dress floating with clouds (Figure 8.2(b)) or, on another occasion, as a powerful woman whose *chakras* (energy centers) were prominently covered by symbols of power and strength (Figure 8.2(c)). This is what visual mentalization is: a picture of a thought, a concept embedded in a picture.

(a) "little thing sitting in the amnion sack"

(b) "a flying woman"

(c) "a 'bionic' woman, with her *chakras* covered"

FIGURE 8.2 *A Patient's Artwork* (Helen)

How I got involved in my career as an artist and psychotherapist/psychoanalyst

My visual vocabulary is made up of my imagined and natural forms. Confronted by the unknown and sentient presences, my feelings of gratitude are nurtured and mysteriously guided in knowing what to do, and that clawing fear of not knowing leaves me. How did this happen, where does it come from, and how does the force to record images continue to go on being? These questions not only motivate me to create but drive me to continue the odyssey.

My images are recorded along a continuum from veils of color to densely textured surfaces of saturated color, often complemented by a subtle to bold linearity. Forms seem to emerge from the two-dimensional surface where I feel, more than know, where to place lines, forms, and color. I "read" the surface with my brush, much as a person who is sight-challenged reads through an arrangement of raised dots on a page.

My work emerges from early-life, perhaps primordial, visual images of masses of people who, as they appear to come toward me, decompensate. It feels ancient, like an enormous Pompeian mural with its cracked and forever-peeling layers of color and substance. Disintegrating "figures" inhabited the dark places of my child-mind. The closer the mass got, the more terrifying. I felt as if I could suffocate from their pressure and endless presence. Lacking an outlet, I announced my distress with physical symptoms that made it painful to take in and give out the very air I needed to live. That door was shut and another was opened . . . The upside was that I also fell in love with life-affirming movement, particularly with improvisation. In fact, my graphic work literally starts as much in my muscles as its imprint, the marks I make, start in my brain. My forms are intuited. Painting is the process used to find or body forth a form. Much like Carl Jung's archetypes, my images are presented rather than observed or invented, and I am a conduit in the process. The iconic painters Chaim Soutine and Mark Rothko both figure large in my painting repertoire. I identify with Rothko, in particular, in that the art of painting is a life and death struggle. It is a necessity that, to paraphrase a recent review of my work, it bridges the gap of time and space and forms a cocoon for the imagination and the heart to hope with. It is the best way I know to synthesize the cumulative experience of the life around me and tell my story, including the life of the unconscious and the spiritual.

My painting *Guests of the Sleeping Mind*, and my poem of the same name, illustrate and give voice to the dynamic externalization of internalized memories – memories that exist like dreams, on many levels and dimensions. The latent theme of my work is transformations, meaning to cross over. The personages in the painting, albeit abstract, are transformational figures, going from one state of being to another and, in so doing, ushering in a new life stage; from unmarried to married; a celebrated, spiritual, and officially recognized union and place in society.

The poem took form while the painting was evolving. The poem is not an illustration of the painting, but rather it is a written statement, much as the painting is a visual statement.

Both the painting and the poem served to process the contents of sessions with Helen, my patient.

FIGURE 8.3 *Guests of the Sleeping Mind*

Source: Sandra Indig. Acrylic on linen canvas, 60in × 24in

Guests of the Sleeping Mind

You become known to me when you lean against the doorposts of my
rooms.
You are known to me when you enter and then again when you leave
touching doorposts with warmer hands.
Your many faces remain over time,
in the life-time of seasons, in the shadows of oak trees lit by many suns.
The light rests against pillows of shifting clouds
rarely perforated by rain drops and pushed by dancers riding the waves of
wind.
You are in the oceans of words,
in the shapes of changing thoughts.
You sail in the ships of youth and in the swimming tides of the long lived.
You walk in dreams folded into images of collapsed and condensed time
and talk through hieroglyphics.
You see in pictures burned into colored balloons of thought.
You light the fires in the bellies of the graceful movers creating poetry
in space and moving between and through the density of waking hours.
In your anger, your fear pricks the torn air that pulls mountains apart and
divides the seas.
You drift within a shattered heart and wallow in the marrow of broken hope
lain on piles of bones waiting to be born again.
In your multiplicity you are the One,
the One who weaves into the warp of golden thread ribbons of red, of blue,
and of purple.
A cloth destined to dress souls honoring celebrated seasons.
Your tapestry is the shroud dried on winter's body.
The tapestry is the color in spring's blush, the curve in summer's smile,

in the pigment of fall's rainbow colored leaves and fading flowers.
In days of mourning your dreams are whispered by the eternally remembered.
She was carried into the days of mourning.
She was lifted by the arms of
her seed and guided by the night vision of the ancient ones.
The weavers of our days are known by eyes seeing between light and dark.
They lifted their eyes into a time when there was no time
but only the warm hands of guests
touching doorways of sleeping minds.

I was motivated and inspired to create this work in order to better understand and contain the transference and counter-transference occurring in session with my patient, Helen (see earlier). I find it significant that she portrayed herself in an embryonic sac and I had painted a tiny figure on the lower left corner of my own production. I believe that this is a visualization of a parallel process. It simultaneously addresses the latent and manifest content and psychodynamics of both containment and transformation through visualization. The similarity, in this instance, between my own and the patient's internal world is, I believe, a powerful example of how the psychoanalytic process can unfold in a creative clinical environment.

In addition to writing process notes in prose, this untraditional approach offered me a way to contain my both difficult and, at the time, extremely traumatized patient. Helen was experiencing symptoms of extreme stress, unbearable anxiety, panic, and an identity crisis exacerbated by unresolved conflicts. Painting and poetry offered me the tools I needed to not give up on but to continue constructive analytic work with this patient. These art forms allowed me to concretize and therefore mentalize my connections to the often unspoken, non-verbal, and therefore largely inaccessible analyst–patient world. As a result of doing the non-verbal work, I was able to make accessible that which was formerly non-verbal – the aim of all therapy: to make the unspoken, spoken and the unthought, thought. Many artists, including those I have worked with in treatment, "regarded directness of expression in making what is not seen visible, as the most important element of their work" (Indig, 1988, p. 58). My art work and concurrent psychoanalytic practice promote and, therefore, encourage the making of psychoanalytic connections between the internal and the external as they exist in the arts – a special product of the human mind in all its richness and diversity. The two paintings and text that follow illustrate this point.

Each of the following paintings is accompanied by text that addresses my work in psychoanalysis and art, much as Helen's case resonated with my epigenetic history.

A Movable Feast

Family dynamics and its history from ancient to modern times is enough to fill many libraries but it is the experience of the family surrounding my birth that found its way onto canvas.

FIGURE 8.4 *Movable Feast II*

Source: Sandra Indig. Acrylic on canvas, 38in × 49in

Words eluded me; only the vehicle of paint ripping and swirling at great speed could unleash and record volumes of feelings, associations, and the residue of images not ordinarily accessible to my conscious mind or cognitive brain. While painting, there was no need to recall the words or stories each grouping told; no need to designate a specific gender, or to record a specific time or place. The framed image comments on the adhesion to a social formula, if you will – the habits ingrained in all who, willingly or not, partake in social gatherings. Visualization facilitates bringing uncensored imagery, similar to free association, into consciousness. By way of this transition, the often unspeakable, unmentalized, perhaps forbidden thoughts and their attendant feelings can become part of the conscious life processes not easily accessible to language.

Erasures

This painting is about communication or dialogue experienced on many levels – as whole or fractured, shattered, or satisfying and productive. There are six panels. Many viewers (including myself) find it provocative and in turn pleasing and disturbing because, like the treatment process itself, one (viewer, analyst, etc.) can only speculate on, particularly, subliminal versus manifest content. "What is going on?" The style of the work is meant to stimulate dialogue. It is a satire on communication presented

FIGURE 8.5 Erasures

Source: Sandra Indig. Acrylic on canvas, 28in × 40in

in comic-strip style so as to better invite the viewer to continue the imagined narrative. For me, it mirrors the phenomena of relatedness and relating, often, in turns, comedic and/or tragic. The important thing is to keep the dialogue going both in life in general and in that part of life that we refer to as treatment in particular.

The practice of art and psychoanalysis: common factors and differences

"Letting go" seems to be the trigger point common to my creative work both as a clinician and as an artist. "Letting go" starts a shift in states of being. It feels like floating somewhere between the two sides of the brain. The contemplative "if" right brain stops to allow the left "yes/no" brain to make a decision that results in an action. A balance between both brain functions enables both the artist and the analyst to listen, to see, and to contemplate the field presented by the patient or the "marks" on a canvas in a space created by both - a transitional space (Winnicott, 1965). In this space, there is a kind of hovering of all the senses versus a direct use of only one of them: the energy of the hovering is without a goal, object, or target. I let the patient's words wash over me until I or we make a connection between their past and present in a meaningful way. Whether or not this connection is verbalized by myself or the patient depends on where we are in the treatment process and her/his developmental level: paranoid/schizoid or depressive (Seinfeld, 1993).

I find that in my own creative endeavors such as painting, thoughts, visions, and feelings seem to "float" as it were until, perhaps, one is grasped and is transformed into something tangible, concrete: a line, a form, a color, word(s), a thought verbalized.

In the case of Jed, it appeared to me that the creative and cognitive process had been reversed. After I had introduced a neuro-psychoeducational piece into our session, he was able to see (in the sense of to understand through visualization) something of the brain–behavior connection. He observed these connections in people important to him in his daily life. In the session that followed, he recognized how his brain and his behavior were integrated into a complex system of communication. As Jed was relating all the positive modifications in his daily life made since our last meeting, I asked: *"How did the change come about?"* Jed: *"When you explained the brain 'lighting up' concept, I recognized in others how their behavior was triggered by a part of their brain 'lighting up' – giving pleasure and gratification."* For instance, he was no longer bothered by his sister's attention to what he had previously considered unnecessary details: what her plans were for dinner, how she was going to "open up" her house for the summer, endless descriptions of a church party, and so on. It appeared that he had changed his brain; he had achieved greater plasticity. He had made new connections, built new neuro-connections. In time, with continued consolidation in treatment, his old judgmental and intolerant behavioral responses fell away from lack of use.

If I were not able to visualize some of the brain's topography, its levels and systems of integration and communication, the "fire together, wire together" concept, I could not have expressed and related my image of the brain "lighting up" to Jed. It was visceral knowledge, both felt and seen, that was transmitted. As a multidisciplined person, these connections are not only vital to practicing my art, but incalculably enrich my work with patients. This makes it possible to appreciate and be grateful for the miracle of the creative effort.

Despite being very knowledgeable in many disciplines, it remains difficult for me to name the source of my creative work. In many ways, it is all part of one magic cloth, like Joseph's cloak of many colors. Creativity is the blanket, or Bionian container, for my associations to my personal history: past, present, and imagined future.

Differences between each of the disciplines I practice are mainly in how each field makes concrete what is only felt. In each, there is an end product of some sort. In clinical work, I aim to help the patient discover, access, and develop their own voice and come into their own story. But in my personal creative work, I strive to be in my own narrative. In the best of circumstances, I produce a good product. I may feel that it is never good enough, never perfect. However, as a clinical practitioner, it is the patient who, in the end, decides if our work is finished, at least for now, and if the issues are resolved; if he/she has the tools needed to lead a less troubled life. I agree with Freud in not seeking perfection or cure, but in relieving suffering. At the end of the day, Freud called analysis the impossible profession because we can never be fully satisfied with the results.

It appears that all work improves with maintaining a fairly regular routine, getting adequate rest, and planning for a healthy diet. I feel balanced and integrated, and have a sense of well-being when I bring my whole self to anything I do, including goal-directed activities. Being organized, present, and focused, and keeping things in the "now" is helpful in creating positive conditions for positive outcomes. To para-phrase the Buddha, the past is already gone, the future is not yet here, so there is only one moment for you to live and that is the present moment.

The only complaint I have is that there are not enough hours in the day, espe-cially enough "down" time. Too much pressure, usually self-inflicted, takes me out of "flow" and leaves me feeling frustrated, fragmented, and somehow smaller. Fortunately, I have learned that these are "symptoms" signaling to me that some-thing is "wrong," and that I have to take an action to correct it. And on the other hand, I feel most fulfilled when I can share my skills and knowledge with others. I feel most professionally and personally integrated when I can do something that is interactive. For instance, leading a group of my analyst colleagues to a museum and eliciting from them aesthetic and analytic associations to the artwork we have seen, and making connections between the dynamics of the artwork and their analytic practice, is most rewarding. One of my wishes is to have an interactive website on which like-minded analyst-artists share discoveries and nourish an interdisciplinary narrative. My task is to cross disciplines, to cross-pollinate, and in so doing become more human. As many others are, I am very taken by the example of Leonardo da Vinci's life and work. Aside from da Vinci's genius, which is no light matter, I would like to explore how this great man, perhaps the greatest, dealt with loss. Processing loss is one of the major themes in both my life and work.

Clinical work and its vicissitudes

Clinical work is markedly different from personal pursuits. By its very nature, it involves an ongoing, unfolding story with many phases and innuendoes as it is tied to a person's presenting issues and deeper behavioral dynamics. There are several ideas that seem important to my work as a therapist. For example, there is the real-ity of form and boundaries, the role of affect and emotion, aesthetic awareness, and the ability to relate with empathy. These are all issues that I have struggled with and continue to do so in my clinical work. This work is always informed by my knowledge of the creative process. A shape situated in a place begins to lay out a story. Things, people, and ideas have to have a place. Talking about some of the com-ponents of aesthetics – such as form, color, line, depth, weight, and distance – has, I believe, to be imagined within a context, a place, whether it be a physical room or virtual reality. Where there is an absence of boundaries, even changeable, porous, interchangeable ones, we are dealing with phenomena such as black holes, oceanic feelings, or dissociation from all that exists. Perhaps this is a positive goal in very advanced meditation, but to most of us it is one of the most terrifying experiences possible (Tustin, 1986, 1990). The following two clinical cases are examples of how some of the issues mentioned above are made concrete in the treatment room.

Jane

Some time ago, I was working with Jane, a patient recovering from surgery. She expressed how terrified she was when she awoke to a very dark hospital room. In a panic, she rang for an attendant, who told her that the TV had stopped broadcasting and that she should not read, etc. However, she asked him to turn on the TV. It emitted a small blue light and that was enough to provide her traumatized brain a focus. She told me that without that focus, she felt insane. In this session, it struck me how Jane was able to see with her brain. She related what she or her brain saw in that blue dot. She recalled historically relevant information that was at once aesthetic, historical, and psychologically comforting.

In conjunction with the concept of boundaries, which includes focus, there is embedded in the Japanese culture the concept of *amoe* or "self-place" experience. Jane's self-and-relational experience helped me to better understand and work with her terror of the darkness in that hospital room and to join with her in identifying the comfort she was able to derive from a small blue light.

The concept of the self embedded in the situational context beyond human relations but in "placeness" is, I believe, aesthetically and analytically relevant when considered from a neuro-psychoanalytical perspective. I would like to elaborate on the concept of "placeness" between an analyst and a patient in the explanatory dimension. Toward this end, I will briefly review a case in which self-place on an experiential level was examined.

Mark revisited

Perhaps it is serendipity or a congruence of circumstances, but most of my practice is with people who are or want to be creatively challenged. At the time that I was working with Mark, I was working on a series of paintings I refer to as my "Black Paintings" (see Figure 8.4). Mark was also painting very dark, often black works. He was mature and had been around the block a few times and, although quite a successful painter, found himself "stuck." With an upcoming exhibit of his artwork, he was highly motivated to both find and receive help.

As he put it, "*my palette is not speaking to me; it feels dead, dried up, and non-responsive. My forms seem repetitive, boring, and foreign to me.*" We talked about the work he brought in and he employed many explicative words to describe his feeling about the work and about himself. When asked to describe when the work was done, what was happening at the time, and where the heart (the focus) of the work was, he began quite spontaneously to enter the space of the painting and the forms contained therein. Despite an increase in his usually animated behavior, he appeared to be more comfortable locating himself in his painting. His associations and ideas offered in response to my suggestion about the kinds of choices made (consciously or not) to use certain colors and not others evoked a recollection of a key memory. He had taken a trip to Florence and seen the paintings of Fra Angelico in the monastery of San Marco. Departing from his usual style, Fra Angelico painted the cells of the monks in a very simple and very spare manner. Almost as an aside, Mark

told me that "*the colors of this Dominican order were black and white.*" It gradually came to him: "*Yes . . . after this trip I too wanted to get back to basics.*" The symbolic meaning that the color black had for Mark, as well as its absence from his palette, was explored in later treatment. For artists, certain colors and/or their absence can be concepts that have deep meaning. The shape, form, and size of something might evoke, in the maker, a place that he/she belongs to or identifies with, and that may contain thoughts, feelings, and emotions common to both therapist and patient alike. A work of art or a projection is in some sense a part-object and often resonates with the artist as both maker and observer. It is very much experiential, a self-place experience. The beholder or the viewer may also enter this space and that interaction or process changes the experience for both. Over time, I find that my patient and I can enter a Winnicottian "transitional space" (Winnicott, 1965). I would like to discover how that experience is organized between the patient and the analyst. I think that the answer does lie within both the neuro-psychoanalytic domain and the person-to-person communication.

The psychological and emotional role that each profession plays in my life

Practicing both professions is like living in a house with many mirrors; there is always a new and different way to see the same thing. Internal or external friction or pressure help me to break into the shell of brittle, inflexible, or fixed ideas. This process has more to do with a deep, personally felt need to translate emotion into convincing pictorial sensation than it does with pragmatic concerns. I would like the gestural and living line in my artwork to not only transcend my personal dynamics, but to merge with, for example, eleventh-century aesthetics of Eastern calligraphy and contemporary Western art. It would also be most satisfying to experience greater recognition and understanding by the scientific community, in general, that art is communication and that artists are communicators. By applying what I know as an artist to my work as an analyst, I have come to believe that *art expresses what psychoanalysis describes*.

It follows, then, that as I use associative methods and non-verbal information in my practice, I would welcome the valuation and acceptance of non-verbal mentalization as being on a par with verbal expression. Additionally, greater cross-pollination between Eastern and Western knowledge, in the area of neuro-psychoanalytic process, would offer me much satisfaction.

In summary, being with the patient, in his/her world, and responding interpretively or empathically (depending on that person's developmental level) accelerates the shedding of what is not the "true self" (Winnicott, 1965). Discovering the true or core self sometimes resembles an archeological dig, hopefully, revealing the "scar" or "basic fault" (Balint, 1968). Such a discovery helps define not only what we are, but also what we are not and, perhaps, will never be. I find that processing the knowledge of personal limitations involves a willingness to accept the fact that one is human and that, in the service of decreased suffering, it is okay to lower one's

expectations. The most challenging aspect of working toward the greater health of the patient is my own willingness to be silent, allowing the analytic process to unfold in its own time. It is always my hope, particularly in cases where the patient has both some skill and capacity to be creative, to understand the power of art to interrupt and/or postpone taking premature action, particularly verbalization. Silence, reflection, and a "letting go" of values that are not part of the self-structure all create a space in which a positive void is created. Using art in treatment, in silence, can create a positive void – a place or space where a less toxic mode of communication can develop and an alternate structure or object can be built. For instance, Dan Chiasson (2015) observed that "poetry starts building when love starts dying; it erects its structure durably on emptiness . . . Rupture and conflict are aesthetic necessities." Difficult memories of loss and deeply felt grief found expression through my poem and painting *Guests of the Sleeping Mind* presented earlier. Writing and painting were and remain alternative modalities to verbalization alone and, as such, allow me to mourn, repair, and restore hope.

Recognizing my own limits in both explaining and interpreting the meaning of art, I have come to the conclusion that art can be described and taught, but that art itself defies explanation. Rather than explain it, I have chosen to live in my creativity. Although psychoanalytic and scientific ideas often offer a great sense of beauty, creativity is my blood; it maintains and enhances my life. Creativity is my North Star as it guides me in the best use of my cognitive and creative skill in the arts. In my clinical work, I am equally guided by the needs of the people who come to me for help and by the wisdom of recognizing what is possible.

I find it empowering to work in different disciplines and modalities. It is my hope that those practitioners willing or interested in strengthening their creative roots or starting new ones will consider including modalities and techniques that are presently unfamiliar to them. I have found that simultaneous work in different fields of knowledge helps close the perceived gap between art and science, and has the synergistic effect of enriching and advancing both.

References

Balint, M. (1968). *The basic fault: Therapeutic aspects of regression.* New York: Brunner/Mazel.

Chiasson, D. (2015). Out of this world. *The New Yorker*, p. 70.

Indig, S. (1988). Art and process: Talking about black-and-white. *Manhattan Arts International*, 6(4), 18–19.

Mohl, A. S. (2014). *The life and times of Leonardo da Vinci: Portrait of a genius.* Unpublished manuscript.

Rozentsvit, I. (2014). Biology of the beholder's visual and emotional response to art. Workshop and PowerPoint presentation, New York.

Seinfeld, J. (1993). *Interpreting and holding.* Northvale, NJ: Jason Aronson.

Tustin, F. (1986). *Autistic barriers in neurotic patients.* London: Karnac.

Tustin, F. (1990). *The protective shell in children and adults.* London: Karnac.

Winnicott, D. W. (1965). *The maturational processes and the facilitating environment.* New York: International Universities Press.

9

ON BEING ABLE TO PAINT

Anna Carusi

A radical change

Just like with a CV, where one starts from the present and goes backwards in time, I start this essay on my being an artist and psychoanalyst from my most recent experiences and then move backwards in time, retelling the story of how this all came to be.

One of my more recent artistic experiences was the construction of a collage of aluminum plates for the Co.ME.L Award for Contemporary Art,[1] resulting in a top-five finalist position. The collage, in which each slab exists and operates as a separate entity, creates an abstract composition with a look to the figurative. The side plates connect the top to the bottom and the whole composition has its own unity, carrying the theme of a "market," built around alternating internal and external images of the market, monochrome and polychrome, painted and unpainted areas (Figure 9.1).

Working with aluminum caused me to come out of my comfort zone and paint in an instinctive way, which represented a radical change from previous painting habits. Indeed, this new artistic experience of working with a completely novel material was the driving force behind those changes that, in retrospect, appear revolutionary when I consider how I painted decades ago.

The goal of my Co.ME.L artistic research project was to explore the relationship between oil paint and aluminum. By chance, I came across a little-known painting on tin by Francisco Goya, completed in 1793–1794, where the brightness that Goya was able to get from the tin was exciting to discover and served as an inspiration for my artistic research project.

The draft of a panel of aluminum plates of various sizes was prepared and assembled on a support. Plate after plate was added until a marketplace was constructed, suggesting the game of jute bags.

FIGURE 9.1 *The Market*

Source: Anna Carusi. Oil on aluminum, 2013

The artistic research project explored the reaction of transparent and non-transparent colors on aluminum, with some areas being painted and some areas being left alone and still others being polished to a mirror finish, thus creating different degrees of gloss and grit. The aluminum was, therefore, not only a background but also a compositional element in its specific brightness.

Once the lower plate was completed, I instinctively painted the top plate, causing the color to no longer be "bounded," in that the new plate had very little to do with the lower ones and gave me access to a new dimension of freedom not present earlier in the artistic research project. Feeling emotionally charged, I decided to leave it as is, still not knowing how to connect the various pieces.

Leaving that day from the art studio with tears suddenly in my eyes, a small painting done by my analyst came to mind. Now dead for several years, my analyst had managed to capture the brightness of the grass under the trees when it is backlit by the sun. "What a journey!" I said to myself, thinking of my personal therapy 25 years ago.

Art and psychology

My artistic temperament led my parents to send me to a painting school when I was eight–ten years old. Although I liked so much the smell of the paints and turpentine when I entered the painting school, a smell that I still feel in my nostrils,

I felt very soon a sense of fatigue and boredom drawing still-life arrangements of objects selected by my teacher. Following the proposals and abstract patterns that were different from my own inclinations was unbearable for me. Instead, I enjoyed doing portraits of American actresses, who were then beginning to be known in Italy, or making drawings in pen and charcoal, which I would then exchange with classmates for pens and postcards. I felt that what I was doing was a living thing, with an immediate return of my drawings, but when I went to art school, I was bored.

After a couple of years, I left the atelier, returning only to artistic endeavors after a hiatus that lasted a few years. At that point, I learned via a newspaper ad, which had drawings of figures in movement, of a correspondence art school in Paris, ABC. I applied and soon starting sending every two months parcels of drawings to my tutor in Paris, who would send them back with his corrections and critical comments.

The object of the drawings was the human figure, both in static and dynamic positions, which I liked a lot. I went to Villa Borghese to draw people in different positions, putting on sunglasses so as not to disturb the spontaneity.

After about a year, I realized that this activity took too long, and that I had to decide whether to make it my principal activity. Even as a child, I was aware of having two souls, so to speak, one artistic and the other social, having always been interested in other human beings.

When the time came to decide what to study at university, the choice was between architecture and something that would help me concentrate on social work. Considering architecture, I felt capable, but the amount of math tests and structural engineering was so frightening that I chose social studies, graduating in Political and Social Sciences. There was not in Italy, at the time, a faculty of Psychology and only in those years translations of English-language research on social sciences, previously banned under the fascist regime, began to appear. A few years later, I graduated in Psychology following a three-year postgraduate course that had just been established.

Full of enthusiasm for this new opportunity, I started working as a psychologist, and since then I have never stopped. I worked extensively in educational institutions, and with social and health services specializing in treating childhood and adolescent problems. After the end of my personal therapy, I specialized in psychoanalytic psychotherapy, following psychoanalytic training in the Italian Society of Psychoanalytic Psychotherapy (SIPPI). Later, I joined the International Association for Psychoanalytic Self Psychology (IAPSP).

On not being able to paint

Many years ago, I read Marion Milner's book *On Not Being Able to Paint* and was very impressed.[2]

An artist and an analyst herself, she wrote that it was difficult for her to express herself through drawing and painting, which seemed after all to be the center of art itself.

In her book, Milner did not consider the professional and recognized artist, or the finished masterpiece, but the experience of herself as an amateur painter from the eminently practical aspect of self-observation and expression. She described the difficulties, clumsy efforts, and irritating limitations that prevented individuals from expressing their creativity. Milner outlined similarities between the analytical and artistic processes, analogies that were underscored by Anna Freud in the Introduction to the book.

Milner's difficulties and frustrations resonated as, at the time, I was paralyzed, unable to express my emotions and my abilities. I realized then that Milner's book would accompany my personal journey, that I would return to it once I had removed my own personal obstacles, unlocking my creativity in the process, just as Milner had. Who knows, I said to myself with a certain sense of humor, if one day I might be able to write something entitled "On being able to paint"?

I was then 40 years old and everything in my life seemed wrong; I felt obscurely that I was not living my real, personal, and individual life. Therefore, I sought the advice from my Jungian analyst from 20 years prior, and she told me that I had to deal with identity issues and encouraged me to find a suitable therapist.

In fact, I wanted to find the right person based on my personal impression rather than on professional pedigree. This has always been my personal approach in life – namely to choose the stakeholders, teachers, guidelines, and techniques that favored the two fields of my personal interests, i.e., psychological-social and artistic.

Therefore, at 40 I found myself starting all over again. After three exploratory meetings with three different analysts, I chose the analyst who told me one simple thing that seemed very sensible: "You don't feel understood by anyone. Let's see what happens if you have an emotional understanding experience." I was astonished by his words – so simple, so true. My analyst was oriented towards self psychology, as I discovered later, and was part of a study group on serious psychological disorders, using the new clinical findings of Heinz Kohut.

Today, after almost 25 years, I think that my personal therapy with Dr. L., a well-regarded analyst in the Italian Society for Psychoanalysis, changed my life, not just because of his undoubted capacity for empathy and analysis, but also because we both shared a passion for painting.

The first time I walked into his office, I noticed that his waiting room was filled with paintings. I asked him if they were his and got a positive response. Altogether, his paintings created a sense of space, panoramic views, and a love for the sea. I learned later that he had traveled much at sea as a ship's doctor. The impact of these paintings and their atmosphere, and, in retrospect, the psychic energy of my analyst, was strong. It was so much so that I asked him if we could do the therapy in his waiting room. I remember he smiled and, with a certain sense of humor, said that even if it took place in the waiting room, it was therapy nonetheless.

For a year, there was no talk of anything but paintings. Colors, technical problems, sources of inspiration, and emotions aroused were the topics of choice. These conversations provided opportunities to talk about previous experiences, life, analytical

and aesthetic issues. What were immediately evident were the parallels between what had happened and was happening in my artistic experience and what had happened and was happening in my process of self-awareness.

At the time, I attended a workshop of a professional painter, Clara, an artist who had a tactile sensitivity to palpable light surfaces. Interestingly, she had also done a Jungian therapy and we shared both an introspective attitude towards our artistic activity and a psychology background where the emphasis is on symbolic activity, aesthetics, and culture.

With the new therapy, I began to attend a different workshop, run by Bob, a British designer, where I could practice my life drawing and watercolor painting. With Bob, my passion for color exploded as new paintings on paper and canvas, watercolor and oil, full of movement and color, were created. Bob was an excellent teacher with real "therapeutic" talent for understanding and encouraging my creativity.

We all know how delicate the terrain of creativity is, especially in the beginning, and how a negative comment towards the first timid attempts to show one's work can be devastating. This is especially true for a person with low self-esteem, as was true for me at the time. Therefore, it was indeed the case with my previous analyst, to whom I once showed a nice drawing of a bird. Her comment was, "It's very nice, but why doesn't it fly?"

A sense of trust in her successor allowed for an unorthodox experience such that we had our first year of therapy in his waiting room. After a year of conversations about painting in his waiting room, I said, "Well, now we can move into the consulting room."

My therapy lasted seven years, with periods of anxiety, weakness, and pain so severe that my analyst sometimes doubted his ability to help me. His understanding and empathetic participation and my artistic activity that I was sharing with him accompanied me on this difficult journey. I found a relative sense of cohesion by painting, and a sense of soothing for excruciating pain and fragmentation while in therapy.

I had, at the time, a country house in Umbria, a green Italian region mainly cultivated with olive trees, my favorite tree. I produced many drawings of olive trees, in pencil, charcoal, watercolor, tempera, and oil, giving expression to my painful recovery from injuries sustained.

I remember how often I would get up at night to go to see what I had painted during the day, feeling a sense of internal cohesiveness as I examined what I had done/was doing. The number of olive trees, subsequently developed using different techniques, marked the starting point of my artistic journey. At the end of therapy, I drew my analyst in front of an olive tree; I later discovered olive trees were his favorite.

When he died a few years later, I said at his funeral:

> The last painting of Dr. L depicts a grove of olive trees, loved by Dr. L. more than any other tree. Dr. L. has left his Earthly body but his spirit lives on in the olive grove, in that spark of life, in that experience of himself, which helped many of us find ourselves.

It was in fact due to this therapy that I was able to continue my personal development or evolution, later becoming an analyst and an artist and being able to fully express and integrate the two souls that were in me.

Becoming a painter

After the experience with Bob, I decided to investigate further oil painting and began to frequent the studio of an American woman, Joan, a professional painter and Professor of Art at the Washington University of Art.

Joan came from Action Painting and the movement and color was what attracted me to her paintings, and therefore I asked her to teach me how to paint with oil. Joan's free expression, her creative energy, and her "Just do it" response every time I hesitated in front of the canvas always gave me the courage to continue. My training with Joan lasted four years, following the normal steps of an art course. During this time, I familiarized myself with graphical and pictorial techniques, and I learned the nature of colors, space organization, composition and plane arrangement, as well as the depth made by the chromatic perspective. Above all, I began to have meaningful access to experiences I was looking for, until then caught by the limitations and impediments so well described by Milner.

The picture that most clearly reveals the presence of this new expressive capacity is *Encierro de Pamplona* (Figure 9.2). I had traveled to Pamplona to see the festival of San Fermin, where the bulls run freely in the streets – the folk festival so well described by Hemingway in *Fiesta*. The running of the bulls from the enclosure to which they are taken a few days before the show to the *plaza de toros* is called *Encierro*, and the *aficionados* run the streets with the bulls in what could be considered a test of courage. The event is unforgettable in its primitive energy, which was what I tried to convey in my painting, after drawing bulls for about a year.

When I showed it to Dr. L., he told me that my therapy was complete. I had achieved a capacity to be emotionally involved and the painting was an expression of that. The painting was, in his opinion, full of strength and vitality, even though the rush of the bulls could still be viewed as being obstructed by a pair of still bulls. It took a long time after the end of my therapy to eliminate those obstacles.

Naturally, it was not just the painting that convinced him that the therapy had run its course. The development of my personal skills, the charge of vitality that I was experiencing progressively, and the desire to fully live new experiences, to make difficult choices, and to experience new possibilities were among the things that Dr. L. mentioned.

Looking back on my artistic exploration, I realize that it has involved an initial choice of abandoning abstract conceptualizations, symbolism, surrealism, and hyperrealism and rather diving into the surrounding world, merging into its forms and colors, resulting in a sensual painting where actual reality permeates the senses. This engagement with the figure of visible reality has always remained in my painting, even in subsequent evolutions as I moved towards more abstract paintings.

FIGURE 9.2 *Encierro de Pamplona*
Source: Anna Carusi. Oil on canvas, 1999

I spent a lot of time painting from life models as well as plein air to see and select what interested me. In this long process, I realized that reality, as we perceive it, is not the true reality, but one possible expression, constantly in flux, of an invisible reality. I gradually tried to express this invisible reality through movement and color. Movement is present in all my paintings, a movement translated into masses built along a diagonal axis. The vital energy comes out everywhere: trees, flowers, animals, landscapes, and human figures – wherever nature is on the move.

However, there is also another movement of successive transformations, such that one slowly realizes that seeing is not from the outside but rather from the inside and the unseen. The inner world is different from the outside but cannot exist without it. In my painting, art is the meeting point of these two worlds.

A significant theme develops through a series of changes, ever more free and yet always related in some way to an original object. So my olive trees have become stylized shapes in black and white, my bulls have become "dancing bulls" (Figure 9.8), and the Mediterranean Maqui has turned into patterns of colors in motion.

Over time, I built up considerable expertise in the field of art, exhibiting in various national and international exhibitions. Regardless of the feedback and success of these exhibitions, this activity has been, and still is, personally significant, such that upon entering my art studio, I feel particularly the sensation that I am entering into a world where I can be completely myself.

FIGURE 9.3 *Mediterranean Maqui*

Source: Anna Carusi. Oil on canvas, 2011

FIGURE 9.4 *Maqui*

Source: Anna Carusi. Oil on canvas, 2011

FIGURE 9.5 *Olive Trees*

Source: Anna Carusi. Ink on paper, 2005

FIGURE 9.6 *Olive Trees*

Source: Anna Carusi. Ink on paper and collage, 2005

FIGURE 9.7 *Encierro de Pamplona*

Source: Anna Carusi. Oil on canvas, 1999

FIGURE 9.8 *Dancing Bulls*

Source: Anna Carusi. Oil on canvas, 2000

Self psychology

After completing my training in psychoanalytic psychotherapy, I joined Aipsé (the Italian Association of Self Psychologists), an association founded in 1997 based on Heinz Kohut's self psychology. For more than ten years, in our small group, we deepened our understanding of Kohut's self psychology by examining his fundamental ideas in the clinical field. This was motivated by personal and clinical needs as well as by the desire to deepen the scientific debate raised in the United States by self psychology.

As with painting, self psychology opened new horizons and new work. The first aspect of Kohut's approach that convinced me was the introspective/empathic method. In fact, I asked myself:

> Wasn't this the crucial point of all of my self-analysis? Didn't my analyst say just this with the memorable phrase *"Let's see what happens if you are understood?"* Wasn't it this question that ultimately led me to entirely new experiences where I finally came into contact with my creative personality?

The systematic use of empathy as a method to get an understanding of the inner life of another individual helped me make surprising discoveries.

After a period of empathic immersion in the patient's subjectivity, his or her global psychic configuration becomes clear, a complex mental state in which all its aspects are interwoven to form a unique individuality. At this exciting time, things start to make sense. It was natural, therefore, to devote special attention to empathy, deepening Kohut's thinking about it, and collecting his writings in a publication dedicated to my analyst.[3]

Milner had outlined in her book *On Not Being Able to Paint* the similarities between psychoanalytic work and the artistic process. Although having started from different theoretical foundations, both Milner and Kohut believe that therapy, when conducted well, enables not only the recovery of one's lost emotional capacity, but also the creation of new attitudes and new relationships based on creativity generated by renewed self-awareness.

Milner's definition of the artistic experience as "contemplative action" is surprising, because it is nearly identical to how I define my own personal artistic experience, i.e. "active meditation."

Being an artist and a therapist

The possibility of suspending reactions to see beyond and reorganize data at my disposal in therapeutic work is due not only to a natural empathic ability, but also to my creative work, which leads me to move beyond appearances and investigate further.

This artistic nature has influenced my therapeutic work in two different ways. In some cases, my artistic temperament, which is not mentioned during therapeutic work, activates the patient's latent or explicit artistic abilities almost immediately. This was the case with Giulia, a young woman whose identity problems seemed

linked to a bilateral angioma that disfigured her face with two conspicuous cheek birthmarks. Her physical handicap seemed a realistic cause of her insecurity, but it was not sufficient reason for her fragmented state in romantic relationships, which was why she came to therapy.

Her romantic disappointments had given her a total lack of confidence in her ability to please others, resulting in a depressive state. Through prolonged empathic immersion, it became clear that behind this sense of inadequacy was not just her physical defect, but also her mother's non-acceptance of her daughter's physical defects, (i.e. absence of mirroring). This was confirmed by Giulia's childhood memory of her mother retouching a photograph of her. Even then, it was clear to Giulia that her mother simply did not accept her daughter's physical defects.

During therapy, Giulia had lingered several times in my waiting room, admiring a ceramic plate from the School of Vietri. What became clear was that Giulia thoroughly liked the plate, and knew that I too liked the plate, and that our inter-subjective experience of feeling in unison was particularly important to Giulia. Indeed, shortly after starting therapy, Giulia enrolled in a pottery class and proved to be remarkably gifted at making ceramics. Ceramics, in time, became a passion for her, an activity that gave her the ability to express her creativity and develop new skills of which she was very proud. She has received many awards, and activated new bonds of friendship with other artists. Together, they have founded an artistic association that continues to exhibit every year. After her therapy ended, I bought one of her beautiful vases, and looking at it truly fills me with tenderness and emotion.

Besides the activation of any artistic skills already latent in patients before therapy, my artistic background influences my ability to see beyond appearances and helps me detect the specific individuality of the patient and his or her specific creative potential. In those cases when this occurs, an inter-subjective field is created that can enhance what Kohut called "the nuclear self." A perfect example of this is Toni, a 45-year-old electronic engineer who came to therapy because he felt life was futile. Toni, a man with great qualities and personal resources, was unable to express them due to a lack of feedback and encouragement from those who surrounded him. Toni developed, over time, a submissive attitude, such that he preferred what was certain to what wasn't and above all else was guided by a concern to "not rock the boat." His upbringing revolved around abstract and conformist schemes and this especially damaged his creative ambitions. Significant, in this respect, is Toni's memory of the beginning of kindergarten, when he showed up at school with a big box of colored pencils of which he was very proud. To his dismay, his teachers told him that at school things were everybody's and therefore so too were his colored pencils.

It took almost three years to understand his individual profile and the importance of creativity in his work. Toni, in fact, implemented repetitive patterns that challenged him to be more assertive. After the initial success due to his remarkable personal qualities, something always "happened" that prevented the achievement of his objectives, his success, and the return on his investment. It did not, for example, bring about better job opportunities, or stop his instinctive negative reaction when confronted with new opportunities, or remove his deep conviction that eventually

he would fail. Therefore, he built up over time a "theory of bad luck" about himself, which led him to test himself less, to choose less, to abandon the interests with which he began. Of course, his thoughts and behaviors significantly lowered his quality of life.

Following some therapy-induced progress, which coincided with a promotion and him getting married, his employer suddenly laid him off. This negative experience strengthened his "theory of bad luck" that failure was just around the corner of every success, even though he was laid off due to objective financial difficulties his employer was experiencing. It was on this occasion that his personality showed a fundamental defect, that of being compulsively self-effacing when confronted with life's struggles.

After he was laid off, he began to work as a freelance engineer for a communications company, and his difficulties with self-promotion now accentuated his subsequent discouragement. We worked together in two directions: the analysis of his pathological accommodation, and the identification of his authentic capacities and creativity. What gradually emerged in Toni's process of self-discovery was the fact that his family's approach was guided by conventional schemes that didn't allow Toni to discover and sustain his own personal approach, which at times was nonconventional. Through therapy, Toni's sense of himself was reinforced and became subjectively incontrovertible.

Toni is both an experienced electronic engineer as well as an excellent graphic designer, activities that he kept separate. He gradually discovered a real talent for web design, finding digital solutions for problems submitted to him by various companies. His training in electrical engineering gave him a technical competence superior to that of a generic computer programmer and his design talents helped him create eye-catching graphical solutions. In addition, due to his marketing experience in the field of telecommunications, he was able to quickly identify marketing strategies to implement. It has now become clear to him that he has an "applied creativity," which is specific and unique and which helps him develop professionally. Recently, for example, he has created an application for the selection of professionals based on consumer ratings of reliability. All these initiatives have been met with indifference and skepticism on the part of his family, while in therapy they were met with much appreciation.

Toni's self-knowledge has been further enriched by a recent hobby, airsoft, a fun recreational team activity based on the simulation of military tactics. He has discovered that he has a great interest in war strategy and the advanced use of technical aids such as night-vision goggles and GPS. This self-vitalizing experience was accepted by his wife, but viewed by his family as incomprehensible, bizarre, and irritating, because it was viewed by them as a war game. For Toni, though, this activity represented a test of his physical endurance as well as a test of his mental capacity to strategize. He also gradually discovered a talent for grasping the whole direction of an action, a capacity similar to that used when one needs to find the global vision of a company. In therapy, my personal creativity and experiences as an artist and an analyst have perhaps created the psychological conditions suitable to encourage Toni to live an integrated life, instead of seeing different aspects of himself as distinct and

unrelated. This, in turn, has given Toni the ability to experience the joy of his own individuality and creativity, thus creating an internal state that seems indescribable in words and yet gives him a deep sense of texture and reality.

This case and others similar to it have resulted in my increased interest in the work of Bernard Brandchaft, best known for his contributions to the development of contemporary inter-subjectivity theory. Brandchaft gave an illuminating contribution to the understanding of defenses and resistances, analyzing the structures of the pathological accommodation that occurs when large areas of self-experience have been abandoned in order to maintain ties that were perceived as necessary.[4]

The function of pathological accommodation is to maintain a "borrowed cohesion" by a closer attachment to objects, shaping development around unchanging principles and compulsively attempting to preserve those attachments intact.

Brandchaft describes the systems of pathological accommodation as he encountered them clinically, and he stresses the extent to which they have become interwoven into the nuclear components of self-experience, shaping the sense of self in profound and lasting ways. He underlines, then, the "dread of not to repeat" when, in the analytic process, the approach of change conveys a sense of threat to the self if there is a shift in its familiar orientation and allegiance. Feelings of deep anxiety, and fears of loss of the self, are in this case primary factors of the resistance to change.

Toni's self-effacing attitude, by which he distanced himself and retreated from life's challenges for fear of disturbing the environment with assertive behavior, as he had experienced in childhood, was denying his rich personality full expression, leading him to a general sense of futility and, ultimately, to depression. In therapy, I addressed his structures of pathological accommodation, reinforcing in parallel the real authentic qualities of the patient as they slowly emerged.

I believe that the long work on myself and the investigation of reality beyond appearances that marks my artistic experience have been instrumental in this and other cases, to create an inter-subjective field in which patients can gradually discover their personal and profound reality.

Effortless being

I have described so far the parallelism of my two core professional activities, those of analyst and painter, their origins near and far, and their mutual influence. These two aspects of my personality coexist in harmony, and I have never felt that they belonged to two separate parts of myself. They are the same thing, in the sense that in both fields I express myself. From a practical point of view, however, it is difficult to manage in parallel two activities that require much time and a high degree of concentration. I am not able to switch the on/off button quickly when moving from one activity to another.

There are fundamental inner differences between being an artist and being an analyst. As an artist, I dive into myself, while as an analyst, I dive into another. If a creative project is in progress, all of my attention is devoted to its development.

Similarly, when I have a particularly challenging patient, my attention and vigilance is constant, even outside sessions. I keep thinking about it, and I sometimes reach a sudden insight, uncovering something that I did not understand, or formulating inside myself the right words to use. I often find myself saying, "Ah, this is what I can say!"

In practice, therefore, I create separate spaces in order to carry out two tasks that require a lot of concentration and energy. If I have to work on a complex art project, such as the development of a theme or a new experiment, I take time out from work. For example, during the course of the aluminum project that I described at the beginning of this essay, my mind was totally occupied with it. I was thinking about how to move the project forward during sessions and as soon as I saw how to do this, I decided to work on it during the Christmas holidays so as not to invade the space reserved for my clinical work.

In the same way, clinical work can interfere with my artistic work, distracting me from what I am doing artistically. The term "active meditation," which defines my art, gives an account of a process in which meditation arises from practical expedient action, and the word "active" sets it apart from pure contemplation.

This basic attitude has led to the gradual elimination of predetermined intentions, unconscious or automatic repetitions. I am, step-by-step, surrendering to something that is spontaneously transferred from inside myself to external action, with the feeling that the ordinary sense of myself has temporarily disappeared. I described earlier how the new experience of painting on aluminum has changed my way of painting, following instinct rather than previously established artistic canons. This project resulted in something unexpected, which I perceived as a radical change that surprised me, and, in retrospect, I realized that I was able to do much more than what I expected of myself and believe that it made me more sensitive to unpredictable developments.

Milner hinted at this different sense of self-wondering when she said:

> Is it not possible that blankness, lack of mindfulness, can also be the beginning of something . . .? Is it not possible that the blankness is a necessary prelude to a new integration? May not those moments be an essential recurring phase if there is to be a new psychic creation? May there not be moments in which there is a plunge into no-differentiation, which results . . . in re-emerging into a new division of the me-not-me, one in which there is more of the "me" in the "not-me," and more of the "not-me" in the "me?"
>
> *(1957, pp. 154–155)*

The explanatory hypothesis of Milner and the same language she used is formulated within her psychoanalytic frame of reference, but I have included it here because it describes an experience that opens the door to self-change and progressive soul-searching.

This temporary removal of the self from conscious self-monitoring has been described by artists, when, after a long time, they can paint with almost no effort

and the artist as maker appears to be absent. This is perhaps what Brancusi called the loss of the ego. At this point, being absent can have more weight to it than what we might construe as being present. Artists share the experience that the ultimate goal of their efforts is precisely to act almost effortlessly.

I noticed that patients experience this same state of effortless being when they can get in touch with their authentic quality and with their spontaneity. It is often surprising how many things suddenly become simple, and how they operate almost "effortlessly." In fact, it takes quite a while to arrive at the point where spontaneity and simplicity are the norm, allowing one to do things without effort. Indeed, it seems as if most people think that worthwhile activities must require significant effort, but being oneself should not.

However, this requires a long walk.

Notes

1 The award, organized by a leading company in the marketing of metals, Co-Mel (Commercio Metalli), was created to establish a synergetic collaboration between art and business, drawing attention to the creative potential of aluminum, through its expressive, aesthetic, and communicative qualities.
2 Marion Milner (1900–1998), a British teacher, painter, and essayist, was introduced to psychoanalysis by Donald Winnicott, and was part of the Independent Group. *On Not Being Able to Paint* was published in 1950 under the name of Joanna Field and then republished in 1957 with a preface by Anna Freud. Milner, M. (1957). *On not being able to paint*. London: Heinemann.
3 Boringhieri, B. (2003). *Heinz Kohut: Introspezione ed empatia*. (English translation) *Kohut's writing on empathy*. Carusi, A. (Ed.). Rome: IAPSP Archives.
4 Brandchaft, B. (1994). *Structures of pathological accommodation and change in psychoanalysis*. Unpublished manuscript; Brandchaft, B. (2010). *Toward an emancipatory psychoanalysis*. London: Routledge.

10

ON BEING AND BECOMING

Julia Schwartz

FIGURE 10.1 *this and no other*

Source: Julia Schwartz. Oil on canvas, 2014

> I can't start
> I can't start this paper.

It's easier to start a painting than to start a paper. Writing a paper is like writing an artist's statement: putting into words – this suddenly foreign language – something that is fluid and prereflective, reflexive. It is like writing a paragraph about how to ride a bicycle or tie your shoelaces by breaking it down into its smallest steps so that what happens organically and naturally feels unnatural, studied. Then you have to figure out how to make it natural again.

So I keep starting over. Starting in different places, but it doesn't get any easier. So I will start in an old place. And see where that gets me.

The old beginning

In 2009, I was invited to give a paper on "Art, Creativity, and Aesthetic Gesture," which was presented at a conference in Chicago:

> I returned to art after more than a decade working as a psychoanalyst. And though my work as an analyst involves words as the medium for communication rather than paint, color, and texture, the two fields are quite compatible as I see them – they share an intent to strip away outer layers and surfaces to reach some deeper expression of feeling.
>
> In my studio as in my office, I try to have as few expectations as possible, and have found that when I do have expectations, I am usually disappointed. I rarely have specific agendas or plans for my work, although there may be an overarching idea or principle. I work on multiple paintings at a time and often on more than one series at a time. I prefer to work in a state as though all the work is in process or in progress.
>
> The approach I take in the studio is similar to the one I take clinically. With the first marks on the canvas, there begins a "dialogue" of sorts, in that what is there exerts an influence on me. Just as when one is engaging with a patient, there is reciprocal mutual influence, only in this case it is an inanimate object... or is it? The canvas is for me something I have a relationship with – I started to type "someone" – a non-living, non-breathing thing that needs to breathe and be given a sense of life. I think I begin, but then it is a back and forth, and of course there are other influences as well – personal history, the world, music, literature, voices. And voices can include both helpful voices but also "idle chatter." So here, too, I am no "isolated mind" but a "world drenched in meanings." All exert some pressure, all make some mark; even as I might make effort to hold them at bay, they are making their mark on me.

FIGURE 10.2 *monarch*

Source: Julia Schwartz. Oil on canvas, 2014

Parallel process process

"Process" means something different to artists than to psychoanalysts. The "process" in "process art" refers to the technical aspects of making the work, the process of the formation of art. But when I use the word "process," I am usually speaking as a psychoanalyst and referring to unconscious processes that are continually influencing the making of the work.

Since 2009, I have continued to write in various forums about the parallels between artmaking and psychoanalysis:

> The other thing about psychoanalysis that is like painting: it is a process that depends on a willingness to give up on certainty, on knowledge, on technique, or on absolute truth.
>
> *(personal notes, 2013)*

> Both fields are practiced in relative solitude, both are undertaken with minimal preconceived intentions, both invite a kind of open-door policy to interpretations.
>
> *(Schwartz, 2012)*

> One thing in common about painting and psychoanalysis: it doesn't matter where you begin, it only matters where you go. Or maybe that you begin at all. It's about the process, about making the painting, including all the mistakes and false starts and dead ends.
>
> *(personal notes, 2014)*

> Being an analyst is a way to be creative within the larger field of psychotherapy, but I think I had been missing part of myself over many years. I always kept active with drawing, but still, part of me had been largely dormant. In the mid-90s, I returned to art in an active way. I took figure drawing classes for a few years, then a painting workshop to learn some rudimentary techniques. After a couple of years, I realized what I needed was to be on my own. I enjoyed the support and the encouragement of the group, and the mentoring I received from teachers was invaluable. But finally, what I needed was just to paint.
>
> *(unpublished correspondence, 2010)*

> I have written something like "*my only intention is to paint without 'intention' which means without conscious intention, because of course there are unconscious intentions (intuition?) guiding the work.*" There are all these things stored up in my mind. I've referred to it as a rolodex of images, memories, feelings, maybe it's a color, a sound, a song, a dream. All of that is with me all the time as possible sources for the work, and I try to be open to whatever is most at the surface at any given moment. I also have described it like a dialogue between me and the canvas, a conversation, an associative process, so the work is usually free-flowing, at least until the end when I might start to have more of a conscious "voice." This is where technique or skill or editing comes in.
>
> *(Brennan, 2011)*

I read or heard once that people paint over and over the thing or relationships that they struggle with, and that fascinated me. For many years, I painted solitary figures.

FIGURE 10.3 *after the visit*

Source: Julia Schwartz. Oil on canvas, 2011

I sometimes painted figures in multiples – pairs and such – but what came naturally were figures in isolation. After the Japanese earthquake and tsunami, the paintings changed dramatically: I stopped painting figures and started painting islands, and shapes that became abstracted. After my show *The Hollow Sea* in 2011, the figures came back a bit, but in a much different way – that was a surprise.

> I began painting islands and icebergs, shapes that took the place of figures. The emotional feelings in the paintings were very much the same, how-ever. The first paintings were little studies about what it was to be an island geographically and metaphorically – I think my feelings for Japan, and even before that, Haiti – all of that maybe factored into those paintings and that shift. And then I took some pieces of writing, grief poems into the studio. One line in particular – "Ice immobile in a hollow sea melts no more." Subsequently, the line between abstract and figurative, that distinction doesn't

seem relevant. I paint, and sometimes the painting has bits of recognizable imagery and sometimes it doesn't.

I read a great Milton Resnick line: "You have to give in to what the paint says – you have to do what it's telling you to do." Materials really have an impact. I was working on small primed linen canvases, which made for some very delicate, sensuous paintings because the linen is so luxurious. Raw linen made for rougher works.

After a solo show, when I was also having a lot of studio visits, I did several paintings that were very odd self-portraits – you might not even know it was a portrait at all except that there are these sort of googly eyes – a reaction to all that attention. I paint what is going on around me, and what is going on in me and with me, so I guess it is as close to a journal as I get.

(Seed, 2012)

FIGURE 10.4 *Insomnia #0813*

Source: Julia Schwartz. Gouache on Bristol paper, 2015

Solitude

I think solitude is very important to my creativity. I am a middle child, and grew up with the feeling of needing to be a caretaker. There wasn't a requirement from my parents *per se*, but I had a little brother, and an older sister who at some point was an unhappy teenager, and a grandmother who had medical trouble and who needed caretaking, and so on. I am just organized to feel responsible. I say this because I think the responsibility aspect of my personality might be linked to why I became an analyst. And I think the art, which took place in solitude – alone in my room – was a kind of sanctuary, a respite from the caretaking role. From the earliest age, I drew. And early memories of drawing are often of my being alone in my room – not lonely, but alone. There is a story told with great affection from my childhood: if I was sent to my room as a punishment, I never wanted to come out after the punishment was over. Being alone in my room was no punishment at all.

I also spend a lot of time being a "receiver" of sorts in many relationships: as an analyst, I am in an intense relationship to and with patients, and in the personal sphere, of course, the relationships are intense. When I say "receiver," I do not mean "receptacle" in a Bionian sense, but I receive and hold images, ideas, phrases and lines from books, songs, patients, and world events. Again, I have come to know this about myself. I think I hold so much unconsciously that it requires time spent in solitude, in a reverie state, for the various images to coalesce in some way that makes sense in my work. When I come into the studio, that is the time for not thinking but for being present with the materials and just painting. Much later, there is time for a kind of back-and-forth "dialogue" between myself and the work, and thinking, analyzing, and so on goes on at that point.

The "night studio"

The drawing alone continued in a practice that I refer to as the "insomnia series" or "night studio." This referred not just to the hour of the day when the paintings were produced but also to my mood and state of mind. The paintings were equivalent to counting sheep – done in a meditative state and with a purpose of calming down and gathering myself at the end of the day (I imagine how others use a drink or meditation, yoga, etc.). As time has gone on, this work has expanded beyond night hours, so the title is a bit of a misnomer. The earliest ones reminded me of John Berger's quote about Morandi: "objects which don't yet exist . . . They are not objects. They are places (everything has its place), places where some little thing is coming into being" (Berger, 2009, p. 144).

Identity

For the first third of my life, my identity was firmly tied to art. My family is evenly divided between arts and science, and I moved somehow between those, tending towards the arts, but especially drawing. During the middle third, which included college and young adulthood, I turned towards the sciences: in college, I

changed majors from dance to biology. I went to medical school and then studied psychiatry in Boston, finally returning to California to become a psychoanalyst. It wasn't until ten years later that I returned to art and my original identity/identification. And in this third third of my life, I am a painter who practices psychoanalysis, a psychoanalyst who paints.

Had I abandoned that original state, that original identification as an artist? I think it was ever-present, quiescent perhaps, but finding expression in myriad small ways. I would like to say thank you publicly to my Seventh Grade art teacher Mr. Bassler, who taught me about blind contour drawing. During all those clinical years, that tool, that gift, was ready at hand, and I employed it. I use it still, in hotel rooms on vacation, watching sick kids sleeping. Over the course of my life, I drew when I could, and when I couldn't, I reminded myself to remember – in that Proustian way – the hotel room in Rome when it was blindingly hot and my baby was delirious, and I could do nothing but feed her sips of rehydration solution and read to her from David Foster Wallace's essay "A Supposedly Fun Thing I Will Never Do Again." When drawing isn't an option, sensory recall is what you have.

FIGURE 10.5 *Insomnia #0825*

Source: Julia Schwartz. Gouache on Bristol paper, 2015

2015: broken

2015 is the year my life broke, my family broke into a million pieces: first, an illness and then, from nowhere, an unacceptable death. For a while, I could not draw or paint at all, only sat in the studio and wept, or wailed. Slowly, I have been starting to paint again, and it may well be what saves me.

But how do you make sense out of senseless events? How do you find meaning in going on when you can't go on? What does a painting of a world look like when the world is emptied out?

The following note was written after installing a show called *States of Being* at the Torrance Art Museum, which included nine artists in all, in which I showed three paintings done after the death of my daughter:

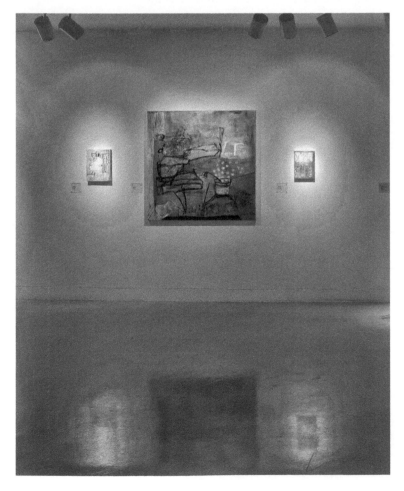

FIGURE 10.6 *States of Being*, installation at Torrance Art Museum

Source: Julia Schwartz. Oil on canvas, 2015

I'm sitting in Gallery 2 surveying the scene. I am surrounded by highly saturated paintings beautifully painted, bright colors. And then these works on the back wall, sanded down, so thinly painted you can see the pores in the canvas like it's skin.

Isn't that the point?

Under hot spotlights, this is my state of being: wrecked, ruined. My skin is raw. I can't get the color right and so I scrape and sand and try again – the Sisyphean painting.

These paintings are unfinished and unfinishable. If I finish, I will have to acknowledge you are indeed gone, gone to ash, body conveyed by some crazy machinery.

In the main gallery, music plays – a combination of video sound and drilling. A perfect soundtrack for a bombed-out life.

FIGURE 10.7 *many ways to see*

Source: Julia Schwartz. Oil on canvas, 2014

Epilogue: the artist statement

I have always liked Keats' idea of "negative capability" and it has been a touchstone in my life and in the studio. This may come in part from being essentially self-taught, although my colleagues remind me they too are always learning on the job. Without the benefit or burden of formal "technique" in painting, I am comfortable with doubt and uncertainty, a stance that fits me well because it is compatible with my nature.

Painting is dialogic, a visceral and gestural call and response as an image is being formed. Some paintings have taken external images and events as their source material, including floods, disappearing icebergs, California light, and the turbulent landscape, while other paintings have taken internal states as their subject matter. After the Japanese earthquake and tsunami in 2011, I stopped painting figures and began painting structures of bone, flesh, and ice, as though the human form were no longer adequate to hold what I felt about the state of the world. Since then, figures slip in and out of paintings at will.

There is a philosophical idea that suggests a work of art is most effective and meaningful when it offers a window into how the artist is making sense out of her existence at the time the work is made. I find myself trying always to find and show myself in my work, grounded in my time, in my locale, in my situation. It is this process rather than the end result or final appearance that is paramount for me.

References

Berger, J. (2009). *The shape of a pocket*. New York: Knopf.
Brennan, V. (2011). Julia Schwartz [interview]. Retrieved from http://studiocritical.blogspot.com.au/2011/06/julia-schwartz.html
Schwartz, J. (2012). Editor's note. Retrieved from http://figureground.org
Seed, J. (2012). A conversation with Julia Schwartz [interview]. Retrieved from www.johnseed.com/2012/07/a-conversation-with-julia-schwartz.html

11

ECHO

Dan Gilhooley

FIGURE 11.1 *Self-Portrait*

Source: Dan Gilhooley. Graphite powder and linseed oil on panel, 2007

I knew from the time I was 12 that I wanted to be an artist. I spent hours drawing. No one in my family was artistic, so right from the beginning it marked me as different. No one around me made art, so no one knew about the magical marks my pencils made on paper. I was an athlete in high school. It was unusual to be a passionate art student and captain of the football team.

Then my dad killed himself. My father had landed at Normandy in the Second World War, and suffered a traumatic brain injury during combat. Today, we'd say his death was the result of "post-traumatic stress," but there were no words for it then. This profound event broke my family. After high school, it propelled me a thousand miles from my home in Wisconsin to New York City, where I learned to make art as I recovered from my father's death.

At Hunter College, I was taught art in a world of geometric abstraction. The sculptor Tony Smith was the central person in the department, and he was a very charismatic teacher. I have a photograph of him in my office waiting room. After graduate school, my interest in making abstract art diminished. My best ideas produced mediocre results. Although I worked hard at making pictures, there was nothing mysterious or captivating about them. I became disenchanted. I saw my ability to make art dissolving but I didn't know what to do about it. By the time I was 30, I too was suicidal. My father's suicide had planted the belief within me that I'd do the same thing. That's when I entered psychoanalysis. That changed my life and the kind of pictures I make.

In the beginning, my analysis was about staying alive session to session. My first hour ended with me asking the analyst, "Do you think I can keep from killing myself before our next appointment?" During the first year of my analysis, I worked mostly on my relationship with my father and my experience of his suicide. During those early years of therapy, I struggled to produce the kind of formalist paintings I'd been taught to make at Hunter, but I couldn't. Eventually, I decided to do some drawings as I had as a child, just to fill the time before inspiration returned. I made a portrait of my girlfriend, of my mother, and of my father's lips. Making pictures about people I loved felt important. At first, I thought these drawings were inconsequential, though making them was very satisfying. After a couple of years, I began to exhibit the drawings. Then I showed my work to a curator at the Drawing Center, who remarked, "Your drawings become a lot more interesting when I hear your stories about them." So I began to write short memoir pieces and exhibited these stories on the wall next to the images. Over the next decade, I produced a body of work, exhibited a lot, and developed an artistic identity.

What I liked about drawing was that it was simple and direct. You only needed paper and something to make marks. Because I worked realistically, drawing involved me in a repetitive process of observing and recording. These were two different activities. Observation attached me to my model's material presence: I'd see the shape of a nose, the texture of flesh, or the tone of a shadow under a chin. Observation also stirred an emotional reaction in me to the presence of this person I loved. Recording what I saw, on the other hand, involved an imaginative act of marking. Using pencil or pastel, I tried to invent a reality on paper that replicated

the material presence of my subject along with the emotional tenor of what I was experiencing at that moment. Through this intimate dance of seeing and marking, my mind became linked with my subjects.

I drew slowly. Some artists are able to capture meaning in spontaneous gestures. For me, meaning emerged through a prolonged meditative process of observing and recording. I wasn't sure of a picture's meaning before I made it. I often portrayed my subjects caught between states like desire and decay. Perhaps as an imprint of my father's death, time and mortality were ever-present themes. The process of repeatedly observing and recording was transportive. In fact, what I enjoyed most about drawing was how it changed my mind. I became lost in a meditative trance.

Then something mysterious happened. In 1988, I made a drawing of my future wife Pat, which I entitled *Selene*. Selene was a name unknown to me at the time, and it would be two years before Pat discovered that she had a great-grandmother named Selene St. Onge. This was the beginning of my feeling that when I made art I wasn't alone. More importantly, when I finished this piece, I looked at it and realized that it was a better drawing than I was capable of making. I was reminded of the 1980 Olympics when the American hockey team defeated the heavily favored Soviets for the gold medal. The American amateurs couldn't compete with the more skillful Russian professionals. But the Americans played beyond their ability and won a match that is remembered as "the Miracle on Ice." For the next 25 years, I had this experience again and again – I repeatedly made pictures that were better than my ability, pictures that seemed to be made by something more than me. This was a strange feeling at first – disconcerting, perhaps dissociative. But over the years, it occurred so often that I came to accept it. Like the American hockey players, on those occasions I drew beyond my ability. Not that my work was actually "miraculous," but the experience was humbling. I'd say, "I know how good I am, and I'm not *that* good." It seemed certain that this experience was linked to my slow meditative process. It was a product of the trance.

My artwork grew directly out of my psychoanalytic experience. In fact, I became an artist *as* I became a psychoanalytic patient. The memoir fragments that I sometimes exhibited alongside my drawings were linked to the visual image like a free association. The psychoanalysts I worked with saw themselves as witnesses of my development. Their goal was to understand me and help me understand myself. They were the first audience for my artistic creations. I'd been taught both as an artist and as a psychoanalytic patient to be original, personally expressive, and truthful. From my perspective as a patient, creativity and artistic expression were the heart of psychoanalysis.

I was transformed by my psychoanalytic experience. Psychoanalysis changed my life. I couldn't get enough of it. After eight years of individual analytic work, I entered a psychoanalytic training program at the Center for Modern Psychoanalytic Studies in Manhattan. I had no previous education in the field of mental health, but that didn't make any difference to the faculty at CMPS. I was fortunate to have entered such a liberally accepting institute. I became passionate about the study of

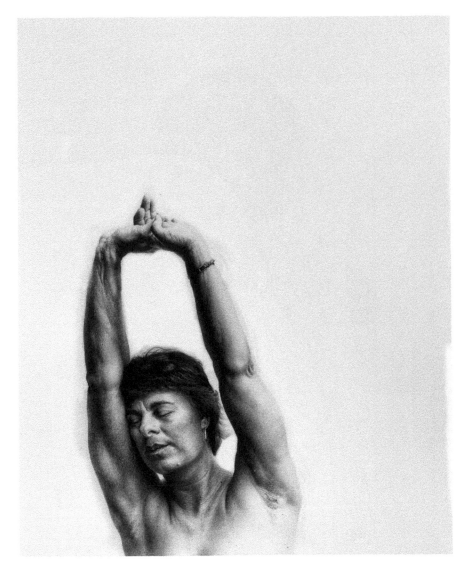

FIGURE 11.2 *Selene*

Source: Dan Gilhooley. Pencil on paper, 1989

FIGURE 11.3 *Diver*

Source: Dan Gilhooley. Pencil on paper, 1990

psychoanalysis, its history and theory of mind. It took me nine years to complete the Center's program. When I'd finished my clinical education, I traveled to Boston for a masters and doctorate in psychoanalysis, earning both degrees from the Boston Graduate School of Psychoanalysis.

My first challenge as an artist wanting to learn how to be a psychoanalyst was the form of psychoanalytic education itself: I'd entered a psychoanalytic *training* program. The word "training" might seem insignificant – but it wasn't to me. Training is the form of education used in the military, athletics, or business where an authority has predetermined how I should behave. The psychoanalytic authority was Freud or the guiding light of my institute, Hyman Spotnitz. As a student, I was taught a variety of protocols based on the formula: "if the patient says this, then you say that." So when a patient entered the consultation room, I'd open my mouth and Freud or Spotnitz would speak. As an artist, I found training to be the antithesis of art and psychoanalysis. I couldn't imagine anyone thinking this authoritarian form of education was a good idea. My artistic education had emphasized discovering one's unique form of expression and cultivating the confidence to speak. So, as an artist, training was a continual stimulus to develop my own psychoanalytic voice.

In my 15 years of psychoanalytic education, I had a lot of time to sort out the kind of analyst I wanted to become. Freud developed a clinical practice based on anonymity and emotional detachment, where reason transformed irrationality. In his view, an analyst should put aside all feeling and act with the coldness of a surgeon. Significantly, Freud was never a psychoanalytic patient, and I think if he'd been a patient, he'd have developed a different kind of clinical practice. It was my experience as a patient that most shaped the analyst I was to become. My most transformative experiences occurred through empathic contact with my analyst, often at moments when he or she revealed something personal.

Here's a dramatic example. After five years of analysis, I arrived to a session in which my analyst seemed unusually remote and detached. About 15 minutes into the session, I said, "You seem very distant. You don't seem to be present, or connected to what I'm saying." I felt confused and injured by his emotional absence. We discussed my reaction briefly. Then he said, "My wife died this morning. I called your home and work to cancel our appointment but I wasn't able to reach you, so I came in for the session." I was stunned. I asked him the cause of his wife's death. He said, "She's been sick for some time." I asked if she'd died in a hospital. He said, "Yes." He paused, and then said, "Her death wasn't really a surprise. But I wasn't prepared for it." Another pause. "I guess there's really no way to be prepared." I cried. He may have cried too, I don't know. I told him how sorry I was. I asked if I could hug him or hold his hand. He said my response meant a lot to him, and asked me to put my feelings into words.

I realize now that I became a psychoanalyst at that moment, and that experience cast the die for the kind of analyst I'd become. When he revealed that his wife had died, my analyst galvanized our therapeutic relationship. Through his stunning revelation, I felt that he and I were one. We both were struggling with the death

of someone we loved. We'd both been knocked flat. Spotnitz would say that my analyst's words fostered a mutual "narcissistic transference." Spotnitz believed that this symbiotic state of mind had to exist between the patient and the analyst for therapeutic change to occur. I could feel my analyst's absence, his wife's absence, and the echo of my father's absence. Absence filled the room. My analyst's words came as a shock, just like the shock I felt when I learned of my father's death. But most

FIGURE 11.4 *Pat After Her Father's Death*

Source: Dan Gilhooley. Pencil on paper, 1997

importantly, in the midst of absence, when he spoke to me truthfully, it was clear that he remained with me. In this symbiotic state of mind, he protected me through the loss we both were experiencing.

As I began practicing psychoanalysis, I developed a clinical approach that reversed Freud's basic position. I became as transparently present as the patient wanted me to be, I became deeply involved emotionally, I welcomed irrationality, and I tried not to intrude. I gave patients lots of room to sort themselves out, to become the people they wanted to be. Although I wasn't aware of it, I approached my patients as fellow artists. I wanted them to each develop their unique voice and the confidence to sing. Most importantly, I identified with my patient to such an extent that I "became the patient." I subjectively "lived" my patient's experience just as someone look-ing at my pictures "lived" my experience. In my mind, we were artists and patients together.

Ultimately, I became the complement of the emotionally detached surgeon oper-ating on a diseased patient. Therapeutically, I came to see my patient and myself as each other's echo. In the early years of psychoanalysis, Georg Groddeck (1976) was the first analyst to discover "the strange fact that I was not treating the patient, but that the patient was treating me" (p. 301). Groddeck's observation shaped the work of his close friend Sandor Ferenczi, who in turn influenced a string of analysts – Frieda Fromm-Reichmann, Harold Searles, and Hyman Spotnitz – each of whom inspired my clinical work. Returning to the dramatic example earlier, it's more accurate to say that, drawn from his self-revelation, my analyst and I sheltered each other through the loss we both were experiencing.

Here's a case that illustrates the therapeutic symbiosis described by Spotnitz and Searles, and my ideas about the echoing process. It's an example of how being an artist affects my psychoanalytic work. Ten years ago, I began seeing Frank. His son Anders had cancer and Frank wanted me to help Anders fight the disease. Anders didn't want my help, but Frank stayed to talk about his anger and despair. Anders fought his cancer for six years, enduring ten surgeries and losing an eye before he died at the age of 23. On the last day of his life, Anders made his father promise he'd recover from his grief. But the loss of Anders was unbearable. Frank often talked about killing himself. He wanted to buy a gun and blow his brains out. Having endured six years of suffering with his son, he wanted to put an end to the pain. He wanted to join Anders in death.

Frank picked out a shotgun and studied it online. I told Frank he couldn't have a gun. Frank wasn't aware that my father had shot himself, or that I'd struggled with the wish to kill myself after my father's death. I knew suicide inside out. I knew the pain of a son losing his father, and Frank was experiencing the pain of a father losing his son. And I knew what it was like to keep a gun out of the hands of a killer. As a boy, I had taken a rifle from my father and hidden it when he threatened to kill us. I knew what Frank was living through. It was quite a coincidence that he'd ended up with me as his therapist.

A few months after Anders' death, I had a dream in which I woke up dead. In fact, those words, "I woke up dead," echoed in my mind, announcing the beginning

FIGURE 11.5 *Trudy*

Source: Dan Gilhooley. Colored pencil on paper, 2001

of the dream. I hovered above my body lying motionless in bed. I floated down from the ceiling and circled my body, checking for signs of life. I laid there unresponsive under a white sheet. I realized I really was dead, and guessed it must have happened in my sleep. Later that week, near the end of his session, Frank said, "I had a strange dream this week. I dreamt that I woke up dead." Frank said this dream was a turning point, a sign from his dead son. Anders had achieved angelic status and was now guiding Frank's mourning.

During the next week, Frank began writing a story about life after death that started with the protagonist announcing, "I woke up dead." This short story evolved into a dreamy noir detective novel set in a timeless space between life and death, in which an unnamed man tried to find the path to eternal life. Frank had never done any creative writing. His education had been in science and mathematics, and he'd had a career in technology. Writing was something new. Frank attributed his creativity to his deceased son, Anders. Anders' artistic nature was now inspiring him. Frank worked on his novel continuously for the next three years, each week reading segments to me during his sessions. His novel became the focus of his mourning. I thought of it as a metaphor for our therapeutic process, and a description of our unconscious interaction.

The month after Frank began writing, I began writing about Frank's writing. I became Frank's literary echo. Frank had no conscious awareness of my writing, but as his novel progressed, it made repeated references to twin authors of the same paper. For example, in one chapter, the main character and his psychoanalyst simultaneously declared they'd written the same article, "The myth of mental illness."

In another chapter, the protagonist and his double from a parallel universe had both written the same scholarly paper, "Conversations with Schrödinger's cat." Beginning with our mutual dreams of waking up dead, Frank described twin authors creating the same text, each echoing the other.

The double (or echo) became a central motif in Frank's novel. In several chapters, Nigel, a detective fashioned after Raymond Chandler's Philip Marlowe, was pursued by his double, a detective named Raymond. Raymond had been hired to find Nigel precisely because they were so alike. No one could have anticipated Nigel's next move like Raymond, because Raymond *was* Nigel. At one point, Nigel appeared to Raymond in a dream and said, "You are me but one door behind. I came back to warn you." Raymond followed in Nigel's footsteps, always one step behind, always an echo. By the conclusion of Frank's novel, Nigel and Raymond had joined forces. From my perspective, Nigel and Raymond were representations of Frank and myself, and their fictional journey was our therapeutic experience.

Although Frank had no knowledge of my personal life, there were several parallels between his novel and myself. Considering that a father–son relationship is a fundamental theme in our work together, Frank wrote a chapter in which a boy was raised by a shell-shocked war veteran whose unrelenting memory of combat disabled him, rendered him unemployable, and led to his suicide. This story mirrored my life growing up with my father. In Frank's story, the son was his father's sympathetic confidant, just as I'd been with my father.

Fear of suicide was always in the background of our work together. In one of Frank's chapters, a psychoanalyst placed a pistol to his head and killed himself. Because of my father, I'd entered psychoanalysis believing it was inevitable that I'd place a pistol to my head. This was my deepest trauma, a future I'd anticipated but desperately wanted to avoid. As Frank read his vignettes to me each week, I came to believe the similarities between Frank's story and my life were the product of our symbiotic state of mind. In an area in each of our minds, we shared the same mental space. Like Nigel and Raymond, when we arrived at that symbiotic place, Frank and I were one.

Here's a more elaborate example of symbiosis and the echo theme that emerged in Frank's book. During those first months when Frank began writing his novel, I had a strange premonitory experience. For the past 17 years, each Friday morning I leave my home in Bellport and drive to Babylon to catch a 5:12 train to New York City. My first appointment in New York is at seven o'clock. On this early December morning, I stepped out onto my porch and thought, "Flat tire." In the darkness, I checked the tires on my car, but I didn't have a flat. I drove to the train station. When I turned off Sunrise Highway to merge onto a two-lane highway heading south to Babylon, there was a problem. Coming around the cloverleaf turn at about 50 mph, there was a car immediately to my left traveling at the same speed. The driver didn't move over to let me merge onto the highway. About 50 feet in front of me I saw the flashing taillights of a vehicle parked at the edge of the cloverleaf. I got a panicky feeling. I stepped on the brake and, slowing down, I tucked in behind the other car. In an instant, I passed a guy kneeling down changing his car's left rear tire. There was no shoulder and his legs were sticking out onto the highway. In the darkness, I hadn't

seen him. My headlights caught his face looking up at me as I whizzed by. Passing within a few feet of him, I thought, "Close call. What a terrible place to change a tire."

I was shaken by the realization that I'd nearly struck a fellow kneeling in the dark at the edge of the highway. I didn't see him and came within five feet of killing him. I wondered how it could be that 20 minutes earlier I'd thought, "Flat tire," and now I just missed hitting this guy changing a flat tire. I tried to make sense of

FIGURE 11.6 *Cameron in the Backyard*

Source: Dan Gilhooley. Pencil on paper, 2005

this coincidence. Could I have known I'd encounter a flat tire before it happened? I didn't recall ever seeing a car with a flat on this Friday morning drive. I wondered whether a part of my unconscious mind existed in the future. Maybe an unconscious part of me had already made this drive and was warning my conscious mind about the danger ahead. Of course, this seems impossible. Nonetheless, passing this close to death fueled my curiosity. I kept playing the experience over in my mind, and my place in time seemed less secure.

Next I questioned my location in space. Perhaps, in an unconscious form of awareness, when I stepped onto my porch, I was actually in Bellport and Babylon simultaneously. In fact, if a part of my unconscious mind is untethered in time, where would I be spatially? Would I be "located" where my conscious mind is attending to reality? Is it possible that in my unconscious I could be in multiple times, in multiple locations? And if I'm in multiple locations simultaneously, are location and time only determined by conscious attention? What makes conscious attention the basis of reality? We know empirically that consciousness comprises only a tiny fraction of mental life. For example, scientists estimate that of the millions of bits of information our eyes process each second, around 16 are consciously experienced (Norretranders, 1998). The rest of this visual information is retained in unconscious regions of our mind where, hidden from consciousness, it determines our behavior. Furthermore, consciousness runs a half-second behind our unconscious mind, which initiates every action, causing many researchers to describe consciousness as epiphenomenal (Libet, 2004). These facts hardly inspire confidence in my reliance on consciousness as the arbiter of reality. I mulled over these questions for weeks. This flat tire experience had a lasting effect, leaving me uncertain about fundamental aspects of myself in the world.

My growing uncertainty about my place in space and time found an uncanny echo in Frank's novel. After writing for about six months, and reading bits to me during sessions, Frank gave me copies of his first two stories. At home, I read his second story, "Convergence," a science fiction story in which a mathematician published a controversial essay demonstrating the existence of parallel universes. This paper upset a group of physicists who tried to undermine the mathematician's career. Distracted by this professional conflict, while driving on a dimly lit road, the mathematician accidentally sideswiped and killed a young man who was changing the left rear tire on his broken-down car. This event dramatically altered the mathematician's life, leading to a mental breakdown followed by years of psychoanalytic treatment. In Frank's story, the accident was attributed to "twilight, poor visibility, and too small a shoulder," all attributes of my near-miss. Although I remembered Frank reading this vignette to me months before, it was a detail lost in a sea of information.

During our next session, I asked Frank when he wrote "Convergence." He began writing it in late August and finished it in October, a couple of months before my flat tire experience. So Frank wrote about a life-altering experience with a flat tire in a story involving a dramatic reconception of our place in space and time two months before I had my near-miss involving a flat tire – a near-miss that caused me

FIGURE 11.7 *Trudy at Ninety*

Source: Dan Gilhooley. Pencil on paper, 2012

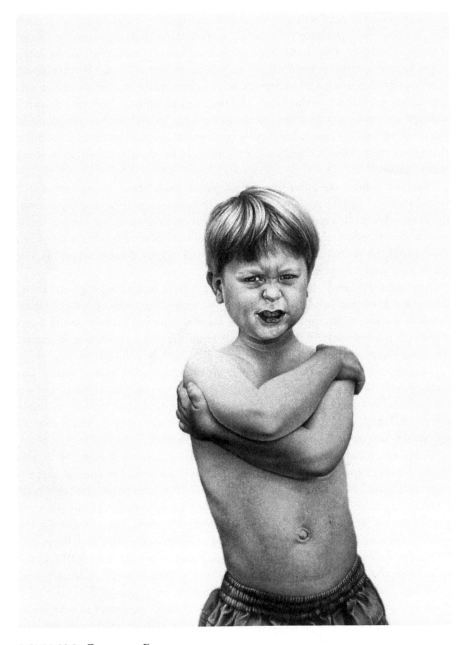

FIGURE 11.8 *Cameron at Four*

Source: Dan Gilhooley. Pencil on paper, 1995

to seriously reconsider my place in space and time. The parallels between these two events seemed too compelling to be merely coincidental.

I asked Frank about the date of writing "Convergence" to determine what came first, my flat tire experience or his story, wondering if there was causal relationship between them. One thing must precede another to be considered its cause. Frank reading me this portion of this story months before my flat tire encounter may have predisposed me to interpret events in a particular way. But that couldn't explain my experience of thinking, "Flat tire" and 25 minutes later encountering a dangerous situation with someone changing a tire. In other words, this detail in Frank's story couldn't have meaningfully contributed to my experience. Looking at these two events in chronological sequence revealed no causal relationship between them.

But look at them the other way around. Frank wrote about an experience two months before I had it. Could it be that his story was a premonition of my precognitive experience? Was his story an echo of this event in my life, or more accurately an echo from the future? Was this illusory, or could my future experience have been the cause of this portion of his present story? That's supposed to be impossible. The future can't cause the present. Or can it?

Anyway, I wondered, how could Frank even have had knowledge about my future? On the other hand, if I presumed that, within our symbiotic mental state, Frank had access to my unconscious, did his story "prove" that my future exists within my unconscious? After all, where else could Frank have got this information about my future except from my unconscious?

I know – thinking like this makes everyone's head spin. Symbiosis threatens our sense of personal integrity. Premonition alters our place in time, and time is the basis for our belief in a continuous self. To reverse our understanding of causality is simply too much. Together, these three ideas undermine our confidence in the structure of our world. Anyone could respond, "Surely this is madness!"

A loss of confidence in reality, at the very least, accurately conveys Frank's emotional experience of the loss of Anders. But, as Frank's novel progressed, his protagonists all lived in a dreamlike world in which the direction of time had collapsed. Frank's characters existed in the unconscious where past, present, and future all occur simultaneously. In his stories, the future and past each created the present. So, the questions I raised in reaction to my flat tire experience were answered in the stories Frank wrote. Two years later, when Frank's character Nigel appeared to Raymond in a dream and said, "You are me but one door behind. *I came back to warn you*," I wondered anew about premonition and my flat tire experience.

In our work together, Frank became an artist. I never suggested that he write, much less that he write a novel. Writing became therapeutic because he was free to be completely creative. He wrote whatever came to mind. Frank is amazed to have written a novel. "Where did it come from?" he asks. He never had an outline or a plan; words just arrived on the page. Frank's creativity converted anguish and anger into a story that transports him, a story that brings him comfort, a story that hopefully will affect others. Frank says Anders is his inspiration. It's Anders' hand that

guides him from the darkness of despair into the light. Frank knows his pain can't be stopped. But it can be transformed, and Anders shows him the way.

I'm curious about the mental act of echoing so evident in this case. What's the role of echo in thought, in drawing and creativity, in symbiosis and therapeutic change? The mental process of echoing happens outside of conscious awareness. It's invisible and hard to describe. We see echo's artifacts, like my flat tire experience appearing in Frank's novel, but we can't see the process that produced the echo.

I wonder if echoing has a part in the origin and continuity of mind. After all, mind must begin with an act of representation. Mind needs to create an echo of my body and the world around me, making an internal rendering of external reality before there can be any reacting, remembering, reflecting, or imagining. In fact, echoing – the creation and recreation of representations of reality – may be the primary creative act. My mind's proper functioning rests on a continuous process of high-fidelity mirroring. If my internal reflection of reality is imperfect, my actions will be flawed and deficient. So my mind makes a mirror capable of sensitively recording reality, and then appears to use this echo of reality to make new mind.

The phrase "make new mind" may seem strange. It's comforting to think of my mind as a stable collection of enduring mental structures. But my mind appears to be both stable and dynamic, both enduring and evolving. Aren't "enduring mental structures" repeating patterns that are themselves echoes? For example, aren't memories just echoes? Cognitive researchers declare that memories aren't an inventory of set images, but rather they are recreated anew (and differently) with each recollection. Perhaps my mind is similarly dynamic, created and recreated in each moment. So, just as echoing might lie at the origin of mind, echoing also appears to be a part of my mind's persistent structures as well as its growth and evolution. Echoing becomes the basis of comparison and measurement. Through the echoing process, I come to know myself as I measure the world. Echo appears to be the germ from which all knowledge emerges.

I realize that the drawing I've done my whole life is an extension of this echoing process. For me, drawing is representation. My drawings are echoes of the material presence of my subject combined with my emotional reaction to them. I'm doing the same thing with a pencil that my mind is doing. Drawing is my meditative observation of reality where I make marks in a trancelike state. Perhaps trance is important to the quality of the echo produced. Echoing is a deeply unconscious automatic process. It's not a product of consciousness, which needs to be suppressed for the echo to appear. That's what trance accomplishes: it reduces the priority of consciousness, allowing unconscious processes to slip into view.

Is there a connection between echoing and my repeated experience of drawing pictures that seemed to be "made by something more than me?" In that entranced state, do I begin to echo an invisible collective unconscious, a Jungian version of the ancient artistic "muse?" Sophia Richman (2014) emphasizes the muse's "mirroring, echoing, and admiring function for the creator" (p. 79). Perhaps the muse and I achieve a state of mutual echoing. In the *Inferno*, Dante (1980) passionately describes his will being taken over by his muse: "a single will fills both of us: you

are my guide, my governor, my master" (p. 67). Through an echoing process, do I assume an identity and intention of a collective artistic unconscious, and thereafter conclude that "something is drawing through me?"

Perhaps like echoing the muse, in our therapeutic work Frank and I became echoes of each other and this formed the basis of the symbiosis that emerged in the case. It began with dreaming the same dream. Then Frank wrote a novel based on the theme of the double. His novel contained echoes of my life, like a shell-shocked father who commits suicide, and a psychoanalyst who shoots himself in the head. Frank even appeared to write about a flat tire event before I experienced it! As Frank wrote his novel, he was unaware that I wrote a book about Frank writing a book. As I became Frank's literary echo, he repeatedly wrote of twin authors of the same text. We became echoes of each other. When we were in this symbiotic state, we seemed to share the same mind.

I think now that the echoing occurring between Frank and myself reflects the process of *us together creating new mind*. Thomas Ogden (2004) describes the analyst's and patient's co-creation of a "third" subjective representation in each of their minds, which is used for the purpose of psychological growth. The third is a new mental structure – a new piece of mind that they share. Through this newly created third, both participants are able to experience thoughts, feelings, and perceptions that had previously been outside their individual realms of experience. This newly created subjectivity – this new form of mind – "seems to take on a life of its own" and becomes the agent of growth and change (p. 169). Perhaps the echoing process is the way the third is created. Maybe that's the creative element in therapy. One obviously recognizes Frank's novel to be the product of a creative process. But are Frank's stories, his words, just the place where we've worked together symbiotically to create new mind? Is creating new mind the way we each grow through traumatic loss?

References

Alighieri, D. (1980). *The divine comedy.* A. Manelbaum (Trans.), New York: Alfred A. Knopf. (Original work published 1320).

Groddeck, G. (1976). *The book of the it.* New York: International Universities Press. (Original work published 1923).

Libet, B. (2004). *Mind time: The temporal factor in consciousness.* Cambridge, MA: Harvard University Press.

Norretranders, T. (1998). *The user illusion: Cutting consciousness down to size.* New York: Viking.

Ogden, T. H. (2004). The analytic third: Implications for psychoanalytic theory and technique. *Psychoanalytic Quarterly, 73*(1), 167–195.

Richman, S. (2014). *Mended by the muse: Creative transformations of trauma.* New York: Routledge.

12

THE ART(S) OF WITNESS

Through the camera and the psychoanalytic situation

Donna Bassin

For 30 years, I have maintained a psychoanalytic practice; for even longer, I have been an artist. The links between my work in the studio and in the consulting room are implicit to me. Attempts to make these links explicit, perhaps of more direct use for the clinician, may be viewed as doing injustice to both practices. And while for years I have attempted to elucidate those enlivened edges, without frames in which art and clinical practice are often limited, they are ultimately elusive and free-flowing (a feature I aim to represent in my photography). This essay is an attempt to grapple with the elusive nature of edge – if not to capture its essence, then at least to offer examples of how it has manifested in my own life, in the overlapping space between my clinical practice, past traumas, and my artmaking.

Ground zero

Immediately following 9/11, New York City's Department of Mental Health called me to join a small problem-solving group whose task included the facilitation of bereavement for the grieving families of the victims. I worked as a mental health consultant to the community police tasked with helping family members accept their loved ones were dead, not just missing. We faced many challenges. How could family members mourn without a body? What could the city do to facilitate the families' painful acceptance of the reality their loved ones were dead? Would the process of mourning become more difficult, even traumatic, if they were confronted with ground zero? This unprecedented experience, outside the range of clinical practice, was something none of us were prepared to undertake. Still, we decided to take them to the site.

We rode mostly in silence, traveling down the Hudson River by water ferry from the Family Crisis Center at Pier 94 to the western bank of the World Trade Center district. On board were the Mayor, clergy, Red Cross, mental health coun-

selors, community police, and 50 family members of those who were killed. These were families who were almost ready to acknowledge that their loved ones were dead, not missing, and hopefully would at the end of the journey accept a death certificate. I imagined myself as Charon, the ferryman of the dead on their journey to Hades, at the helm.

At ground zero, smoke from smoldering rubble, burnt paper, plastic, and perhaps human flesh filled the air. We were guided to a safe area, a chasm in the debris in which we could stand and try to absorb what we were seeing. "Excuse me," a woman asked, "will you help me look for my daughter?" I stood in disbelief, looking at the destruction around me and shaking my head *yes* to her while realizing I wasn't fully present. I didn't understand why we were there. I don't remember if I said anything to her, and despite my assigned task as mental health support for the community police and the families, I was lost to myself and only temporarily held together by my fascination with the sublime, the simultaneous attraction and sense terror felt in the presence of such great destruction.

All of us were briefed about what we would see, but language could not capture what we experienced. Being inside this violated and dismembered space of ground zero evoked terror and rage. Being *inside* ground zero was visceral. I lost all sense of scale, of embodiment, all sense of myself as a human being with resources. The rubble screamed the collapse of individuality, security, and mastery that was impossible to represent. Words didn't suffice and thoughts were gibberish. The experience inside ground zero tapped into a helplessness that was preverbal because there was no way to represent and contain experience. Life there was no longer a range of color but only its absence. It was gray and covered in white ash. It was "like the surface of the moon," as Kurt Vonnegut described Billy Pilgrim's first observation of the destruction of Dresden upon exiting the meat locker in *Slaughterhouse-Five*.

When it was time for us to return to the ferry, it was difficult for some to leave. I recall a woman clinging to her husband and pleading with me. "Please," she said, "Can we get a blanket for my daughter? I can't leave her in the cold." I gently told her we had to return to the boat. She asked to stay for a few more minutes. This mother knew her daughter was dead but there was still a wish to comfort and protect her. My body shook as I barely managed to suppress my own anguish. Bodily sensations cut through me like the sharp edges of the surrounding blasted masonry. The pain was familiar and ancient but unbearable.

The present frame

As I disregard the customary restraining boundaries between photographic and psychoanalytic practice, I become attentive to their enlivening raw edges and discover analogous elements. The methods leading to exposure and illumination of course differ, but I have found that attention to some analogous elements between them has enriched my practices in both the studio and consulting room. Both research methods share a common birth in the nineteenth century and early twentieth century, as well as a concern with providing exposure and illumination: making visible

things not previously seen and illuminating something other than what is usually or manifestly comprehended. While manifestly more obvious in artmaking, which has the advantage of creating material objects, both practices seek to capture and transform the ineffable into something that can be looked at, worked on, worked over, and perhaps even discarded in the service of making space for new growth something else. Both practices involve coming to know the world we live within – and ourselves – by the marks we make on the material world and each other. One's experience is shaped in the very process of finding representation.

I explore the facilitating environments of my fine art photographic practice and the psychoanalytic situation. I reject a customary use where psychoanalysis reads the art object for content and instead, following Bennett (2005), prefer to explore what art does, rather than what art says. In my own experience, artmaking, like psychoanalysis, contains its own strategy for thoughts coming into being or consciousness.

Memorial Day 1961

The day my sister died, some four decades before 9/11, the color leeched out of my childhood home – or at least that is my enduring memory. In earnest, but in a futile childish gesture, I cut out simple shapes from colored construction paper and pinned them on the bedroom doors. Childhood scribble demanded, "Be happy," or reminded, "Hey, I am still alive." I tried to restore some life and joy to my grieving family.

Similarly, following 9/11, I attempted to engage with the painful and destabilizing emotions of the victims' families, not yet aware that my own unresolved loses were impacting me.

Working-through in a psychoanalytic-informed photographic practice

I spent too much time in the devastating ruins of ground zero. The usual structures of safety and security were breaking apart and I had fallen through. Personal and political disillusionments were too challenging to be contained. 9/11 ignited my own unresolved and unrepresented losses. I was thrown back into the black-and-white world of trauma and interminable mourning.

Eventually, this crisis became an opportunity. Having had no choice but to surrender to becoming "undone," I began to process the changes that loss had brought. 9/11 led me from years of processing experiences through writing and speaking in the relatively protected space of the psychoanalytic consulting room and sent me back to strategies of childhood problem-solving.

Now, over a decade later, I realize 9/11 cracked my former structuring frames and in these cracks strategies of childhood coping strategies were there for me. Artmaking began to fill the cracks. I realized my impulse to find and/or make resonating art and gather the attention of receptive witnesses had returned, recalling my childhood need to seek support and understanding following my sister's death.

This close encounter with community grief and reactivated, unmetabolized child-hood losses (when a family loses a child, parents often become emotionally absent) overwhelmed my professional expertise, but eventually led to the development of my photographic practice and a shift in my clinical psychoanalytic work.

This reactivation of childhood losses and accompanying coping strategies set me on a journey to understand the needs of the living to process the death of loved ones, particular under traumatic circumstances, and to re-examine psychoanalytic theory and practice regarding traumatic loss and mourning.

1960s

Tension between whether to grow up and become a doctor/healer or an artist has been an enduring aspect of my life since the childhood death of my younger sister. I struggled over whether to become a doctor who might cure childhood cancer or an artist whose work would pierce the hearts of the grieving – like my parents, whose mourning of their child was interminable.

In the 1960s, I used my father's old box cameras and the darkroom where he developed his medical X-rays to document what my generation thought then would be the ultimate social revolution. I photographed the music and the protests of the late 1960s and early 1970s. When I was on an assignment from the *Michigan Daily* (as an apprentice college photojournalist), Janis Joplin threw a bottle of Southern Comfort on my Nikon and publicly demanded my removal from the stage. I stopped taking my photographic work seriously and pursued the other beckoning road: a career in clinical psychology and psychoanalysis. My camera and aspirations as a photojournalist whose work would document the tragedies and joys of the 1960s revolution and the unrepresented traumas of the Second World War were set aside.

Beyond ground zero

There was much discussion about self-care and working-through among those who volunteered to support the traumatized, terrified, and grieving community. But who was available to help the "healers" and how available were we to accept that help?

The Red Cross was there to debrief all of us. In my hubris, I refused their help, thinking I needed to quickly return to my patients. But I was running away from the smell of death. Although I was upset, I felt relatively intact. I didn't think I needed to speak of it.

That evening, I had a nightmare. I was in the basement of a house. I feared for my life and the well-being of my children. Outside was a holocaust. I was trying to fill a backpack with life support supplies so I could flee, but the seams kept opening up. The backpack ripped into pieces and the contents spilled out unusable on the floor. Around me, the room was filled with soldiers who didn't recognize me or see that I was in danger. I looked around the room and saw only blank faces.

Dolls

I had a vintage dollhouse from the 1950s in my office, and the next day, I found myself doing my own play therapy. Between patients, I constructed scenes in the dollhouse with miniature toy figures and furniture. The dollhouse was a refuge, small and manageable, unlike the world outside or in my head. Toys are ideal for reconstructing universes as they lack self-consciousness and don't feel used. Here, within the interior sanctuary of the dollhouse, I could imaginatively exist at once as both doll and animator. I moved these plastic objects around until I found a virtual but empathic resonating scenario. The open-sided dollhouse, now filled with a record of my play, created a peep show of interior life.

The world of miniatures allowed for some necessary externalization as a way station to view/reprocess and repossess. The creation of each miniature world was an act of recreating loss and remembrance. With a small world, one can take the world inside oneself. Experiences that had been too big, overwhelming, even traumatic, were now rendered small enough so they could be repossessed. Playful manipulation with and within miniature worlds allowed for temporary repossession of experiences once too overwhelming to be witnessed.

The doll is constructed to mimic the human form. But it is unable to care for and respond to the owner's feelings. Realizing that dolls aren't responsive requires an internal search for what is missing. Is the childhood of the artist marked by an ability to temporarily recognize the deception of the dolls and to continue the search for more enduring illusions? The artist's capacity to find some truth in a fictive structure may be related to that tension.

Dollhouse play was the space within my office where between patients I replenished the maternal presence, reconstituted the container, and reconstructed the shattered mirror in order to be available to my patients. Eventually, I moved the dolls outside the dollhouse. I have taken the dolls on vacation to Cape Cod, Belize, and Mexico and photographed them in new settings in order to both carry and transform the memory baggage of childhood.

The manifest objects of the images are miniature worlds on the edge of real and fantasy, past and present, history and memory, and conscious and unconscious. No one challenges the child's play as to whether it is real or not. My more successful images balance on this edge. The resulting images provide visual testimonies of absence, loss, grief, and disruption, experienced within the analytic dyad in my office as well as in New York City.

I eventually placed a pinhole camera (a small wooden box with film and an aperture with a shutter) in that dollhouse room. It served as the fourth wall. The film captured my play for later development and reflection. The camera, small enough to go inside the rooms within the dollhouse, became the eyes for an adult body that could not see what was going on inside.

I opened the shutter just before a patient walked in and closed it 45 minutes later as they left. I rearranged the scene over and over. These were 45-minute exposures mirroring the 45-minute length of a therapy session. The dolls were "exposing

themselves," enacting the fragmented traumatic experience for me, that which was psychically arrested, fixed with a camera. The dolls existed on the edge of reality and dream, a liminal space outside the frame, a space created in an attempt to reconstruct a narrative of my own experience.

A pinhole camera has no lens but rather just a light-gathering hole. The camera's aperture, standing in for the eye of the observer, was placed within inches of the dolls and created distortions of scale and, in the best of outcomes, ambiguity about the objects themselves. I began to refer to my images as something created in the space between my conscious intent and the framing capacity of the camera. I began to adjust the angle of the camera's placement to pull for hyper-real distortion. That distortion itself suggests the distortion of psychic reality. Further play with light and focus transformed the dolls and gave them illusory animations. Lacking a viewfinder, the photographer can imagine the field of vision, but in exchange, the camera often records something on the edge not consciously noticed. Each photograph, then, is a collaboration between the camera's point of view and the photographer's intent: this was a co-creation of a third eye.

The intrinsic characteristics of the pinhole camera – the simplicity, imperfections, distortions, and inexact exposures – undermine efforts at mastery and technical perfection. They often produce accidents such as light leaks or hyper-distortions. The accidents can be seen as flaws within a model of conventional photographic practice or, as I came to see, an opportunity for a useful rebellion against what we think we should see.

Breaking the frame and drawing from the edge

Both photographic and psychoanalytic practice are created within a frame. This frame momentarily contains the continuous flow of the field and focuses our attention within a viewfinder. However, frames produce edges that foreclose the forms and unthought-of thoughts that glimmer on the periphery. As one explores the limits of photographic composition, the structures of psychoanalytic practice as well as the contained narratives of our patients, one is curious about what haunts outside. What shows up at the edge? The analyst and photographer must come prepared to capture an image that has never existed before. Both require a practice in which a mindful emptiness or lack of intention (without memory or desire) is required to be surprised by the new. It takes practice, as Walter Benjamin (2002) observed, to lose one's way in a city, to allow oneself the freedom of a flâneur who could aimlessly stroll, browsing and considering equally the trash and commodities of cultural products. In my recent work as an analyst and as an artist, the frame is both embraced and subverted. In my current artwork, I attempt to play with the edges of time and space that traditionally define a photographic image.

I am interested in how the artist as well as the analytic dyad dissolves fixed and well-worn visions and disrupts familiar narratives to challenge our perception. As an artistic strategy, I photograph liminal territories and edge habitats, where the influence between bordering realities can be seen. I have photographed the glass

tunnels where people meet gorillas in their zoo habitat, at Coney Island's boardwalk where women embrace their inner fish and dress like mermaids, and many other environments.

Art becomes a witness

The preceding remarks are perhaps best represented by looking at the artwork itself. What follows are photos from *The Afterlife of Dolls* (2003), a series I created from the images I captured in the dollhouse in my office, then later sorted, edited, and exhibited at the Montclair Art Museum.

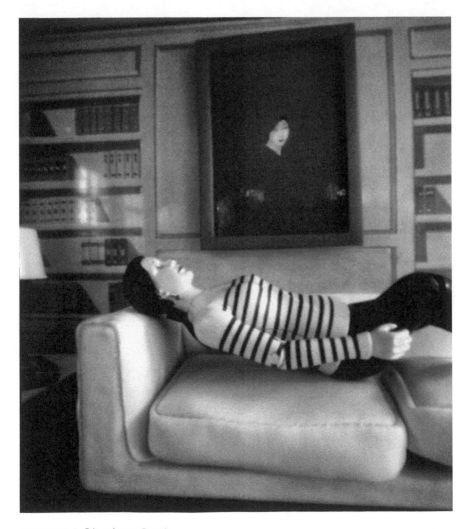

FIGURE 12.1 *Listening to Laurie*

Source: Donna Bassin. Pinhole photograph, 2003

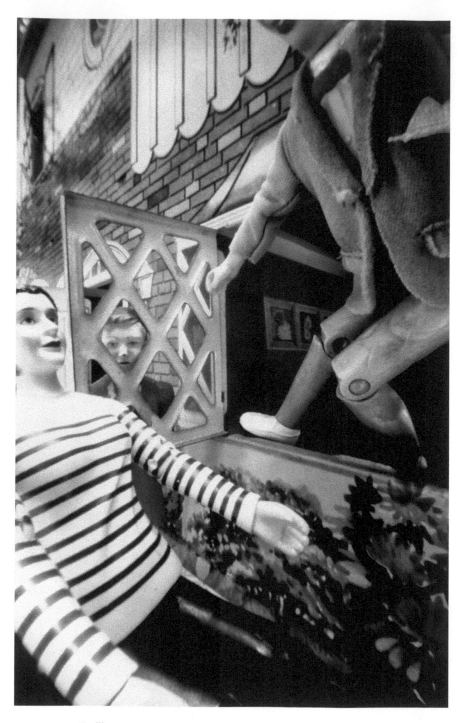

FIGURE 12.2 *Dollhouse: Window*

Source: Donna Bassin. Pinhole photograph, 2003

In *Listening to Laurie* (Figure 12.1), the doll figure I call "Laurie" is a toy bearing a striking resemblance to Laurie Simmons, a well-known photographer who in the 1970s and 1980s used dolls to address a variety of cultural concerns. By placing the Laurie figure on the couch, I played with the idea of listening to my artist self and accepting her importance. The photograph above the couch on the wall is *Red Mask* by the artist Sarah Charlesworth, suggesting the role of the mask or persona worn outside the office.

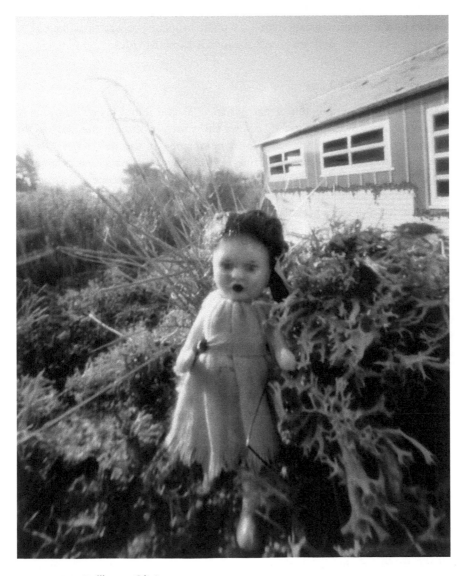

FIGURE 12.3 *Dollhouse: Olivia*

Source: Donna Bassin. Pinhole photograph, 2003

In *Dollhouse:Window* (Figure 12.2), the "Laurie" doll is outside the dollhouse. The "mother-figure" doll is stern and stands motionless, peering through one of many window panes, as the leaping trickster Pee-Wee Herman doll disrupts her stillness. The window portal is both a means of escape from the dollhouse and a way to look inside, a representation of my own mind.

Dolls were finally moved outside of the dollhouse in my office and taken with me on vacation to the beach. The scale and distortions in the photograph created by the placement of the pinhole camera to the staged scene create an ambiguity about whether or not the doll and the dollhouse are real. Playing on the edge, I questioned whether the traumatizing experience(s) actually happened or were imagined. How does one enliven the doll and give that which is inanimate life?

Drawing from the Edge

Ten years after the exhibition of *The Afterlife of Dolls*, I found myself returning to themes explored with that series, however this time unwittingly attending to the psychic structures of creating space for remembrance. In this new series, *Drawing from the Edge,* I actively destroy past imagery with white oil pastel marks attempting to take charge of, as well as represent, the ubiquitous experience of destruction, loss, and absence. Subsequently and enacting performatively a strategy of mourning, I then observe to see what still remains, and attempt to coax new thought-form from the whitened field. This takes me back to the mother at ground zero trying to find her daughter under the white ash; it takes me back to the years following my sister's death, trying to find what is still alive in my grief-stricken family. And this personal process resonates with my understanding of the psychic activities of mourning. At some point after the death of a loved one, we begin emotionally to acknowledge their loss, to accept their ultimate and permanent disappearance from our material life. This initiates a process of refinding within the psyche that which was once outside of it. Subsequently and over time, new internal relationships are creatively constructed, based on bits and pieces of memory of self in relationship to the loved one. That mourning in a sense is an attempt to make that which was once present, but now gone and materially invisible, internally visible and enlivened. That which appears empty on the surface *is* merely surface – but in actuality it is filled with a presence.

While grounded in the material reality of the small, mysterious Himalayan kingdom of Bhutan, the photos aren't about Bhutan *per se*, but rather explore and draw from the edge of my Western mind and Eastern Buddhist culture. They are "souvenirs" of what was absorbed and remembered.

The constructed landscapes of this series call attention to the way landscapes come into being, but only in relationship to the weather, gaze, mood, memory, and the desire that frames them. My landscapes are composites created with a series of interrelated events rather than capturing one physical location. This process, concretely, allowed me to capture, repossess, reintegrate, and transmit dissociated, emotional, sensory, or perceptual fragments captured by the iPhone into a new

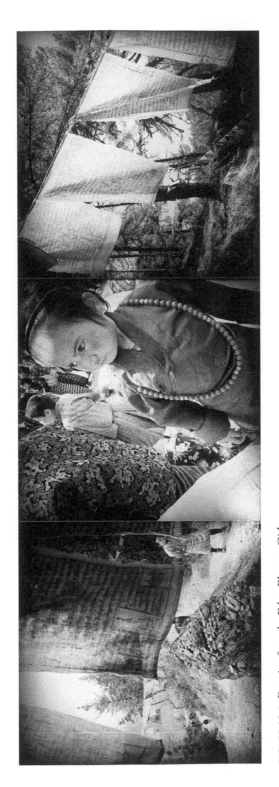

FIGURE 12.4 *Drawing from the Edge, Bhutan, Girl*

Source: Donna Bassin. Photograph with oil pastel and pencil, 2015

FIGURE 12.5 *Drawing from the Edge, Bhutan, Tree*

Source: Donna Bassin. Photograph with oil pastel and pencil, 2015

FIGURE 12.6 *Drawing from the Edge, Bhutan, Takin*

Source: Donna Bassin. Photograph with oil pastel and pencil, 2015

FIGURE 12.7 *Drawing from the Edge, Bhutan, Man*

Source: Donna Bassin. Photograph with oil pastel and pencil, 2015

subjectively meaningful narrative (a process similar to trauma becoming known). Photographic images transformed the original indescribable, invisible, traumatic experiences into a "thing" that could be worked on and worked over. Baer (2002) suggests that photography, with its structure of developing a negative that "harbors an image until it's printed," can provide special access to trauma, which also needs the deferred context of its recoding, or repeated presentation, to be visible and have meaning (Baer, 2002; Foster, 1996). My intent was to have the experience of a stranger in a new land without the use of the viewfinder or deliberate composition, to temporarily ignore my conscious edge- or frame-setting tendencies and to capture the undefined at the edges of perception.

In the high altitudes of Bhutan, the thinner atmosphere and the mist combines to produce a white haze, lifting and falling, and in the process creates the visual appearance of soft edges visually dissolving the materiality of a landscape. At moments as I walked through Bhutan, I panned the countryside with iPhone in hand and finger continuously on the "shutter" as if mindlessly wiping a glass clean. It was as if I were trying to stay inside the experience rather than standing outside – as Zen Master D. T. Suzuki (1994) suggested – trying to catch life as it flows. I photographed the visual array without the use of the viewfinder or deliberate composition, capturing that which was, without intent. By the end of my journey, I had scooped up hundreds of fragments of the mystical landscape. The task was then to work with the fragments I had captured and to extend them imaginatively towards a more resonating experience.

Despairing at the loss of the dimensions of movement and time in single-imagery landscape and wondering what the world looks like without confining edges, I began to arrange diptychs and triptychs by linking forms on the edges through formal composition and memories of mood and experiencing self-evoked on the journey through Eastern landscapes. In the space between two adjacent forms emerged a third – belonging to itself and to the two images that co-created it.

The boundary breaks the flow of the continuous nature of reality, temporarily drawing our attention to what is within. And at the boundary or edge is where "something new begins its presencing" (Heidegger, 1971, p. 154). I started making marks, emerging on the edges of my new combined photographs, drawing from within the image inside the frame to sketch out a possible emergence of something new.

Breaking edges and reconfiguring are a component of experiencing a dynamic present – perhaps part of the process of how mourning reconstitutes. 9/11 awoke forgotten memories within my past and concurrently those experience(s) of 9/11 infused the past, a new remembrance co-created from the conjuncture between the past and present results. In *The Afterlife of Dolls*, I turned my attention away from the crushing material reality of violence and death. I created a subjective reality in a playhouse, manageable and indirect, to assist me in the restoration of narrative and language blown away after the attack. The images contain the melancholia of loss and the disassociation of traumatic states.

In *Drawing from the Edge*, I began to take this process of confluence into the strategies of artmaking itself. This process of concurrence breaks the attachment

with fixed states, such as unresolved and invisible grief, allowing for a new presence of mind. A new image of thought arises from the juxtaposition, freed from history and offering a new reality.

One's own witness

My community work with inconsolable parents following 9/11 re-presented and revoked early childhood losses – not only was my sister gone but my parents had gone missing as well. Like the soldiers in my dream, they were oblivious to my coming undone. They lost sight of me and I of them. When loss is surrounded by absence, the loss is rendered incomprehensible and tragically unavailable for experience. The afterlife of the trauma was captured symbolically in the doll play – in the recoding opportunity and structurally in the final artworks that served as virtual witnesses. Consciously, this was cognitively known, but dynamic history was trapped in these images until further photographic experimentation with breaking and reconfiguring edge.

In the process of creating these (relational) aesthetic moments between self and resonating art object and eventually between self/art object and receptive audience, memories can be re-embodied, a dialogue with the world is established, and relational attachments, virtual or actual, can be rebuilt and serve as the witnessing other. The artist has an opportunity to create an aesthetic object: an expression that gathers together and resonates with the artist's previously unconscious/peripheral impressions. This potentially deep rapport between the maker and his or her creations provides, according to Bollas (1978), the generative illusion of "fitting with an object." This fitting, referred to by Bollas as an "aesthetic moment," is a form of witness.

Additionally, the constructive and reparative elements involved in the making of art may reduce the artist's anxieties about destruction and provide reassurance that one can master destructive impulses and bad internal objects. The very creation of an art object restores a sense of aliveness and integrative capacities for the maker.

The undoing of trauma requires becoming one's own witness – finding a way to occupy, to dwell within the tension of trying to find truth in a fictive structure. Perhaps this is the source of the artist's life-long questioning.

References

Baer, U. (2002). *Spectral evidence: The photography of trauma*. London: MIT Press.

Bennett, J. (2005). *Empathic vision: Affect, trauma, and contemporary art*. Stanford, CA: Stanford University Press.

Benjamin, W. (2002). *The arcades project*. H. Eiland (Trans.). Cambridge, MA: Harvard University Press.

Bollas, C. (1978). The aesthetic moment and the search for transformation. *Annual of Psycho-Analysis, 6*, 385–394.

Foster, H. (1996). *The return of the real: The avant-garde at the end of the century*. London: MIT Press.

Heidegger, M. (1971). *Poetry, language, and thought*. New York: Harper & Row.

Suzuki, D. (1994). *Introduction to Zen Buddhism*. New York: Grove Press.

INDEX

9 781138 859128